DAVID JOSELIT is a Professor in the De̲_____ _____
at Yale University. He taught for several years at the University of
California, Irvine, and from 1983 to 1989 he worked as a curator
at The Institute of Contemporary Art in Boston where he co-organized
several exhibitions, including 'Endgame: Reference and Simulation
in Recent Painting and Sculpture.' He writes frequently about
contemporary art and culture, and is the author of *Infinite Regress:
Marcel Duchamp 1910–1941*.

Thames & Hudson world of art

This famous series provides the widest available
range of illustrated books on art in all its aspects.

If you would like to receive a complete list
of titles in print please write to:

THAMES & HUDSON
181A High Holborn
London WC1V 7QX

In the United States please write to:

THAMES & HUDSON INC.
500 Fifth Avenue
New York, New York 10110

Printed in Singapore

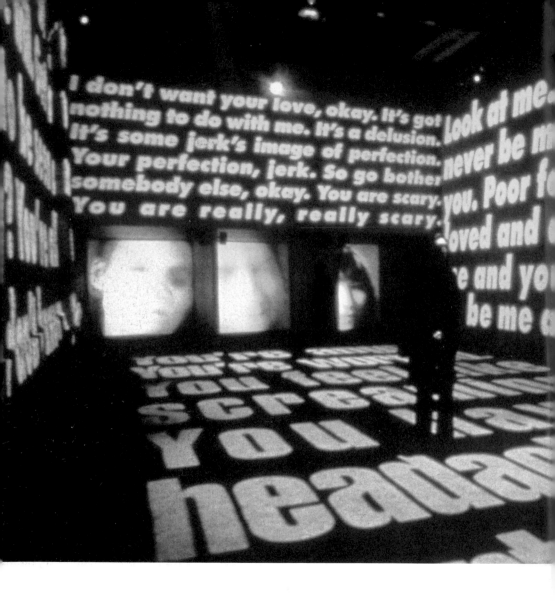

187 illustrations, 75 in color

David Joselit **American Art Since 1945**

Thames & Hudson world of art

For my parents, Jill and Lawrence Joselit

Acknowledgments

I am very grateful to Janet Kaplan who proposed me as an author for
American Art Since 1945 and to Nikos Stangos, my editor at Thames &
Hudson, whose warmth and acumen have leavened the process of writing.
A year-long fellowship at the Clark Art Institute enabled me to complete the
book, and to that institution, and particularly to Michael Ann Holly, Mariët
Westermann, and Gail Parker, I offer warm thanks. My research assistant
at the Clark, Pan Wendt, was efficient, intelligent, and cheerful and my
colleague there, Whitney Chadwick, offered helpful advice on preparing
a volume in the World of Art series. The following friends and colleagues
graciously responded to direct queries: Julie Ault, Whitney Chadwick,
Thomas Eggerer, Russell Ferguson, Karin Higa, Amelia Jones, Miwon Kwon,
Simon Leung, Sally Stein, and Damon Willick. A book like this one grows
from the work of many historians, critics, and curators. For this intellectual
community I am grateful. As a former curator, I have learned much from
artists themselves as my frequent citation of their writings and interviews
attests. Finally, the arguments in this book have been fashioned – and tested
– in the classroom. I thank my students at the University of California, Irvine,
for their lively intelligence and their intellectual generosity.

First published in paperback in the United States of America in 2003 by
Thames & Hudson Inc., 500 Fifth Avenue, New York, New York 10110

thamesandhudsonusa.com

Library of Congress Catalog Card Number 2002109021
ISBN 0-500-20368-7

Designed by John Morgan
Printed and bound in Singapore by C S Graphics

Frontispiece:
1. **Barbara Kruger**, *Power,
Pleasure, Desire, Disgust*, 1997

Contents

Preface

The title of this book announces a period and a place to be surveyed – *American Art Since 1945*. In doing so it makes a tacit, if impossible, promise: to represent the totality of art produced within a particular set of temporal and geographical boundaries. And yet a survey need not embrace this fantasy of comprehensive coverage. It may instead follow a procedure of conceptual mapping. No one would mistake a map for the territory it represents; maps are abstractions which, in order to function, must omit vast amounts of detail. This book offers one particular account of American art since 1945: it does not consider every artist of merit during the period, nor does it pretend to do so through a simulated reportorial neutrality. But, like maps, the arguments put forward here may function as navigational tools which enable readers to make sense of a large and diverse aesthetic field. It is my goal to provide useful perspectives on American art from which to evaluate and appreciate even those many individuals, movements, and practices that I do not consider. In other words, if my map is effective, it will assist in further exploration. Consequently, I regard the artists I have written about here as exemplary – literally examples of broader strategies and tendencies. Given the unfamiliar forms of so many art objects of this period, I have often found it necessary to analyze the work of individuals at length, even at the cost of further limiting the number of artists whom I am able to include.

Over the past several decades, disciplines in the humanities have experienced lively and sometimes rancorous debates concerning the constitution of artistic canons. The question of whom to include in histories of literature or art has grown contentious both inside and outside the classroom as the traditional dominance of white male writers and artists has been challenged and amended. This salutary effort has stimulated work on 'alternate' histories devoted to the experience and accomplishments of people of color, women, gay men, and lesbians. But it has also led to a thoroughgoing critique of the very impulse toward

canonization. In this book I neither shy away from canon-building nor do I simply accept traditional narratives of art history. Rather, I have attempted to reframe canonical movements by indicating their position in a broader field of practices, and to introduce 'alternate' histories into this inevitably mainstream account of American art since 1945. In Chapter 3, for instance, I discuss Pop art's mimetic transpositions of consumer products alongside street photography's poignant expression of the alienation arising from commercialization. And in Chapter 6, I link Conceptual art to the emergence of identity politics as manifested in feminist and activist aesthetics among women and people of color. My hope is to show that the 'mainstream' and the 'margin' must not remain separate from one another in our understanding of late twentieth-century art. Indeed, the distortions which result from canonization are largely due to the isolation of particular practices from a field of complementary and opposing activities.

This book thus attempts to broaden and diversify existing canons. But canonization does not simply entail the selection of an approved roster of artists; it also requires the development of synthetic narratives which may account for the various art activities of a particular period. Since the 1950s the dominant readings of postwar American art have linked its accomplishments to progressive European movements of the early twentieth century. For some critics and historians, US artists embody the triumph of European modernism, while for others American art represents the betrayal or decadence of the avant-garde of the teens, twenties, and thirties. Regardless of whether a particular judgment is positive or negative, American art since 1945 is typically evaluated according to the fundamental aesthetic imperatives of the early twentieth century. Foremost among these are the impulse toward abstraction embodied in movements ranging from Cubism to Constructivism, and the critical and celebratory responses to industrial modernization spanning Dada's depictions of mechanized eroticism and Futurism's troubling embrace of war machines. The scholarly accounts of these links between European avant-gardes and the so-called 'neo-avant gardes' of American art have been enormously productive but also significantly misleading. In this book I offer a synthetic reading of postwar art in the United States whose center of gravity lies not in the European avant-gardes of the early twentieth century, but in the social and aesthetic transformations of the American 1960s. My text is there- fore attentive to three interlocking dynamics: the consolidation of a public sphere rooted in

consumption and mass media like television and the Internet; the emergence of personal identity as the preferred platform from which to make political demands in the United States; and the transformation of art objects from traditional media like painting and sculpture to 'informational' media like text, photography, readymade commodities, and video. I believe these three conditions to be fundamental to American culture in the late twentieth and early twenty-first centuries, and I am convinced that artists – including many of those I have addressed in these pages – have not only represented this new social and aesthetic paradigm but have also participated in bringing it to life.

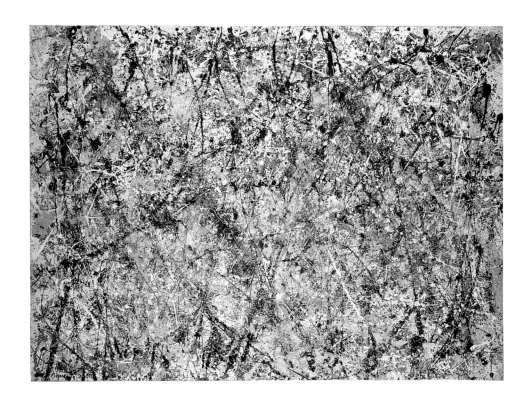

Chapter 1: The Private Gesture in Public: Art of the New York School

Arenas of Canvas

In a well-known essay of 1952, the art critic and poet Harold Rosenberg wrote, 'At a certain moment, the canvas began to appear to one American painter after another as an arena in which to act – rather than as a space in which to reproduce, re-design, analyze, or "express" an object, actual or imagined.' The 'certain moment' Rosenberg refers to is the emergence during the 1940s of a group of American painters variously labelled the New York School, the Abstract Expressionists, or Action Painters. This loose association of artists, whose most prominent figures included Jackson Pollock, Willem DeKooning, Barnett Newman, Mark Rothko, Clyfford Still, and Adolph Gottlieb, sought to re-invent painting from the ground up – literally in the case of Pollock (1912–56), whose distinctive method consisted of placing unstretched canvas onto the floor of his studio and then dripping or otherwise propelling paint onto it with highly controlled, dancer-like gestures. Rosenberg probably had Pollock in mind when he claimed that the nature of painting had shifted from a space for picturing things to an 'arena in which to act,' but to differing degrees such a transformation characterizes the work of most Abstract Expressionists. These painters allowed the process of making their art to stand as a fundamental aspect of its 'content.' And although in one sense these actions were intensely private, paradoxically they were destined, as works of art, for the public sphere. Influenced by postwar theories of existentialism,

liberally leavened by Cold War paranoia, painters like Pollock sought to externalize – and thus to make public – what they saw as an internal psychological reality. Continuing the traditions of European Surrealism, which were introduced in New York via several expatriate European artists, ranging from the poet and impresario of Surrealism André Breton (1896–1966) to painters such as Roberto Matta (b. 1911) and André Masson (1896–1987), unconscious desires and drives were identified as the artist's proper subject matter.

But how does one represent a mental topography? In Pollock's case this dilemma was resolved by radicalizing processes of painterly automatism, theorized by Breton, and promoted by Matta in New York, in which the artist worked to disable his internal censor and to allow his body to generate an image without premeditation. Pollock, as well as his most astute critics, including Harold Rosenberg and Clement Greenberg, regarded his non-objective and gestural mode of applying layer upon layer of dripped or flung paint as the physical expression of a psychic reality. As the artist famously declared, 'The method of painting is the natural growth out of a need. I want to express my feelings rather than illustrate them.' But if Pollock and his cohort were enacting a private need, or expressing individual feelings, there was a core belief among Abstract Expressionists that their heroic access to authenticity through the act of painting did not pertain solely to themselves, but rather could be meaningful to a much wider public. In looking at the tangled webs projected across the surface of a canvas like *Autumn Rhythm, Number 30* (1950), for instance, the viewer may simultaneously lose her or himself in the pulse of line and color, and regain a coherent perceptual position

3. **Roberto Matta**,
Invasion of the Night, 1941

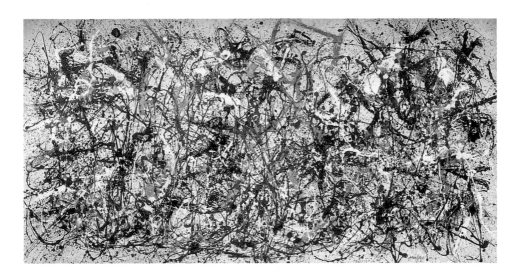

by recognizing the almost orderly patterns which Pollock's loops and vectors of paint provisionally establish. In other words, some of the artist's own process of making the work is re-enacted by the viewer in the realm of perception.

Clement Greenberg, who with Rosenberg was the most influential critic of New York School painting, and whose writings continue to shape the understanding of modernist art in the United States to this day, was uneasily aware of the paradox of the personal and the public in art like Pollock's. On the one hand Greenberg, like Rosenberg, insisted that 'authenticity' and emotion were the engines of significant painting; on the other hand he also defined abstraction in terms of larger supra-personal developments in the history of art. For Greenberg, the objective of modernist painting was to analyze and express its basic constituent conditions as a medium. In the case of Pollock, this meant a dramatization of the material nature of paint – its viscosity in conjunction with its motion – as it is dripped and tossed onto the canvas. For Greenberg, then, Pollock's emotion transcended the painter's own unconscious drives in order to express a broad cultural reality – the nature of modernity as expressed in painting. In general, the art of the New York School seized upon the most personal and individual psychic material in order to express a shared set of values and experiences. In this sense, the arena of the canvas, which Rosenberg identified as the painter's locus of activity, must also be seen as a microcosmic reflection of the larger arena of the public sphere.

One of the central arguments of this book will be that postwar American art is derived from, and represents, new experiences of the public produced by the explosion of visual mass media beginning with broadcast television in the 1940s and continuing through the Internet of the 1990s. Under these conditions, identity – an ostensibly private affair – has acquired the political force once attributed to collective identifications such as class and nation. In the postwar era, experiences of the 'public' took place more and more frequently either alone or in small groups in front of a television or before a computer screen. Paradoxically, while linking individuals to the world, these media also atomize and isolate viewers by, among other things, sorting them through ideological identifications into various categories by race, ethnicity, gender, sexual orientation, as well as a multitude of other factors ranging from geographical location to age. It will be contended here that American art of the postwar era arises at the intersection of these new media public spheres and the politicized experience of identity that develops alongside them. Usually this historical conjunction is associated with the liberationist movements of the 1960s and is epitomized by slogans such as 'the personal is political.' However, the association of the personal and the public (if not the political) was already well established in the ostensibly apolitical abstraction of the New York School. It is in the figure of the heroic painter, who expresses his or her personal emotions in an idiom believed to be universally relevant, in which the paradigm of the 1960s is already apparent.

While individualism might suggest a withdrawal from public life, individuality had a powerful political meaning in the immediate postwar era. For many Americans during the Cold War, individualism – as opposed to totalitarian models of government associated with fascism or the Stalinist Soviet Union – seemed an appropriate moral and political response to new global realities. According to such convictions, in a democracy it was not only one's right, but one's duty to behave as an individual: the development of a private 'lifestyle' could function as a public act. If individualism was adopted as a sign of American values politically, it also fostered the growth of consumer society by affirming shoppers in their distinctive skills of evaluation and analysis in the face of the dizzying variety of products on offer in affluent postwar America. While not self-consciously or programmatically adopting such ideologies, Abstract Expressionist painters nonetheless occupied them through their enactment of heroic

5. **Mark Rothko**, *No. 5 / No. 22*, 1950. In Rothko's paintings clouds of color touch one another, scrambling relationships between figure and ground. As the artist himself suggested, his shapes may function as performers, but the dramatic action is almost entirely perceptual.

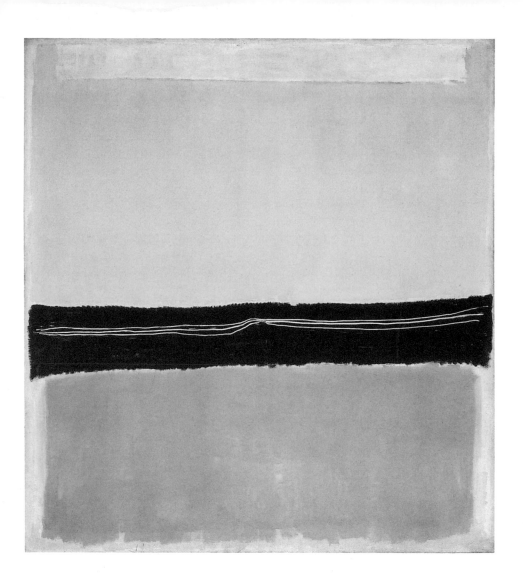

personae within and outside of their paintings. Among the artists of the New York School, a premium was placed on developing a distinctive formal vocabulary that was recognizably associated with a particular artist. Jackson Pollock had his skeins of dripped and flung paint. Willem DeKooning had his mosaics of interlocking biomorphic forms. A Barnett Newman painting made after 1948 could be recognized by the presence of a narrow vertical line or 'zip' which transected broad fields of color, and the canvases of Clyfford Still (1904–80) were characterized by dense tectonics of color bounded by jagged organic contours or 'tears.' By 1949 Mark Rothko had invented his own signature motif consisting of two or more rectilinear clouds of color in a vertical canvas. Style among Abstract Expressionists was closely aligned to individuality.

Style alone, however, is not a heroic characteristic. Heroism entered through a painter's difficult and even tortured attempt to arrive at and represent self-knowledge. For Pollock such an endeavor was embedded in the alternating currents of chaos and order which his mode of painting engendered. For Willem DeKooning (1904–97), who, alongside Pollock, was the best known and most widely celebrated Abstract Expressionist, the heroic derived from a process of painting and re-painting present in the work through *pentimenti* – the traces of painterly strokes partially effaced or else abandoned, like statements broken off in mid-sentence. DeKooning was notorious for working and re-working his canvases – sometimes over very long periods. The cumulative effect of these layers of making and unmaking is an expression of the difficulty of bringing an image into being – a heroic process of aesthetic birthing. Indeed, the gendered term 'birthing' is used advisedly because in many of DeKooning's best known works, his heroism is achieved through and upon the represented bodies of women.

In 1953, DeKooning mounted an exhibition titled 'Paintings on the Theme of the Woman' at the Sidney Janis Gallery in New York. The works included in this show, which are among the most celebrated of the New York School, represent female figures equally reminiscent of ancient fertility goddesses, such as the Venus of Willendorf, and 1940s calendar pin-ups. In the context of DeKooning's career, the 'Women' paintings relate to a series of male and female figure studies of the late 1930s and 1940s in which bodies are broken apart into an array of biomorphic shapes and then re-ordered. During the 1940s, even DeKooning's ostensibly non-objective paintings included organic forms which

[margin annotations, handwritten:]
Fascism – dictatorship that exalts a nation + race.

DeKooning birthing (aesthetic heroism). framing his heroism)

Seeming

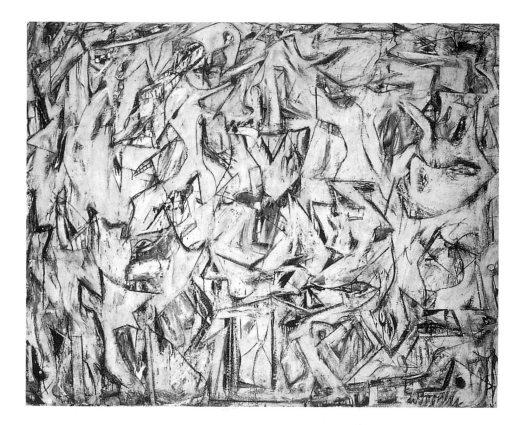

6. **Willem DeKooning**,
Excavation, 1950.
The nervous angular shapes
suggest a montage of organic
fragments whose origin or
context is unknown to the
viewer. In this sense, the
work's title is apt, in pointing
to a layering of meaning which
is partial and retrospective,
as though derived from the
shards uncovered in an
archaeological excavation,
or from the emergence of
unconscious impulses
in dreams.

recall those of his figure studies, establishing abstract fields
resembling undulations of liberated flesh. In the 'Women' paint-
ings of the early 1950s the implicit violence of DeKooning's
earlier figurative works is heightened through the artist's prac-
tice of slashing paint across the canvas, and his tendency to
exaggerate breasts, lips, and eyes in what, to many, seem like cruel
and cartoonish images of grotesque sexuality. Indeed, both for
male critics of the 1950s as well as feminist art historians of
the 1980s and '90s, these works make explicit the gender politics
prevalent in much Abstract Expressionist art – not only
DeKooning's – in which the gestural act of the male painter is
metaphorically aligned with masculine sexual potency and the
patriarchal values which celebrate it as a source of universal
human creativity. A review of the 1953 Janis exhibition by Sidney
Geist makes these associations explicit. Geist wrote, 'In a gesture
that parallels a sexual act, [DeKooning] has vented himself with
violence on the canvas which is the body of this woman.'

7. **Willem DeKooning**,
Woman, 1, 1950–52

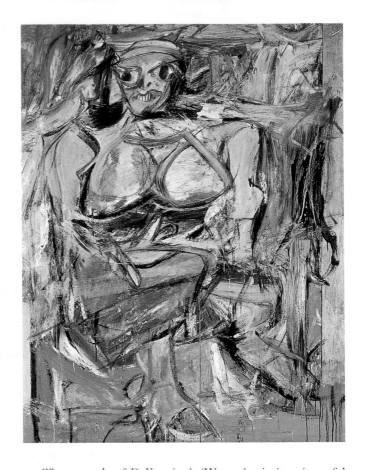

The example of DeKooning's 'Women' paintings is useful because it demonstrates that, as art historian Ann Gibson has recently argued, the heroic stances of New York School artists universalize a single identity position – white male heterosexuality – at the expense of others. An important paradox is at work here which, as will become clear in the next section, also underlies the Abstract Expressionist fascination with Native American art. As Harold Rosenberg's projection of a public dimension onto the private act of painting made clear, individuality was essential to the self-definition of mid-twentieth-century abstraction in the United States. However, this individuality was meant to stand for a universal set of human values and emotions. In order to create such a universal individuality, Gibson argues, the painters of the New York School needed to subsume other identities within their single transcendent one. So, as Geist's crude metaphor suggests, painting could be understood as a form of sexual intercourse

performed by the male painter on the woman/canvas, femininity being thereby both represented and appropriated – conquered and transformed – by the male painter. However, as Gibson and Anne Wagner have argued, this reading placed women and people of color who painted in the milieu of the Abstract Expressionists in a difficult, if not impossible, position. As Wagner argues with regard to Lee Krasner (1908–84), who was married to Jackson Pollock, all of those qualities which were valued in Pollock's art – its access to emotion and its flirtation with chaos would be condemned as excessively feminine or even hysterical when met with in the art of a woman. From this perspective Krasner's tautly woven hieroglyphic canvases of 1949, which beautifully synthesize the painterly gesture with alphabetic form, might be unfairly regarded as little more than a response to her husband's more freewheeling gesturalism. For Krasner, as well as for many other artists on the periphery of the New York School, the universal humanist values associated with Pollock or DeKooning were not accessible; instead their art was evaluated in light of the particularized identity of, for instance, femininity.

In painting of the New York School, individualism was expressed through an array of distinctive visual styles. However, the particular type of individuality valued in this milieu was the heroic emotion and suffering of heterosexual white men who, during the 1940s and '50s, were unquestionably assumed to represent 'humanity' as a whole. Two points must be established here: first, that already with this movement, which was the first of

8. **Lee Krasner**, *Untitled*, 1949

international significance to emerge from the United States, the question of identity as a public and, therefore, a *political* category was in place; second, the particular form of identity which this mode of painting represented and enacted was severely limited. The history this book tells is of the broadening and fracturing of the heroic mode of selfhood initiated in American art of the 1940s and '50s – a development which parallels the nation's increasingly diverse population and cultural life. The heroic individuality of the New York School was famously characterized by Harold Rosenberg as 'anxious.' Perhaps part of this anxiety derived from the knowledge or intuition that any presumption of universality within identity must be tenuous in the extreme, and that in the years to come, such a partial account of the public dimensions of selfhood would be challenged and enriched on many fronts.

Ideographic Pictures

The heroic struggle to attain and represent self-knowledge among painters of the New York School grew from their conviction that an individual's personal existential acts – including acts of painting – could express a fundamental human nature. By conceiving their art in such general terms, the Abstract Expressionists created links between themselves and the viewers of their paintings, thereby constituting an inclusive public sphere which, in theory, embraced everyone. If one means of establishing such a broad purview of collective identification through painting was by regarding the painter as a hero, and the artwork as his or her heroic labor, there was also a second track pursued by the Abstract Expressionists in creating a collective consciousness or a public sphere. This emerged from their fascination with symbolic languages which could communicate across temporal and cultural boundaries. For Jackson Pollock, Barnett Newman, Mark Rothko, Adolph Gottlieb and others, such cosmologies could be found in Native American or ancient myths, as well as in the array of archetypes – symbols such as the sun and the moon – which structure the 'collective unconscious' as theorized by the psychoanalyst and one-time disciple of Freud, Carl Jung. For Newman, Rothko, and Gottlieb, who are sometimes referred to as the 'mythmakers' among the New York School, the goal was to invent modern myths which could speak to any sensitive viewer, regardless of his or her cultural background. Each of them, along with Pollock, cited and modified archetypal images drawn from elsewhere in the process of inventing their own distinctive

modern 'ideographs.' Here again, as in the adoption of heroic personae, the Abstract Expressionsts sought to create a public through their painting ... one which was as universal as humanity itself and which would resonate with the Jungian notion of a shared vocabulary of mental or dream symbols – the 'collective unconscious.' Paradoxically, in seeking to invent their own mythic representations which could communicate broadly, these artists ended by creating unfamiliar forms and modes of painting which mystified as many viewers as they captivated.

Barnett Newman (1905–70), who wrote art criticism in addition to painting, served as a spokesman of sorts for the perspective of the mythmakers. Newman's writings and curatorial work were pivotal in establishing an analogy between the function of Native American aesthetics and that of the New York School. Working with the gallerist Betty Parsons, Newman participated in organizing and writing essays for exhibitions of Pre-Columbian and Northwest Coast Indian art in 1944 and 1947 respectively. In an essay reflecting on the 1944 show, he made an explicit connection between ancient art of the Americas and the most contemporary productions of metropolitan New York. He wrote, 'The New York art public found that these arts held for them a personal message. They were no longer the historical curiosities of a forgotten people, the crude expression of a primitive, undeveloped people. Rather, they were the sublime creation of highly sophisticated artists with the same doubts, the same wonderings, and the same searching for salvation ... which activates men of spirit today.' Newman's elision of Pre-Columbian cultures with the preoccupations of mid-twentieth-century New York is open to serious challenge in its quasi-imperialist collapse of cultural and temporal difference. Notwithstanding this critique, these remarks eloquently communicate the conviction held within Newman's circle that art is transhistorical and transcultural, and that Native American forms may serve as models for such a universal, symbolic language.

Among those painters of the New York School interested in mythic imagery, a two-step development may be perceived. The first step was an adoption of totemic forms inspired by existing native or archetypal sources, often filtered through an interest in Surrealist modes of automatism. Pollock, for instance, possessed several volumes of the *Annual Report of the Bureau of Ethnology* containing illustrations of Southwest Indian sand painting in which elaborate cosmological figures were temporarily traced on the ground as part of native ceremonies. In 1939 and 1940 he

9. **Jackson Pollock**,
Stenographic Figure, 1942

10. **Jackson Pollock**,
Totem Lesson 2, 1945

engaged in Jungian analysis with Dr. Joseph Henderson, during which time his therapist encouraged him to bring in and discuss his own drawings full of archetypal symbols. These explorations inform many of Pollock's paintings during the 1940s, such as *Stenographic Figure* (1942), *Guardians of the Secret* (1943), *Totem Lesson 1* (1944), and *Totem Lesson 2* (1945), in which the elongated figures of Navajo sand paintings haunt his own distinctive evocation of symbolic figuration.

Similarly, the early and mid-1940s paintings of Mark Rothko (1903–70), including *Sacrifice of Iphigenia* (1942), *Primeval Landscape* (1944), and *Rites of Lilith* (1945), are populated by spindly totemic forms over bands of modulated color in an imaginative, Surrealist-inspired re-staging of ancient myths. Barnett Newman also embraced the mythic during the 1940s through his fascination with genesis. During this period his works often contained egg, sun, or seed shapes, sometimes in combination with spurs resembling stems or tree trunks, all suggesting organic generation or fertility. In works such as *Gea* (1945) and *Pagan Void* (1946) the notion of origin is explored on three registers, including natural or organic cycles of life, mythological accounts of such cycles, and finally the Abstract Expressionist imperative

16

11. **Mark Rothko**,
Primeval Landscape, 1944

to take painting back to its own origins. Such intersections of vegetative and painterly beginnings were also characteristic of the canvases of Arshile Gorky (1904–48), whose forms are derived from his close observations of nature. The loosely gridded 1940s paintings of Adolph Gottlieb (1903–74), such as *The Prisoners* (1946) or *Division of Darkness* (1947), include arrays of totemic forms which perhaps come closest to a specific native model – in this case, the bark painting of Northwest Coast Indians.

During the late 1940s many artists of the New York School took a second and final step in their development as ideographic painters. At this moment the effort to illustrate or to 'update' ancient cosmologies or stories gave way to a more thorough-going invention of modern non-objective ideographs. Instead of picturing myths, the Abstract Expressionists sought to enact them. Rothko, Still, and Newman provide the clearest examples of this development. In all three artists' work, fields of non-objective color came to function as 'actors' in what Harold Rosenberg called the 'arena of the canvas.' Indeed, Rothko made this point

12. **Arshile Gorky**, *The Liver is the Cock's Comb*, 1944

13. **Adolph Gottlieb**,
The Prisoners, 1946

explicitly in a text of 1947 in which he declared, 'I think of my pictures as dramas; the shapes in the pictures are the performers. They have been created from the need for a group of actors who are able to move dramatically without embarrassment and execute gestures without shame.' It is possible to understand Rothko's distinctive motif of stacked rectilinear fields of color, 5, 14 whose evolution had already begun at the time of this statement, as an anthropomorphic theater of perceptual actions. Part of the drama derives from the emergence and withdrawal of figure into ground: it is notoriously difficult to determine any precise spatial mooring among Rothko's color fields as it is in Still's canvases whose elements alternately seem to come forward and to recede. Over his productive career, Rothko mined this ostensibly simple abstract hieroglyph in order to produce a wide range of perceptual and emotional effects ranging from sunny combinations of orange and yellow, which strike an almost painfully high key, to his very somber, almost monochromatic paintings of the mid-1960s.

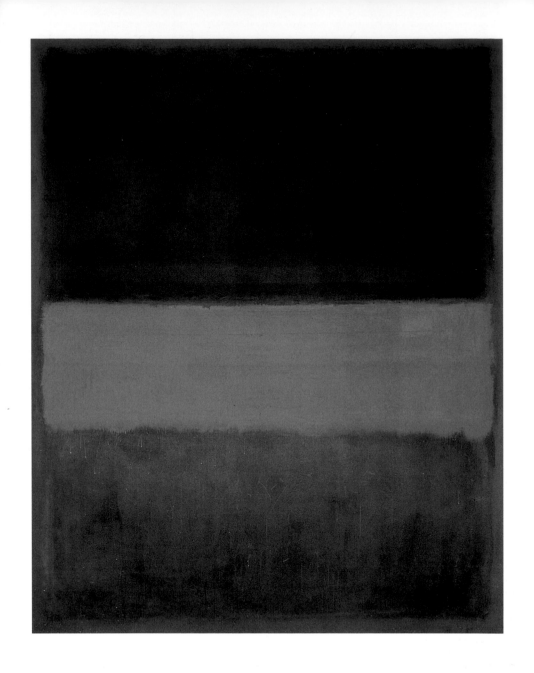

Likewise, with *Onement I* (1948), Barnett Newman invented his own distinctive painterly format – the thin vertical line or 'zip' transecting a monochromatic field of color. In his subsequent development of this motif, Newman varied the color and number of zips, the sharpness of their edges, as well as the color and dimensions of the canvas they would divide. But in all cases a similar perceptual contradiction was established between the broad fields of color, which embrace the viewer in their large scale 'environments,' and the zips, upon which the eye can never rest, but rather rapidly slides up and down in a hyper-active, unending blink. These thin vertical bands function as perceptual borderlines or cuts, which serve both to divide and join together the tinted canvases they transit through.

18

14. **Mark Rothko**, *No. 61 (Rust and Blue)*, 1953

15. **Barnett Newman**, *Onement III*, 1949

Each of these works pivots on the division of a painterly field, but each does so with a different effect. While Rothko's *No. 61 (Rust and Blue)* (opposite) suggests a ponderous layering of emotions associated with his distinctive juxtaposition of colors, Newman's vertical line, or 'zip,' transects the monochromatic *Onement III* (right) with great velocity. Whereas for many viewers the horizontality of Rothko's forms suggests a landscape, the vertical orientation of Newman's painting evokes upright human stature.

In the mature work of both Rothko and Newman, the artists' earlier fascination with myth or genesis is displaced onto the question of a different type of origin – the origin of perception. Such a project may be understood in light of Clement Greenberg's influential argument that modernist painting arises through a self-critical procedure of stricter and stricter analysis leading to the minimal means necessary to produce what the critic regarded as a good painting. But there is a dimension to Rothko and Newman's art which is much rawer and more potent than Greenberg's account can capture. Newman, himself, evokes this quality in a 1947 essay titled 'The Ideographic Picture.' In discussing Native American art, he wrote, 'To [the Northwest

16. **Barnett Newman**, *Pagan Void*, 1946. Newman's early paintings often embraced the subject of religious and biological origins as a metaphor for the creation of a new model of seeing through art. As in this work, he often used forms suggestive of eggs, seeds, or planetary bodies like the sun or moon.

Coast Indian] a shape was a living thing, a vehicle for an abstract thought-complex, a carrier of the awesome feelings he felt before the terror of the unknowable.' While ostensibly on the subject of native art, Newman's text clearly captures the experience of making and viewing non-objective art. And what he emphasizes through this analogy, and what Greenberg's accounts tend to repress, is the sublime 'terror of the unknowable' which abstract painting may provoke. Indeed, withdrawal from mimetic representation necessitates a kind of ritualized occasion of seeing anew – one that is both powerful and potentially terrifying. This terror is familiar to anyone who has entered a museum gallery only to be confronted by a radically unfamiliar visual language – exactly the experience of all but the most initiated viewers encountering art of the New York School for the first time.

This chapter began with a discussion of the Abstract Expressionists' heroic efforts to realize themselves through their art, or in Pollock's words, to paint 'out of a need.' Newman's concept of the ideographic picture, in which shape functions as a living thought-complex, points to an analogous but complementary visual event – the *viewer's* recognition of his or her own 'need' (or unconscious) through confrontation with ideographic painting. These two experiences – the painter's externalization of private emotion and the spectator's recognition of such emotion as pertinent to him or herself – are the bookends of a single representational slippage between inside and outside, psyche and representation, individual and public sphere. It is this ambitious project, begun by the Surrealists in Europe, of inventing a public language for private emotion and sensation that the painters of the New York School seized upon so enthusiastically. Through their ideographs the Abstract Expressionists lured the viewer back to the origins of perception, not simply as Greenberg would have it, to the minimum means necessary to form a painting. Both through the universalization of their heroic stance, and through the invention of what they hoped to be transcultural modernist ideographs, the painters of the New York School sought to enact an experience of origins which could function on three levels at once – the personal, the aesthetic, and the cultural. In so doing they turned the personal inside out in order to produce a new paradigm of the public sphere.

Private Gestures as Public Acts

Thus far the term 'public' has been conceived broadly to encompass a community as vast and abstract as 'humanity' at large. Both through the heroic persona of the artist engaged in existentially inflected painterly acts, and in ideographic paintings meant to embody a perceptual ground-zero, Abstract Expressionist art communicated the ostensibly paradoxical message that individualism may serve as the foundation for a public sphere. Such a transcultural notion of community founded in a shared human psychology is theoretically so broad as to risk rendering itself meaningless. The question may therefore reasonably arise, 'What kind of collective consciousness can result from such abstract forms of identification?' There is more than one answer to this question. On the one hand, the generality of the 'human' presumed by New York School abstraction is premised on whiteness and maleness, and therefore cannot be legitimately granted the generality it presumes. On the other hand, this abstract notion of a community composed of all humanity served to consolidate and represent a very specific and particular public sphere – the postwar United States. Indeed, beginning in the late 1940s, the painting of the New York School attained an unprecedented public profile both nationally and internationally. Despite the artists' ostensibly apolitical emphasis on autonomy, individuality, and transcendence, their art came to be associated with specifically American values.

If New York School painting is generally accepted as the first avant-garde movement of international significance to develop in the United States, it is less often acknowledged that its emergence coincided with the explosion of American consumer society, and with the sophisticated forms of mass communication which accompanied and enabled this development. In what is probably his most famous essay, 'The Avant-Garde and Kitsch' (1939), Clement Greenberg established an opposition between high art which, according to him, withdraws into its own terms and procedures, and commercial culture, or kitsch, whose sweetened and hackneyed aesthetics are as inauthentic as modernism's practices are rigorous and principled. Painters such as Pollock, DeKooning, Rothko, and Newman, whose uncompromising abstraction requires sustained reflection from the viewer, might be opposed, for instance, to the pandering accessibility of popular artists like Norman Rockwell (1894–1978). However, if Greenberg and many subsequent critics and historians have sought to sustain an opposition between New York School

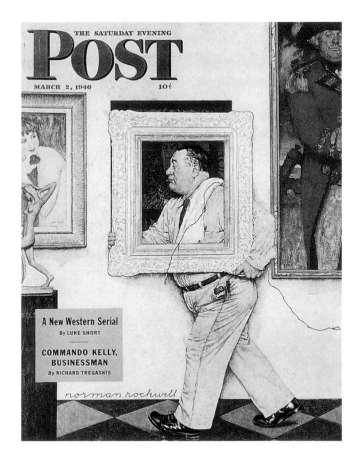

17. **Norman Rockwell**, *Framed*, 1946, on the cover of *The Saturday Evening Post*, March 2, 1946

painting and mass culture, the historical record suggests that the boundary between them was not always so clear. The success of Abstract Expressionist art owes much to the attention paid to it in the mass media, and particularly within one of the most popular mouthpieces of American culture in the 1940s and '50s, *Life* magazine.

In the years after World War II, the marketing of art in the United States accelerated significantly. One indication of what art historian Serge Guilbaut has identified as the entry of art into everyday life during this period was the explosion of commercial galleries in New York during the 1940s. But it was *Life* magazine with its vast readership and authoritative voice which could confer celebrity on an artist through its coverage, and it was *Life* which chose Jackson Pollock for such attention in a 1949 feature article titled 'Jackson Pollock: Is he the greatest living painter in the United States?' Many have noted that Pollock's portrait in

Life, in which he stands, sullen and defiant, with arms crossed and a cigarette hanging from his lips, virtually eclipsed the painting *Summertime* which hung behind him in the picture. Pollock's gruff persona accords perfectly with pre-existing notions of the American hero (or anti-hero) – from cowboy to Hell's Angel – in qualifying him to occupy the position of artist-as-rebel. Such rugged individualism was exactly what the readers of *Life* wanted from an artist and this is what the magazine delivered. Despite the often derisive tone of the text with regard to Pollock's painting, the artist's portrait truly spoke more eloquently than words – and indeed, in this context, more eloquently than his works as well.

There is a convergence, while not an absolute congruency, here between the concept of individuality current among the initiates of New York School painting, and mass cultural accounts. In much of the popular coverage of avant-garde artists like Pollock there was an emphasis on the artist's irrepressibility or outlandishness. In another of *Life*'s articles of this period, covering a boycott launched by a group of New York School painters against the anti-modern bias in a juried exhibition of contemporary art at the Metropolitan Museum, a sober group portrait of the Abstract Expressionist community was published under the headline 'Irascible Group of Advanced Artists Lead Fight Against Show.' The name stuck, and henceforth the Abstract Expressionists were often labelled 'Irascibles.'

Unlike Clement Greenberg's stark opposition between avant-garde and kitsch, *Life*'s coverage of New York School painting seized upon a self-conscious and fundamental quality of the work – its emphasis on individuality – but simplified and conventionalized it. For the artists discussed in this chapter, individuality signified an existentialist reinvention of perception and subjectivity from the ground up, whereas for *Life* individuality served as one readymade lifestyle among many – a rebellious type of persona extensively mined, for instance, in Hollywood film. The significant point here is that the generation of the New York School had irreversibly entered what may be termed a 'media public sphere,' or in historian Benedict Anderson's terms an 'imagined community,' established by the shared consumption of media like magazines, television, and film. Whereas the coverage in *Life* and elsewhere distorted the artists and their art in many ways, it also enabled their careers. Significant material consequences resulted, such as the ability to sell paintings more easily, and the expansion of the art world from a small band of

sophisticated initiates to the much broader audience of casual museum-goers with which we are familiar today. Moreover, from this point on, artists increasingly had to confront and sometimes, as with Andy Warhol and Pop art of the 1960s, to incorporate the exigencies of celebrity into their practice of art.

Life seized upon the quality of individuality in the new American avant-garde and transformed it into celebrity. Even in applying the mildly pejorative term 'irascible,' the magazine's coverage manifested a sense of pride in or at least fascination with the unfamiliar forms of the New York School. Indeed, in the course of the 1950s, such 'irascibility' was deployed to promote an image of American openness and democracy abroad in a series of international exhibitions indirectly sponsored by the US government. A variety of scholars, including most prominently Serge Guilbaut, have argued that the painting of the New York School came to stand for American values of democracy during the Cold War. The 'freedom' associated with abstraction was opposed to the so-called brainwashing attributed to the official Soviet aesthetic of Socialist Realism in which specific ideological values were narrowly communicated through an accessible, figurative style. Guilbaut, Eva Cockcroft and others have noted that during the 1950s the Museum of Modern Art in New York served as a nexus of aesthetics and politics in the cultural register of Cold War conflict. Paradoxically, while the American Congress was, and remains, skeptical of advanced art, making official sponsorship difficult, the Museum of Modern Art, some- times with the secret support of the CIA, and always with the guidance of its politically connected patrons, the Rockefeller family, stepped into the breach. MoMA's International Council was established in 1956 to organize exhibitions of American art throughout the world – a policy which dovetailed conveniently with the Rockefeller family's efforts to cultivate a receptive environment for their international business concerns in Europe, Latin America, and Asia.

The ideological framework for these projects is exemplified by a passage from MoMA curator Alfred H. Barr's introduction to 'The New American Painting,' which included several artists of the New York School and which toured eight European coun- tries in 1958–9. Barr wrote of the artists, 'Indeed, one often hears Existentialist echoes in their words, but their "anxiety," their commitment, their "dreadful freedom," concern their work primarily. They defiantly reject the conventional values of the society which surrounds them, but they are not politically

engagés even though their paintings have been praised and con-
demned as symbolic demonstrations of freedom in a world in
which freedom connotes a political attitude.' Barr's passage per-
fectly embodies the paradox of the political reception of Abstract
Expressionism: it was precisely its apolitical assertion of freedom
that was seized upon politically as an index of the superiority of
American democracy. What is particularly compelling about the
history and reception of New York School painting is how a
rarefied realm of gestural art-making – Harold Rosenberg's
canvas as an 'arena in which to act' – serves as the kernel of ever-
wider arenas of public action and signification. The innocence of
the Abstract Expressionists – their utopian desire to re-figure
perception – was ultimately heavily taxed by the worldly roles
their art was asked to assume, both within the mass media and in
international diplomacy.

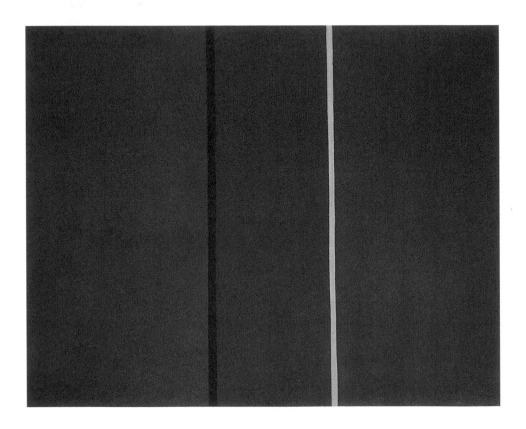

Chapter 2: Expanded Gestures: Painting of the 1950s

Stains and Graffiti

Both the painting and the criticism of Abstract Expressionism embraced two contradictory objectives at once. On the one hand, through its gestural marks and fields of color, the optical effects and material viscosities of the medium were allowed to emerge as the content of New York School painting. For a critic like Clement Greenberg, whose prestige in the art world was consolidated during the 1950s, modernism was precisely such an articulation and refinement of the fundamental characteristics of painting as a medium. But despite its rigorous pursuit of non-objective self-referentiality, art of the New York School could not be limited to an exclusively formalist perspective. It simultaneously pointed inward toward the contents of the artist's psyche, and outward toward universal symbolic or ideographic languages. In other words, as demonstrated in the previous chapter, the 'arena of the canvas' was at once an optical and a social space – the locus of acts which were both intensely private and decidedly public. This unstable alliance of the formal and the social, the private and the public, depended upon a faith in the heroic individuality of the painter whose aesthetic gestures were believed to be at once intimate and universal. In the course of the 1950s, as this notion of the autonomous and exemplary creator began to weaken (it would ultimately collapse in the revisions of identity and authorship of the 1960s), the antipodes of Abstract Expressionist art began to pull apart and polarize, suggesting a panoply of sometimes contradictory responses to the legacy of the New York School.

During the mid- and late 1950s Abstract Expressionism enjoyed broad international prominence, attaining the canonical status that previous generations of artists had conferred on Cubism. The avant-garde challenge which had characterized advanced art since at least the mid-nineteenth century dictated that an ambitious artist identify and absorb the philosophical problems and aesthetic strategies of previous generations in order either to amplify or to negate them – and sometimes both at

18. **Barnett Newman**, *Covenant*, 1949

once. For some artists of the generations immediately following the New York School, the challenges posed by Abstract Expressionism inspired a further analysis and refinement of the painterly act. Figures as diverse as Morris Louis and Frank Stella attenuated their brushstroke to the point where the artist's personal gesture was less important than a systematic or rule-based manipulation of medium. For others, the 'arena of the canvas' and the action painting which took place there suggested a different set of possibilities leading away from painting altogether. Artists like Allan Kaprow and Carolee Schneemann – early practitioners of freewheeling events known as Happenings – understood that aesthetic acts need not be restricted to painting. Instead they made environments – arenas in real space – in which the perform- 31, 33 ing bodies of the artist and his or her collaborators, and often audience members as well, became constituent elements of the work. In other words, the legacy of Abstract Expressionism led in at least two ostensibly contradictory directions – toward an increasingly severe formalism, and toward a performative erasure of distinctions between aesthetic and social space. While these alternative developments of the post-New York School arena of art-making seem paradoxical, one of the objectives of this chapter will be to demonstrate the parallels between these antipodal responses, and their ultimate synthesis in the early manifestations of Pop art.

19. **Morris Louis**,
Beta Kappa, 1961

20. **Morris Louis**,
Beth Heh, 1958

Louis invented a method of pouring paint directly onto canvas so that the force of gravity was apparent in the resulting painting. In some works, like *Beth Heh* (opposite), colors blend into dense but paradoxically translucent masses which, for a Cold War audience, might recall mushroom clouds. In other canvases, such as *Beta Kappa* (below), colors remain separate, but their serried lines frame the work's central void.

21. **Helen Frankenthaler**,
Mountains and Sea, 1952

In the mid-1950s, among artists like Helen Frankenthaler (b. 1928) and Cy Twombly (b. 1929), the terms of this relationship between the optical and social aspects of painting were already in play. If on the one hand, Frankenthaler's invention of 'stain painting' initiated a more autonomous gesturality, in which fields of paint seemed to compose themselves with relatively little intervention by the artist, Twombly's nervous scrawls and

doodles on canvas elide the artist's gesture with the anonymous social language of graffiti. Frankenthaler's 1952 work *Mountains and Sea* is credited as her first 'stain painting,' in which form was generated largely by pouring thinned paint onto unsized, raw canvas laid onto the studio floor. This technique allowed the fluidity of the medium to generate both the contour of the painting's elements and a distinctive halo encircling them, resulting from the uneven bleeding of the medium into absorbent canvas. As in Pollock's work, where line and shape were released from the imperative to describe things objectively, Frankenthaler's paintings center on relationships between adjacent areas of color. However, in contrast to Pollock's tendency to create overlapping webs or skeins of line, Frankenthaler's works of the early and mid-1950s allow free-form 'puddles' of paint to accumulate side by side while remaining distinct from one another except for charged regions of contact around their edges. In a work such as *Mountains and Sea* this compositional strategy establishes a centrifugal pinwheel effect which has been compared to organic processes of exfoliation. Other paintings of the time, such as *Shatter* (1953), establish a more sedate atmosphere, suggesting the tesselations of a mosaic. In general the propulsive force of gesture in the art of Abstract Expressionists like Pollock or DeKooning is absent in Frankenthaler's work, which by contrast seems to emerge independently of the artist's actions. Indeed, Harold Rosenberg criticized her work on these grounds by remarking that her 'action is at a minimum; it is the paint that is active.'

2, 4

22

What Rosenberg regarded as a defect – that the action in Frankenthaler's art was attributable more to the nature of paint than to any heroic activity of the artist – in fact signals an important shift in much ambitious American painting of the 1950s and '60s, in which the artist's gesture is displaced by medium-based processes and systems. In the work of a painter such as Morris Louis (1912–62), for whom Frankenthaler's innovative technique of staining was famously inspiring, the physics of motion appears to have engulfed human gesture. This is particularly true of Louis's so-called veil paintings of the mid-1950s which he made after seeing Frankenthaler's *Mountains and Sea* in 1953. These dense images, paradoxically composed of several diaphanous layers, were generated through his closely guarded technique of pouring thinned paint over a canvas raised and gently folded into a kind of funnel. In these works it is the direction of the poured paint, drawn by gravity rather than the artist's own propulsive force, which generates form. Often, as in *Intrigue*

19, 20

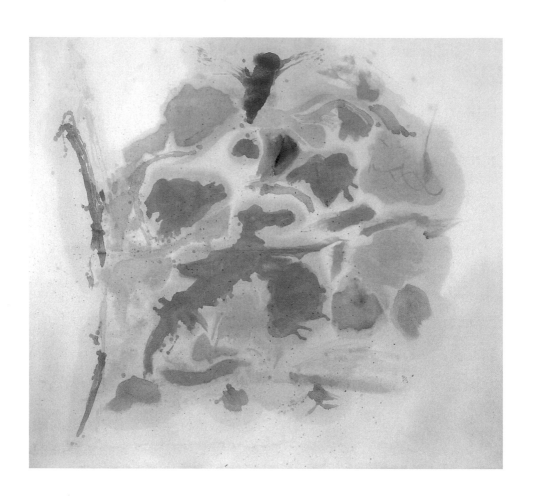

(1954) or *Beth Heh* (1958), a puddle resulting from successive 20
pourings is visible at the bottom of the canvas. Such a strong
architectonic rooting of the work serves to fasten down its
ethereal layers of overlapping color while accentuating the
autonomous dynamic of gravity.

For Greenberg and other modernist critics, a fundamental
virtue of the staining technique was its capacity to close the gap
between the canvas as a supporting ground and paint as an ani-
mating figure or form placed upon it. Because color was absorbed
directly into the weave of the fabric, figure and ground are unified
into one tinted object and one perceptual unit. By contrast, Cy
Twombly's art of the mid-1950s dramatizes the agonistic rela-
tionship between canvas and mark. Paintings such as *Criticism*
(1955), which is typical of Twombly's work at this time, consist of
a canvas uniformly painted white into which he scratched and
scrawled with crayon, pencil, and pastel as though gouging into a
whitewashed wall. If for Frankenthaler and Louis the artist's
gesture approached the status of an autonomous material event,
for Twombly it approximated writing – a mode of inscription
which promises, though often fails to deliver, social legibility.
Twombly's gestural technique has often been compared to
graffiti, and indeed it strongly resembles the crudely drawn
pictograms and doodled images which mark the walls of public
places. By 1957, when he began to include words in the broad

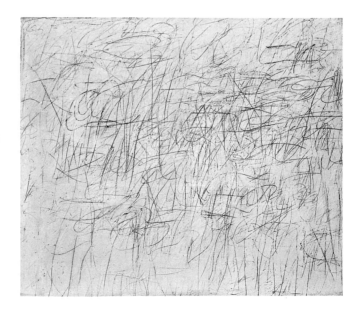

22. **Helen Frankenthaler**, *Shatter*, 1953

23. **Cy Twombly**, *Criticism*, 1955

While Frankenthaler allows paint to stain the canvas in free form puddles (opposite), Twombly's marks (right) have the nervous energy of graffiti. Each of these works isolates and intensifies one aspect of the Abstract Expressionist legacy – the nature of paint as medium in the case of Frankenthaler, and the idiosyncracy of gesture in the case of Twombly.

monochromatic surfaces of paintings like *Arcadia* (1958), such comparisons became inescapable. Like Frankenthaler's stain paintings, which seem to continue the legacy of formalist abstraction established by the New York School, Twombly's jittery marks ostensibly belong to the tradition of Pollock's calligraphic webs of flung paint. But as in Frankenthaler's art, where the action began to drain out of action painting, in Twombly's work the heroic pretension of Abstract Expressionist gesturalism is decisively undermined. In place of grand painterly acts emerging from authentic psychic need are decidedly anti-heroic, furtive scrawlings reminiscent of anonymous communications on bathroom walls.

Frankenthaler and Twombly together establish the poles of response to the New York School during the moment of its emergence as the dominant mode of modernist painting in the mid-1950s. Both artists ostensibly continue the project of Abstract Expressionism by isolating and refining two of its fundamental characteristics. While Frankenthaler dramatized the fluidity of paint and its capacity to generate form, Twombly initiated a mannerist gesturalism in which the psychic need of Pollock is transposed to the desublimated impulses of graffiti. However, underlying these apparent extensions of New York School formalism are two strategies which run counter to its tenets, and which would animate much ambitious American art of the 1950s. First, Frankenthaler displaces the heroic personal gesture of the artist onto processes and procedures effected by chance. In her art, painting emerges less from the artist's psychology than from actions she sets in motion in the material systems of the medium. For his part, Twombly allows a pre-existing social language – the rhetoric of graffiti – to enter into the arena of the canvas in place of the original and invented visual idioms developed by artists such as Pollock or DeKooning. Instead of making his own world from the ground up, Twombly finds an aesthetic outside of himself which he amends and refines. These two related perspectives delineate an agenda for advanced art of the 1950s. On the one hand, the question of non-compositionality, or how to make a painting in the absence of heroic gesturalism, emerges as a fundamental philosophical and aesthetic problem. On the other hand, Twombly's appropriation of a worldly language originating outside the accepted boundaries of conventional aesthetics would go on to be radicalized in environmental works like Happenings, where expressive gestures were staged not on canvas, but in real space and time.

24. **Cy Twombly**, *Arcadia*, 1958

Anonymous Gestures and Expanded Arenas

Fundamental to New York School painting was a belief that abstract art emerged from the artist's psychic depth. A complex understanding of individuality encompassing several registers at once, ranging from personal heroism to nationalist ideology, underwrote the non-objective forms of Abstract Expressionism. It is all the more surprising, then, that while second, third, and fourth generation Abstractionists continued to promote a myth of personal aesthetic autonomy, many of the most promising directions in American abstraction in the 1950s dwelled on the impersonal, anonymous nature of the artistic gesture, or what art historian Yve-Alain Bois has called anti-, non-, or a-compositionality. Non-compositionality encompasses several aesthetic strategies, each of which is intended to bypass or suppress an artist's personal gestural idiom. Bois has identified several of these: the utilization of readymade forms in lieu of invented ones, the deployment of chance procedures rather than intuitive composition, the reduction of color to monochrome, the application of grids to systematize and unify painterly imagery, and the use of serialization in which uniform elements are added to one another rather than balanced optically. All of these techniques suggest the antithesis of action painting as theorized by Harold Rosenberg and practiced by many Abstract Expressionists. An interpretive riddle thus presents itself: Why and how did the mode of modernist painting shift from the myth of personal creativity to assertions of anonymity in such a short period of time in the early and mid-1950s?

One way to account for this apparent historical reversal is to amend our picture of the New York School by remembering that the painters associated with it were more diverse than we have yet acknowledged. Ad Reinhardt (1913–67), for instance, who is typically considered an Abstract Expressionist (despite his resistance to the label), deployed a number of non-compositional strategies as early as 1950. Works like *Abstract Painting, Red* (1952) and the series of related works to which it belongs, are structured according to a grid and composed of virtually monochromatic, close-valued red squares and rectangles. The 'action' in Reinhardt's paintings is rooted more in the viewer's perceptions than in the artist's procedures of making: it is the viewer who must labor to distinguish form within the nearly undifferentiated fields of Reinhardt's works. In a poetic phrase Bois has referred to such a sustained act of looking as the 'narrativization of one's gaze.' In Reinhardt's work, certain formal problems

25. **Ad Reinhardt,**
Abstract Painting, Red, 1952. As in many of his works, Reinhardt here juxtaposes rectilinear fields of color whose value is so close that separate shapes are difficult to distinguish. The pattern of the painting only emerges with sustained viewing: as it becomes discernible, it presents the viewer with a range of optical and philosophical questions concerning difference and perception.

which were central to Abstract Expressionism, such as creating an all-over image (one that does not hierarchically emphasize any single element or area of the composition over any other) or breaking down the stable opposition between figure and ground, are raised and resolved without the gestural heroics associated with Pollock or DeKooning, or even the intuitive arrangement of broad color fields which distinguishes the works of Rothko or Newman. The example of Reinhardt might therefore suggest that non-compositional painting is the twin of Abstract Expressionism, shorn of the latter's agitated gesturalism but addressing scientifically, as it were, the very same philosophical and aesthetic questions.

There is a great deal of truth to such an account, but it tells only part of the story. The cooler, more anonymous painting of the 1950s not only responds to formalist questions posed by Abstract Expressionism, but also to a shifting social terrain in which the myth of autonomous action or creativity had become difficult if not impossible to sustain. The heroic images of New York School painting were quickly recoded during the late 1940s and 1950s by the worldly roles they were made to play both within mass media like *Life* magazine, and through their politicized circulation in official or semi-official exhibitions abroad (see p. 31). In other words, even as the art of the New York School emerged, the autonomy of the Abstract Expressionist gesture was palpably threatened. Such a situation, in which individuality is understood to be conditioned by group norms, is in accord with what the sociologist David Riesman famously called the 'other-directed person' in his influential book *The Lonely Crowd* (1950). According to Riesman, the 'other-directed' personality, typical of middle- and upper-middle-class urban professionals, emerges in the United States alongside the expansion of consumer culture in the years following World War II. Riesman describes the type as follows: 'The other-directed person must be able to receive signals from far and near; the sources are many, the changes rapid. What can be internalized, then, is not a code of behavior but the elaborate equipment needed to attend to such messages and occasionally to participate in their circulation.' Riesman's language, in which the human being is likened to a kind of radar, or television receiver, suggests the degree to which consumer culture of the 1950s was believed to be founded on the individual's internalization of external systems of making and perceiving meaning.

In the realm of art-making, 'chance' has served as a means of acknowledging and representing the other-directedness of the creative process. What, after all, is chance but the intrusion of external factors or events into the personal arena of creativity. But chance procedures are never entirely left to chance: typically an artist establishes a set of rules to be followed within whose well-determined parameters no particular outcome is premeditated. In 1951, for instance, while living in Paris, the American artist Ellsworth Kelly (b. 1923) made a number of collages, some of which served as studies for full-scale paintings, where the distribution of black and white or colored squares on a grid was determined by a random drawing of numbers. The results, such as *Seine* (1951) or *Spectrum Colors Arranged by Chance* (1951–3), are generated not from the artist's personal touch, but rather from his equally idiosyncratic determination of procedures of selection and organization. The artist's 'gesture' does not disappear – rather, it is filtered through processes which he or she determines, but does not completely control. This is particularly clear in works such as Kelly's *Cité* (1951) where an image is 26 derived from cutting up one of his drawings composed of brushstrokes into squares and randomly re-arranging them in a new gridded format. In such works the expressive gesture is submitted to various systems of scrambling and reorganization pivoting on the grid. Such a practice in which the artist sets in motion an open-ended operation rather than performing discrete, bounded actions also characterizes the paintings of Frankenthaler or Louis where the artist's process of pouring is completed by the action of the paint itself.

A significant difference exists, however, between the art of Frankenthaler and Louis and that of Kelly. Whereas the imagery of the former artists emerges *within* the boundaries of the canvas, Kelly often establishes a congruency between the unit of color and the contour and dimensions of the canvas support. In *Colors* 27 *for a Large Wall* (1951), for instance, a spectrum of colors are used to create a series of individual monochrome panels combined into a grid. Not only, as Bois notes, does *Colors for a Large Wall* introduce several non-compositional strategies at once – including the grid, the monochrome, serialization, and the readymade – but it also lays the groundwork for a rigorous association between the canvas panel as a unit, and the work's basic quantum of color. Such a congruency between the material objectivity of the support and constituent elements of color exemplifies a variety of non-compositionality sometimes refered to as 'deductive.'

In such works, the painterly event or system is derived – or 'deduced' – from the shape and dimensions of its canvas. One might say that in such practices the delineation of the 'arena of the canvas' is as important, if not more so, than the 'events' which take place within it.

In a series of works known as his 'black paintings,' begun in 1958, Frank Stella (b. 1936) provided the painterly gesture with a new deductive justification by generating his geometric patterns from the overall dimensions of the canvas support. Although Stella has said that he did not explicitly plan the black paintings as a series, taken together they explore several permutations of a simple idea. Each painting fills the rectangular expanse of canvas with different configurations of nested or radiating black lines whose patterns are sometimes rectilinear, sometimes diamond-shaped, but almost always produce an optical illusion of simultaneous pyramidal projection and recession. The simplicity of Stella's compositions is matched by his working process. Apparently he sketched configurations in pencil onto a canvas

30

26. **Ellsworth Kelly**, *Cité*, 1951

27. **Ellsworth Kelly**, *Colors for a Large Wall*, 1951

and then painted black stripes by hand as evenly as possible, forgoing masking tape as a means of insuring sharp lines. Like a workman, and unlike the heroic Abstract Expressionist, he used a housepainter's brush to apply commercial enamel paint onto raw canvas. In other words, in his principles of design, his choice of materials, and his mode of painting, Stella sought to displace the autonomy of the artist's gesture onto methods and practices such as housepainting, which exist outside the realm of the art world. Nor was Stella alone in this 'de-skilling' of the painterly gesture. Around 1960 Agnes Martin (b. 1912) began to make evocative paintings composed of hand-drawn grids, and Robert Ryman (b. 1930) established a series of largely monochromatic white canvases whose restraint in color called attention to the materiality of the medium.

The 'other-directed' quality of Stella's black paintings, however, was not limited to their formal procedures. It was significantly heightened by the application of sometimes inflammatory, and often mystifying, titles such as *Arbeit Macht Frei* (1958) and *The Marriage of Reason and Squalor* (1959), all of which refer in some way to metaphorical dimensions of

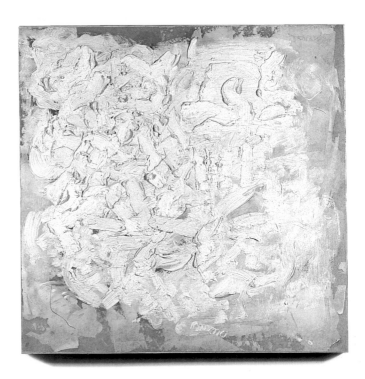

28. **Robert Ryman**,
Untitled, 1961

48

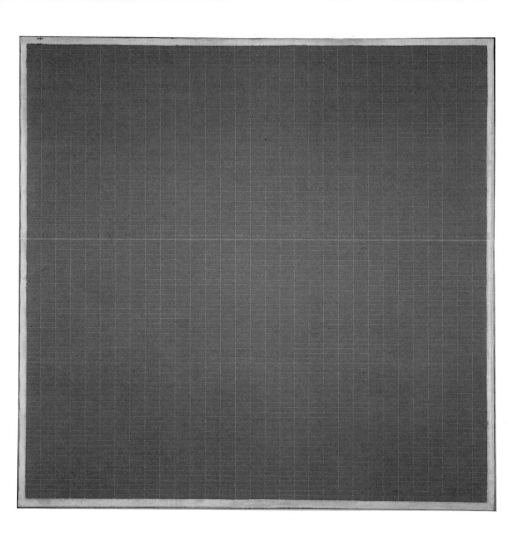

29. **Agnes Martin**, *Night Sea*,
1963. Though ostensibly uniform,
Martin's grids contain a great deal
of variation. Her simple system
produces fields of subtle tone
whose visual power belies their
quiet modesty.

blackness. *Arbeit Macht Frei*, which may be translated as 'labor liberates' was the notorious slogan emblazoned on the entrance gate to the Nazi extermination camp at Auschwitz. This highly charged phrase seems wildly inappropriate for the rigorously formal painting divided into four quadrants which it names. But if Stella's formal strategy may be viewed as 'other-directed' in its reliance on ostensibly arbitrary rules and unskilled labor rather than psychically charged gestural painting, so too do his titles carry this notion of other-direction beyond the realm of form to that of metaphor. This distinctive mode of linguistic framing implies that no color – least of all the highly charged tones of 'blackness' – can function as an exclusively optical event. Rather, each inevitably contains within it a virtually uncontrollable catalogue of cultural associations encompassing, as in this case, allusions to race, good and evil, and the opposition between ignorance and knowledge.

The strange titles Stella applied to his black paintings suggest the paradox encoded in non-compositional art of the 1950s and its later manifestations during the 1960s. While such paintings may appear arcane and hermetic in their formalism, they nonetheless point decisively outside the realm of art toward socially inflected procedures and metaphorical associations. One might say that in emphasizing the 'other-directedness' of their gestures, artists like Kelly and Stella opened the arena of the canvas to the very commercial, corporate, and even political systems of meaning which Abstract Expressionist art endeavored to exclude. The painter's gesture, formerly regarded as the privileged carrier of his or her unique individuality, now began to function as an internalization of wordly codes – what Riesman called 'the elaborate equipment' necessary for perceiving social realities. If such an 'introjection' of the world within the arena of the canvas served as one response to the legacy of the New York School, a converse approach emerged alongside it in Happenings, in which gesturalism, formerly confined to the canvas, was projected out into the world.

Allan Kaprow (b. 1927), who began his career as an Expressionist painter, regarded the multi-layered events taking place in real time and space which constitute Happenings as an expansion of Pollock's mode of painting. In 'The Legacy of Jackson Pollock,' an important text written in 1958, the same year Stella began his black paintings, Kaprow suggested this genealogy explicitly. He wrote, 'Pollock as I see him, left us at the point where we must become preoccupied with and even dazzled

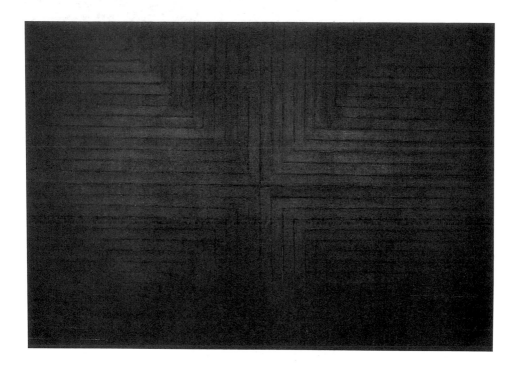

30. **Frank Stella**, *Arbeit Macht Frei*, 1958

by the space and objects of our everyday life, either our bodies, clothes, rooms, or, if need be, the vastness of Forty-second Street. Not satisfied with the suggestion through paint of our other senses, we shall utilize the specific substances of sight, sound, movements, people, odors, touch.'

In the Fall of 1959, Kaprow put these principles into action in his *18 Happenings in 6 Parts*, presented at the Reuben Gallery in New York. The event itself took place in a special environment designed by Kaprow which recalled his assemblage sculptures of the preceding few years. The gallery was divided into three 'rooms' by semi-transparent plastic sheets painted and collaged by the artist to give the effect of a three-dimensional action painting dilated to fill the space of the gallery. This expansion of gestural painting into three dimensions served as the mise-en-scène for a more complex set of live actions which constituted the Happening proper. On the night of the event, audience members were given elaborate instructions which read in part, 'The performance is divided into six parts.... Each part contains three Happenings which occur at once. The beginning and end of each will be signaled by a bell.' Audience members were expected to move from room to room in the course of the evening, so that

31

their own bodies became dynamic elements in the work, and their physical perspective as spectators was caused to shift. The actions themselves, embellished by sound, lights, and film and slide projections, were relatively simple or childlike, such as a woman squeezing oranges or a concert with toy instruments. It is worth trying to imagine the carnivalesque distraction that this event produced: flashing lights, inexplicable sounds, the discomfort of being forced into small plastic cells in order to witness incomprehensible actions directly, as well as distorted fragments of other equally strange occurrences through the partially obscured plastic walls of each room.

Michael Kirby has argued that Happenings were different from conventional theater in several important ways. First, rather than establishing coherent narratives, Happenings tended to create simultaneous actions or absurd juxtapositions which were difficult to synthesize or absorb. Instead of being tightly scripted, they were typically 'scored' like music: actions were specified, but their execution was improvised. Happenings were

31. **Allan Kaprow**,
18 Happenings in 6 Parts, 1959. This environment recalls Kaprow's early abstract art. The screens he built to delineate three separate rooms constitute one layer of the Happening's multi-valent imagery, which also included a wide array of live actions. Unlike traditional theater, the 'sets' in a Happening cannot be separated from the work as a whole.

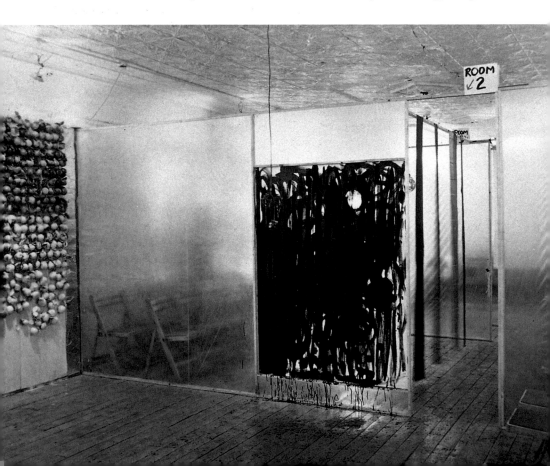

often unique performances and when they were repeated, they were never quite the same. Second, the participants in Happenings were not actors – in fact, as Kirby has written, 'The performer frequently is treated in the same fashion as a prop or a stage effect.' Everyday actions and movements prevail rather than virtuoso performances. Third, Happenings disrupt the conventional relationship between event and audience members by challenging the latter's expectations, disorienting them by requiring shifts in position, or by directly incorporating them in the action at hand. Fourth, Happenings occurred either in galleries or in public spaces, rather than theaters, and were conceived by artists, often taking place in specially constructed environments which functioned not as stage sets but as free-standing installations. In short, Happenings engage a whole range of aesthetic problems which emerge from painterly rather than theatrical traditions. Indeed, Kaprow has suggested that at a time when the artist was hemmed in by commercial pressures and interests, Happenings could return art to a creative, dynamic environment reminiscent of the studio where it was conceived and constructed, rather than positioning it in 'the "better" galleries and homes [which] ... dessicate and prettify modern painting and sculpture.'

On one level, then, Happenings by artists such as Allan Kaprow, Jim Dine (b. 1935), Red Grooms (b. 1937), Robert Whitman (b. 1935), or Carolee Schneemann (b. 1939) may be seen as re-inventing the performative, heroic gesture of the artist at a moment when such autonomous gesturalism was threatened by the pressures of consumer culture in general, and the expanding art market in particular. As already argued with regard to non-compositional paintings such as Stella's (see pp. 42-50), by the late 1950s the artist's gesture could no longer stand as the simple effect of his or her inner psychic need. While painters such as Kelly and Stella dramatized this situation through a mechaniza-tion or routinization of their painterly process, or through the introduction of chance into their procedures, artists such as Dine and Grooms explored the problematic through a vaudevillian mode of performance in which the artist both asserts and comically undermines himself. In Dine's thirty-second performance, *The Smiling Workman*, presented at the Judson Memorial Church in 1960, for instance, he parodies Abstract Expressionist paint-ing processes in part by swallowing a paint bucket full of red fluid. In Schneemann's well-known work, *Meat Joy* (1964), flesh itself became the medium for Expressionist form-making (and

32

33

unmaking) in space. In a famous sequence of the piece a group of nearly nude performers writhe and embrace on the floor along with raw chicken, sausage, and fish. As in *The Smiling Workman* where paint is ingested, the visceral nature of the body as a 'painterly' material demonstrates what Stella had shown in much more austere terms in his black paintings. For in Happenings such as *The Smiling Workman* or *Meat Joy*, the artist is both an active subject and an object – s/he who makes the work, as well as a compositional element within it. In other words, the cycle of expression and objectification which non-compositionality explored as a formalist problem, is rendered here as a visceral psychic condition of the artist her or himself.

32. **Jim Dine**, *The Smiling Workman*, 1960

33. **Carolee Schneemann**, *Meat Joy*, 1964

Mediated Gestures

The previous section compares two complementary responses to Abstract Expressionism by artists of a subsequent generation. Painters engaged in non-compositionality continued working within the boundaries of a canvas but governed their gestures by autonomous systems like chance, deductive composition, and the grid. Conversely, in Happenings, the object-status of painting was dispensed with altogether as gesturalism moved into real time and space. These opposing strategies, each possessing its own aesthetic (austere formalism on the one hand, and expressionist excess on the other) nonetheless responded to a single artistic and historical condition – a breakdown in the perceived autonomy of the expressive individual. Taken together, the two tactics suggest a zero-sum game in which painting must either let the world in or, conversely, suffer disappearance into it.

During the mid-1950s Robert Rauschenberg (b. 1925) and Jasper Johns (b. 1930) occupied a middle ground in this skirmish – a position eloquently summarized in Rauschenberg's famous statement of 1959: 'Painting relates to both art and life. Neither can be made. (I try to act in that gap between the two).' Rauschenberg and Johns bridged this gap by incorporating fragments drawn from the mass media alongside their own painterly marks. Indeed, commercial forms of visual communication such as magazines or television perfectly embody the link between art and life: as image languages they approach the status of art, but as the premier means of experiencing a public sphere in the late twentieth century, they produce the locus of everyday life. In their canvases of the 1950s Rauschenberg and Johns practiced an art of 'mediated gestures' in which their own aesthetic marks re-enunciate and re-code the raw materials of the media public sphere.

If Harold Rosenberg regarded the Abstract Expressionist canvas as an arena in which to act, the composer John Cage, and later the art historian Leo Steinberg, compared Rauschenberg's paintings to tabletops upon which things happened to fall. In his 1961 essay, 'On Robert Rauschenberg, Artist, and His Work,' Cage wrote of the artist's painting: 'This is not a composition. It is a place where things are, as on a table or on a town seen from the air: any one of them could be removed and another come into its place....' Indeed, since 1954, in paintings such as *Collection* (1954) or *Charlene* (1954), Rauschenberg included mass-produced fragments ranging from scraps of newsprint to a working electric light bulb within dense fields largely composed of his own brushstrokes. In slightly later works, such as *Rebus* (1955), the

34. **Robert Rauschenberg**,
Collection, 1954

35. **Robert Rauschenberg**,
Rebus, 1955

Art historian Leo Steinberg used
the term 'flatbed' to describe
how in many of Rauschenberg's
paintings collaged elements
come together like a collection
of things laid randomly on a table.
More recently art historians like
Jonathan Katz and Thomas
Crow have discerned elaborate
allegorical meanings in these
combinations.

distribution of elements is less tightly packed – and resembles the random disorder of a tabletop. If Cage's analysis of Rauschenberg's painting is remarkably acute, this is due in large part to the composer's great influence on both Rauschenberg and Johns, as well as Kelly and Kaprow. These artists and many others during the 1950s and '60s were indebted to Cage's notion of chance in which 'found' or existing sound displaced traditional qualities of musical composition. This attitude exemplifies a critical shift during these years from the artist's *production* of images to his or her *recognition* and re-presentation of the aesthetic values and pleasures of everyday life. In this sense Cage both disseminated Marcel Duchamp's notion of the readymade, developed in 1913–15, and transformed it by insisting upon its performative potential.

If Rauschenberg's paintings of the mid-1950s resembled tabletops, such a mode of composition synthesized the fundamental strategies of both non-compositional painting and Happenings. On the one hand, the diverse and unrelated contents of works such as *Rebus* seem to be governed by chance, and on the other, as in Happenings a few years hence, canvases like *Rebus* embrace the materials of everyday life. Steinberg and art historian Rosalind Krauss have compared Rauschenberg's compositions to the workings of the mind, in which thoughts drift and mingle, one coming to the fore as another recedes. Indeed, what might be called Rauschenberg's 'media unconscious' simultaneously continues Pollock's practice of painting from psychic need and re-situates it within the transpersonal realm of the mass media. Rauschenberg not only transformed the compositional mode of the New York School – from exalted arena to ordinary tabletop – but he also reinvented the artist's gesture as something which takes place in the context of, and against, existing codes and images.

Perhaps the most dramatic instance of such an agonistic practice of gesturalism is Rauschenberg's *Erased DeKooning Drawing* (1953), in which he arduously erased an original work on paper requested from and given to him by the prominent Abstract Expressionist for this purpose. Rauschenberg regarded this 'drawing' not as an act of destruction, but rather as an artwork achieved affirmatively through erasure. *Un*making was thus elided with making. By rendering the artist's mark literally invisible but conceptually present through its relation to previous art, Rauschenberg established a form of 'blank gesture' analogous to the type of unrhymed but metered poetry known as blank verse.

36. **Robert Rauschenberg**,
Erased DeKooning Drawing,
1953

ERASED de KOONING DRAWING
ROBERT RAUSCHENBERG
1953

In Rauschenberg's later solvent transfer drawings, in which painterly mark and photograph converge, such 'blankness' inheres in the artist's act of appropriating found images rather than exclusively inventing his own. In his series of illustrations for Dante's *Inferno* (1958–60), for instance, which foreshadows his use of photo silkscreening after 1962, the Abstract Expressionist painterly mark and the photograph converge. To make these drawings, Rauschenberg soaked magazine photographs in solvents such as lighter fluid and then rubbed them with the tip of a pen onto paper. In the resulting images, the mark of the artist's tool emerges through a photographic reproduction: the personal gesture wells up through a readymade picture, remaking it, as it were, from within. If *Erased DeKooning Drawing* established a reverberation between gestures of making and gestures of unmaking, the solvent transfer drawings initiated an analogous opposition between images produced by an individual

37. **Robert Rauschenberg**, *Canto XXXIV* (from *XXXIV Drawings for Dante's 'Inferno'*), 1959–60

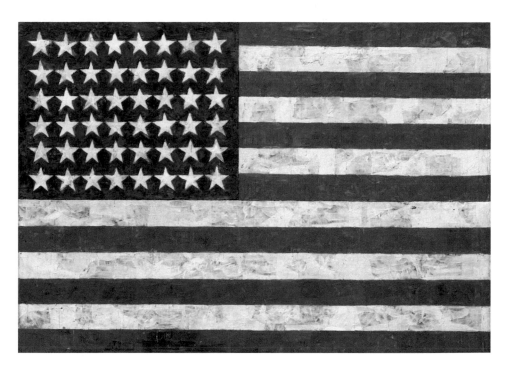

38. **Jasper Johns**, *Flag*, 1954–5

39. **Jasper Johns**, detail of *Flag*, 1954–5, showing collaged newsprint elements

(as exemplified by the rhetoric of Abstract Expressionism) and images disseminated through the mass media.

In his solvent transfer drawings Rauschenberg's personal mark emerged *through* mechanically reproduced photos, but in Jasper Johns's painting of the mid-1950s such media scraps were nearly stifled in paint. In several works of this time – most famously, in *Flag* (1954–5) – Johns established a technique which combined painting and collage by dipping tiny pieces of newsprint in a viscous wax-based medium known as encaustic and applying these units to canvas like brushstrokes. If Rauschenberg's 'tabletop' compositions combined gestural mark-making and media fragments in a centrifugal field of multiplying relationships, Johns's series of flags and his contemporaneous paintings of targets, numbers, and letters possessed a centripetal logic in which discordant meanings were concentrated into a single holistic form. In *Flag* this elision of diverse meanings occurs on three registers. First, the quantum of paint is elided with the quantum of information. Bits of newsprint are engulfed by the artist's medium in a procedure suggesting the domination of expressive gesturalism over mass communication. And yet the presence of these newsprint 'kernels' just visible

through a painterly surface could cut both ways, implying an end to the autonomy of the artist's mark just as readily as its triumphal pre-eminence. Second, Johns's compositions both belong to and exceed the traditions of deductive or non-compositional painting. His choice of the American flag as a subject, for instance, introduces an explosive contradiction between the purely formal nature of an appropriated geometric pattern of stars and stripes, and its highly emotional charge as a patriotic symbol. In his use of motifs such as numbers, letters, flags, and targets, Johns chose to paint things which are congruent with their own representations: numbers, letters, flags, and targets are *already* representations, which Johns reiterates. By appropriating the elements of such highly developed linguistic or visual sign systems he gives his deductive or non-compositional configurations a range of secondary meanings only indirectly suggested by Stella's allusive titles or Kelly's adoption of color spectrums. Finally, on a third register, *Flag* suggests two alternate models of social life, one represented by the nationalist symbol of the stars and stripes, and one represented by the mass media, which literally grounds it. In this painting, the most powerful symbol of political life, the flag, is composed of elements drawn from mass cultural communication – newsprint. Such an association between media and the public sphere serves as the foundation for much of the most advanced art of the 1960s. In their 'mediated gestures' of the 1950s, both Johns and Rauschenberg carried the formalist preoccupations of post-Abstract Expressionist painting into the explosive realm of Pop – a realm in which individual actions and collective ideologies are filtered through the norms and imperatives of the mass media.

40. **Jasper Johns**, *Gray Alphabets*, 1956. By using stencils to produce letters in this and related paintings, Johns suggests that, in addition to serving as the basic unit of written language, the letter is simultaneously an image: indeed, in this work letters function as brushstrokes. The artist's use of newsprint, which is itself composed of letters, adds a further dimension to the association he makes between text and painterly form.

63

Chapter 3: The Media Public Sphere: Pop and Beyond

Remapping the Street I

Pop art collapses 'high' art into 'low' by incorporating commercial imagery and industrial modes of mechanical reproduction into painting and sculpture. But Pop did much more than transpose comics, billboards, and product packaging into the realm of fine art: it exemplified a new form of public life rooted in consumer culture. By the late 1950s, television, a form of broadcasting directed toward selling products, had emerged as the premier national forum in the United States, effectively marginalizing – or absorbing – other modes of public speech. Pop artists such as Andy Warhol, Claes Oldenburg, Roy Lichtenstein, James Rosenquist, Tom Wesselmann and others explored the nature of this new 'media public sphere' in a variety of ways. On the one hand, they charted the commercialization of public space, and on the other they demonstrated how commodities came to serve as public icons which possess ideological values well beyond their ostensible functions.

In this section, we will focus on the first of these themes. Three works made by Claes Oldenburg (b. 1929) between 1960 and 1963 exemplify Pop art's participation in the privatization of public space. The earliest of these, *The Street* (1960), had two manifestations. The first filled the Judson Memorial Church gallery in downtown New York with a chaotic jumble of crude anthropomorphic drawings made on discarded paper and cardboard scavenged from the street. This installation, which encompassed the floor as well as the walls, resembled a cardboard shantytown – and indeed Oldenburg performed as an urban vagrant within it as part of the 1960 Happening, 'Snapshots from the City.' Later in the year, at the Reuben Gallery, *The Street* was re-installed in a more open format with totemic 'drawings' spaced across the walls and hung in the center of the room like a collection of iconic city-dwellers milling in a crowd. In both versions of the work, Oldenburg emphasized the gritty suffering of urban life in part through the poverty of his recycled materials, heavily outlined in black to suggest charred fragments of waste.

42

41. **Claes Oldenburg**, *The Street*, Judson Gallery, Judson Memorial Church, February-March 1960

If Oldenburg brought a representation of the street into the
cloistered space of the gallery in his installations of 1960, in
his next major project, *The Store*, he made a converse move by
rendering the gallery as a modest commercial storefront. For
two months in the winter of 1961–2 the artist rented a small store
in the East Village of New York where he sold energetic,
expressionist plaster reliefs which reinterpreted the kinds of
commodities, ranging from cakes and pastries to inexpensive
dresses, which might be sold in neighboring businesses. In these
works, the multiple dimensions of the commodity – the fantastic
associations aroused by advertising as well as its quotidian
functionality – were intermingled in new 'products' which were

highly animated. Oldenburg's plaster reliefs were not simply replicas of things like 7-up cans or wedding dresses, but rather highly subjective 'portraits' of commercial items in which the line between a thing and its symbolic associations was hard to discern. As the artist later stated with regard to these reliefs, 'I wanted to imitate my act of perceiving them.' By equating the public life of the artist with that of a shopkeeper, *The Store* was a particularly forceful acknowledgment that, by 1961, commercial spaces had become the pre-eminent public spaces of the United States where citizens are typically regarded as consumers. In this regard, Oldenburg's invention of *The Store* soon after his elaboration of *The Street* was perfectly logical. In fact, he explicitly linked the two works in his book *Store Days*, published in 1967: 'The Store is like the Street an environmental (as well as a thematic) form. In a way they are the same thing because some streets or squares (like Tsq [Times Square]) are just open stores.' Indeed, stores are where private desires intersect with the public sphere of consumption.

In the third of Oldenburg's trio of installations in the early 1960s, *Bedroom Ensemble* (1963), he renders what is ostensibly the most private of spaces – a bedroom. And yet here, too, in his crisply geometric, dramatically foreshortened, and synthetically upholstered ensemble of furnishings, the commercial surges forth. For this is not a domestic bedroom, but clearly an evocation of the slick anonymity of motel accommodations, inspired by Oldenburg's sojourn in Los Angeles in 1963–4. In place of genuine comfort, this hard-edged interior resembles the false coziness of furniture showrooms: it *represents* domesticity as already transformed into a stylized commodity. And indeed motel rooms are literally bedrooms for sale. Thus, between 1960 and 1963, the model of the public sphere underlying Oldenburg's art shifted from the street to the bedroom, just as later in the decade the women's and gay liberation movements would similarly claim the personal as the political. As we have seen, in the late 1950s and early 1960s Robert Rauschenberg and Jasper Johns had invented a practice of 'mediated gestures' in which the allegedly autonomous mark-making of Abstract Expressionism was reframed by the materials and conventions of the mass media (see pp. 56-63). At around the same time, Oldenburg – and other artists associated with Pop – asserted a complementary condition in which public spaces were 'privatized' and private spaces were commercialized. In both instances, the line between the private and the public was significantly blurred.

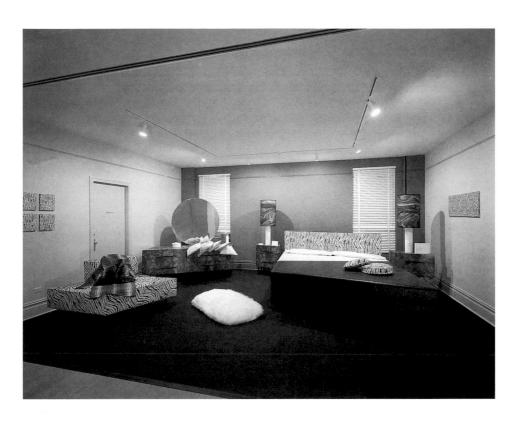

44. **Claes Oldenburg**, *Bedroom Ensemble 2/3*, 1963–9

Overleaf:

45. **Andy Warhol**, *White Car Crash, Nineteen Times*, 1963

46. **Andy Warhol**, *Red Race Riot*, 1963

In 1963 Andy Warhol (1928–87) made several paintings of scenes from the street which share little of the expressionist pathos of Oldenburg's treatment of the subject three years earlier. For Warhol, the street was imagined as a site of trauma; a place where violence may erupt at any moment. His 'Disaster' series, for instance, includes works such as *White Car Crash, Nineteen Times* (1963) and *Orange Car Crash, Fourteen Times* (1963), in which the same grisly news photograph is silkscreened nineteen and fourteen times respectively onto variously toned canvases. As art historians Thomas Crow and Hal Foster have argued to different effect, the horror of such fatal accidents is both extended and undermined through their repetitive reproduction and aestheticization in Warhol's silkscreening technique. As the artist himself concisely put it, 'When you see a gruesome picture over and over again, it doesn't really have any effect.' But, as usual, Warhol's oracular pronouncement contains a paradox. One of the primary effects of the 'Disasters' is the viewer's recognition that the horror of the work lies less in the scene being viewed than in the scandal of his or her own

45

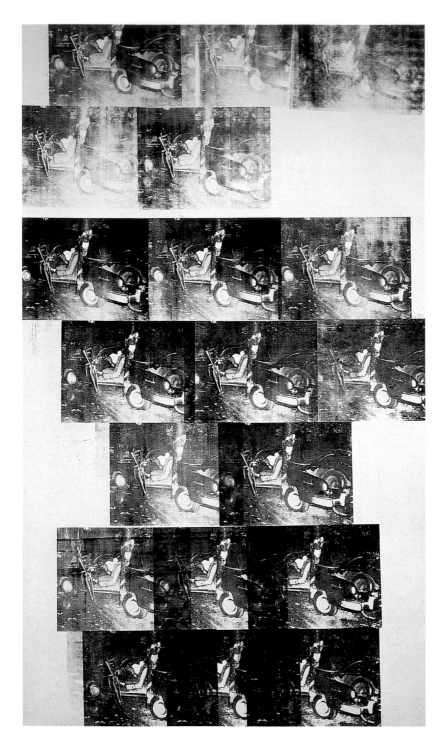

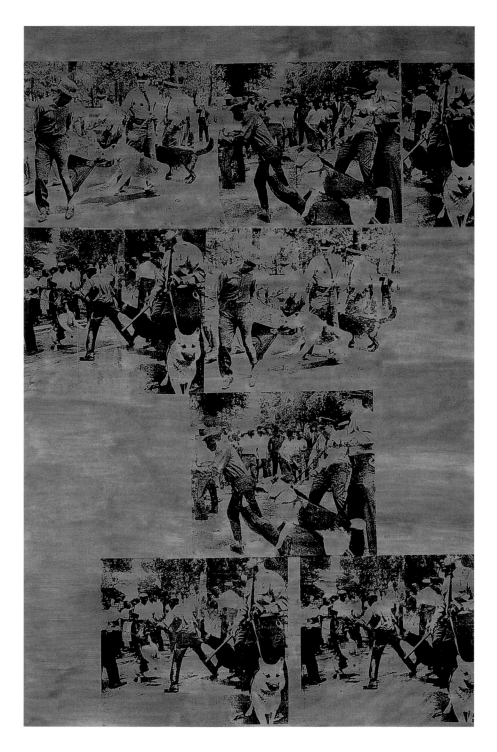

indifference to the twisted and maimed bodies represented. And this distancing effect has everything to do with the automobile as a commodity designed to carry people *through* urban space rather than enabling public congregation *within* it. The automobile allows the mobile driver/spectator to look out at the street while remaining insulated from what is seen. Car crashes rupture this safety and anonymity by dramatizing the vulnerability of commodified privacy. As Crow puts it in a different context, 'Though he grounded his art in the ubiquity of the packaged commodity, [Warhol] produced his most powerful work by dramatizing the breakdown of commodity exchange.' In these paintings of crumpled cars and mangled bodies, exchange is re-imagined as collision.

The perfect pendant to the car crashes is Warhol's series of paintings of race riots such as *Red Race Riot* and *Mustard Race Riot*, also made in 1963. These works are composed of multiple silkscreened reproductions of photographs taken from *Life* magazine in which an African-American civil rights demonstrator is attacked by police dogs. If the car crashes demonstrate the rupture in bourgeois 'privacy-in-public' through the automobile accident, the race riots represent those coercive measures taken by the government and the police to contain and terminate public protest in the street. Together, these two series cannily articulate both sides of the privatization of public space in the 1960s – its commercialization for the privileged and its criminalization for those who dissent vigorously. It should be emphasized, moreover, that Warhol's silkscreen technique is itself a formal allegory of the attenuation of public space. In these works events are not experienced through direct participation, but rather via the 'official eye' of the news reporter who is him or herself the avatar of a large corporation. Warhol's photo-derived paintings affirm that public opinion and consensus is engineered through what Daniel Boorstin famously called 'pseudo-events' – actions staged expressly for the camera. Moreover, by repeating his motifs on a monochromatic ground – albeit with colors such as 'red' or 'mustard' which have a double edge in their reference to blood and gas – Warhol further 'degrades' the notion of public events to the point of rendering them as wallpaper (a 'medium' he would explore only a few years later in his *Cow Wallpaper* of 1966).

The contraction of the public sphere into its commodified representations and the corresponding dilation of photographic imagery or readymade commodities into a freestanding 'world' of events is elaborated differently in the work of Marisol (b. 1930)

46

and George Segal (1924–2000), two artists often associated with
Pop art, but seldom included within its central canon. Marisol's
portrait sculptures in which different segments of the subject's
anatomy are articulated – or disarticulated – as separate wooden
blocks or cut-outs, are often combined with photographic por-
traits. In *John Wayne* (1963), for instance, the famous Hollywood
cowboy is rendered like a merry-go-round figure mounted on a
red wooden horse, and yet the frontal view of his 'face' consists
of a standard publicity head shot. The folksy wooden sculpture
and the slick celebrity photo are inextricably linked, as though
Wayne's fictional persona, characterized by its unpolished
masculinity and embodied in Marisol's rough wooden elements,
had fallen back from, or 'out of' the picture. This circuit of

47. **Marisol**, *John Wayne*, 1963

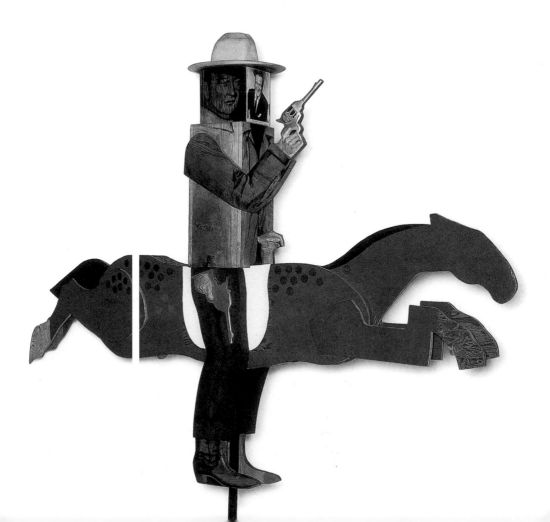

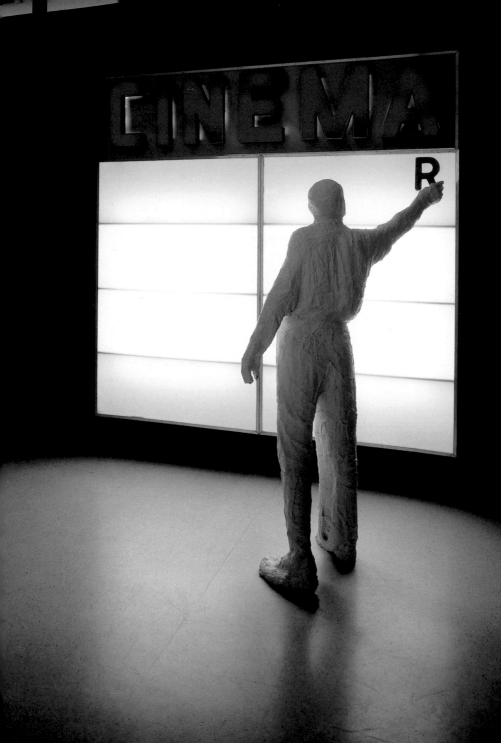

commodified image and blunt physicality also characterizes the conditions of the work's production: it was commissioned by *Life* magazine for a special issue on the movies. In other words, the three-dimensional fine art sculpture was made to be reproduced as a two-dimensional photograph in a mass market periodical.

In Segal's work, a different sort of oscillation is established between psychological and commercial elements. In his ensembles, such as *The Dinner Table* (1962) or *Cinema* (1963), the readymade settings – table and chairs, or brightly lit cinema marquee – are more vivid, even more 'alive' than the plastercast figures which surround them. Here, the world of things seems to participate in the evacuation of selfhood. It is those things, Segal suggests, rather than human agency, which constitute a public world.

Commodity Icons

In *The Philosophy of Andy Warhol (From A to B and Back Again)*, Warhol articulated a theory of democracy in which a brand name functions as the symbol of national identity:

What's great about this country is that America started the tradition where the richest consumers buy essentially the same things as the poorest. You can be watching TV and see Coca-Cola, and you can know that the President drinks Coke, Liz Taylor drinks Coke, and just think, you can drink Coke, too. A Coke is a Coke and no amount of money can get you a better Coke than the one the bum on the corner is drinking. All the Cokes are the same and all the Cokes are good. Liz Taylor knows it, the President knows it, the bum knows it, and you know it.

A prescient political analysis shines through Warhol's faux naïveté in this passage. For if all *Cokes* are equal, the same cannot be said for those who drink the beverage, who range in rank from presidents to bums. In this passage, as in his silkscreened paintings of commodities and celebrities, Warhol neatly encapsulates a fundamental contradiction in American consumer society. Namely, that in the everyday world of television, supermarkets, and shopping malls, democracy is equated with equal *access* to products, while those socio-economic inequalities which make such access moot for the poor – and for a significant proportion of the middle class – are left largely unacknowledged and unexamined. Coca-Cola is a global product and wherever it is sold its distinctive trademark carries a quantum of US nationalism along with the fizzy brown beverage. Like the stars and stripes, Coke

48. **George Segal**, *Cinema*, 1963. As is typical in his sculptural ensembles, Segal created the figure in *Cinema* through a plaster cast which is left a ghostly white. The glowing light from the cinema marquee transforms this figure into a proto-cinematic shadow, thereby transforming the work's representation of 'live action' into an allegory of photo-mechanical mediation.

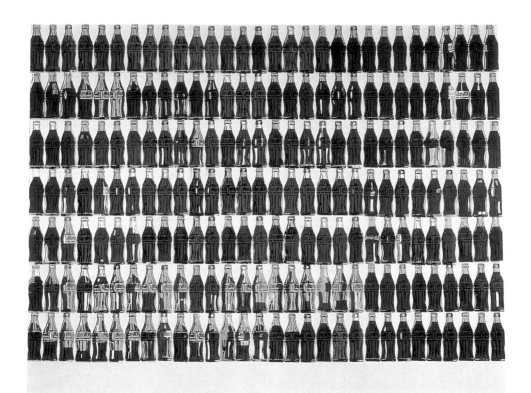

stands for America. But even as he evokes this association, Warhol undermines it through his allusion to the bum, who may be drinking the same Coke as Liz Taylor but who does so in a dramatically different milieu. Coke is not like every other commodity because it possesses the capacity to represent national identity. Acknowledging this special ideological force is essential to understanding a work like Warhol's *210 Coca-Cola Bottles* (1962), in which the repressed condition of unequal access to the consumer market returns formally through the uneven inking of individual silkscreened bottles. Indeed, Warhol was consistently drawn to products with a special emotional charge, such as Coke or Campbell's Soup, which for anyone raised in mid-twentieth-century America conjures up an idealized vision of home and family.

Coke may then be understood as an icon of America, and Campbell's Soup an icon of family values. The term 'icon' refers to a venerated symbol representing fundamental religious or cultural beliefs. In his choice of subject matter, Warhol, along with several other Pop artists, recognized that commodities and their human counterparts – celebrities – function as the icons of consumer society. Such an association between celebrity and a quasi-religious veneration has often been noted with regard to Warhol's *Gold Marilyn Monroe* (1962), in which a single silkscreened image of the actress floats in a gold field reminiscent of the gilt grounds of Russian icons or early Renaissance altarpieces. However, if this work endows Marilyn with a provisional sainthood, such distinction is undermined in other of Warhol's paintings where her likeness is repeated over and over again as many as one hundred times. The power of the contemporary icon thus lies not in its *uniqueness* – it is patently reproducible – but rather in its capacity to constitute a community through recognition and identification. Indeed, one could argue that by the early 1960s, the American public sphere was founded as much in identification with certain products and brands as it was through mass communication networks. Of course the brand and the network are related: it is through media and advertising that commodities are invested with the lifestyle associations which qualify them as public icons. In Warhol's paintings, as in other representations of her, Marilyn Monroe is not so much a person as a public entity in which a matrix of values and desires intersect. In other words, Marilyn is a monument to the film industry and to the mode of heterosexual desire it famously promoted in the 1950s and '60s.

50

49. **Andy Warhol**, *210 Coca-Cola Bottles*, 1962. Though each of these Coke bottles is created from the same silkscreens, each is differently inked. As a result the presumably identical products are all individualized; some even appear empty. Through this technique Warhol suggests difference within the ostensible sameness of mass-produced objects. As he declares in *The Philosophy of Andy Warhol (From A to B and Back Again)*, this diversity arises in part from the wide range of people who consume products like Coke.

It may seem odd to describe Pop art with terms like 'icon' or 'monument.' After all, in their ostensibly ironic embrace of the everyday and the commercial, paintings like Warhol's appear antithetical to conventional monuments whose traditional function is to mark the history of a place by commemorating an event or a person. And yet this striking paradox is fundamental to Pop art. In a commercialized Western culture, it is the everyday commodity which structures our experience of place and time – a condition which artists like Warhol and Oldenburg as well as Roy Lichtenstein, Tom Wesselmann, and James Rosenquist explored in various ways.

In several of his early Pop paintings, Lichtenstein (1923–97) isolated a single ordinary thing – a tightly coiled extension cord,

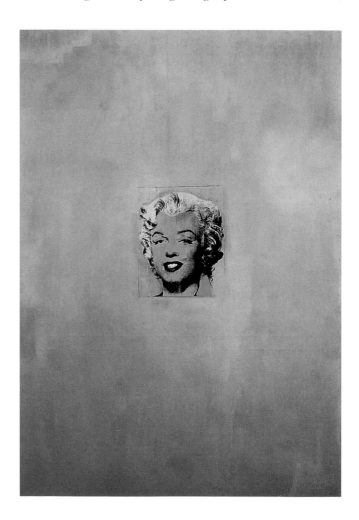

50. **Andy Warhol**, *Gold Marilyn Monroe*, 1962

51. **Roy Lichtenstein**,
Golf Ball, 1962

a ball of twine, or a golf ball – on a blank ground. If Warhol established iconicity through the repetition of silkscreened photographs, Lichtenstein endowed the central images of *Electric Cord* (1961) or *Golf Ball* (1962) with the gravity of an obelisk or a dome by divorcing them from their functional context. This effect is heightened through a radical simplification and abstraction of contour and color, and a corresponding slippage in scale whereby the sphere represented in *Golf Ball*, for instance, might just as easily represent a pockmarked moon. By isolating things we normally overlook, Lichtenstein monumentalizes the everyday.

For his part, Claes Oldenburg imagined that such monuments to the ordinary – a wing-nut, a baseball bat, a teddy bear, or a Good Humor bar – should literally occupy urban space in place of the equestrian sculptures or ceremonial fountains which traditionally mark it. Oldenburg's schemes of the 1960s, most of which exist only as drawings, have been called 'anti-monuments' in that they tragicomically interrupt the texture of the city. In a proposal of 1961, for instance – his first of this sort – he suggested a devastating tribute to immigration in the New York harbor which would consist of an invisible reef upon which ships would run aground and their wreckage accumulate. In a slightly more lighthearted scheme of 1965, he proposed that the intersection of Canal Street and Broadway in downtown New York be filled by a massive concrete block inscribed with the names of war heroes. These proposals, dramatizing the hardships of immigrants on the one hand, and the horror of war in the age of Vietnam on the other, emphasize a quality of the monument which is often suppressed – its function as an *obstruction* to the smooth operation of the city around it. In theory even the most innocuous of traditional monuments should make the passer-by stop and reflect on the sweep of time and its effects on a particular

52

place; Oldenburg's monuments literalize such a form of contemplative arrest. Even his less politicized concepts, such as erecting a large upright screw in the center of Piccadilly Circus in London in place of the statue of Eros that stands there, or an up-ended pair of scissors on the site of the Washington Monument, possess those effects of displacement of scale and meaning characteristic of Lichtenstein's painting.

If Oldenburg imagined punctuating the city with monuments to the everyday, Lichtenstein's art emerged from an analogous encounter: he derived his painted icons from an urban environment encrusted with advertising. In a 1966 interview the painter identified this 'new landscape' as his primary inspiration:

52. **Claes Oldenburg**, *Proposed Colossal Monument to Replace the Washington Obelisk, Washington, D.C.: Scissors in Motion*, 1967. Oldenburg's proposals for monuments wittily inflate the scale of ordinary objects like scissors to the magnitude of solemn architectural icons like the Washington Monument. The particular choice of a thing – a working scissors, for instance, to replace a phallic obelisk commemorating the first American president – often suggests erotic or scatological associations.

53. **Roy Lichtenstein**,
Seascape II, 1964

[Advertising] has made, in a way, a new landscape for us – billboards
and neon signs and all this stuff that we're very familiar with,
literature and television, radio. So that almost all of the landscape,
all of our environment, seems to be made up partially of a desire to
sell products. This is the landscape that I'm interested in portraying.

In their different ways, both Oldenburg and Lichtenstein isolate
fragments from this landscape of commerce. But unlike
Oldenburg whose projects jarringly position monumentalized
commodities within traditional urban settings, Lichtenstein's
premise is that the city itself has been irrevocably transformed
through a spectacular mass media. Indeed, his paintings demon-
strate that any subject matter, no matter how resistant to
commercialization, may be translated into the idiom of the com-
modity. His best known technique for doing so is the adaptation
of Ben Day dots, a process by which screens of tiny dots are used
to tone printed reproductions. In many of Lichtenstein's paint-
ings, like those derived from individual panels of war or romance
comics, the fields of dots appear as they would in their original
source material, but in many others the technique is applied 'in-
appropriately' to traditional genres of painting. In a series of
virtually abstract landscapes such as *Seascape II* (1964), for
instance, the ineffable atmosphere of the seashore is conveyed in

part through overlapping blocks of Ben Day dots. A 'new land-scape' results not through the representation of commodity culture *per se*, but rather through the mechanization of vision itself. In other words, commercialization is associated not just with things, but with a new way of seeing.

In *The Society of the Spectacle* (1967), the French philosopher Guy Debord provided a theoretical framework for the condition that Lichtenstein describes as a 'new landscape' of advertising. In his influential book Debord established a close equivalence between objects of exchange and their representations. According to his argument, commodities literally function as signs, and signs as commodities. His text opens with a powerful assertion of this condition: 'The whole life of those societies in which modern conditions of production prevail presents itself as an immense accumulation of *spectacles*. All that once was directly lived has become mere representation.' Debord's spectacle is analogous to Lichtenstein's 'new landscape' where vision itself is commercialized, or to Warhol's understanding of Coca-Cola as simultaneously a beverage and a symbol of American democracy and economic imperialism. Such a symbiotic relationship between commodities as objects and commodities as signs is explored in complementary ways by two other artists associated with Pop, Tom Wesselmann (b. 1931) and James Rosenquist (b. 1933), both of whom incorporated the commercial language of billboards within their art. In Wesselmann's nudes, still lifes, and assemblages of the early 1960s he built collages composed in part from advertising materials which he scavenged from the street and later solicited directly from billboard companies. From 1954 to 1960 Rosenquist worked as a billboard painter, developing skills he would later apply to his painting. By using the rhetoric of advertising, Wesselmann and Rosenquist explored the same paradox that Debord theorized so perceptively – that in consumer culture, things are transformed into spectacular images of themselves.

In Wesselmann's still life paintings, for instance, it is not sim-ply different objects which are juxtaposed but different orders of representation. In *Still Life #28* (1964), for instance, which incor-porates a working television within its composition centered on a kitchen table, there are at least three visual languages in play in addition to the televisual. Traditional figurative painting is embodied in the prominent reproduction of a famous portrait of Abraham Lincoln on the wall behind the table; the rhetoric of print advertising is carried by various collage elements ranging

from two Ballantine Ale bottles to the face of a cat; and Wesselmann's own 'hand' is present in those sections of the work which he painted himself. In a 1964 interview on Pop art, the artist claimed that through such juxtaposition he allowed 'different realities … [to] trade on each other; lots of things – bright strong colors, the qualities of materials, images from art history or advertising – trade on each other.' The most dramatic instance of this 'trade' among things results from the inclusion of a television, which establishes a symbiotic relationship between 'still' objects and moving flows of electronic information. At many times during the day commodities like Ballantine Ale are animated on the TV screen as advertisements; similarly, kitchen tables like that in *Still Life #28* also appear in situation comedies Indeed, for the viewer, these narratives of televisual drama, news, and advertising perpetually re-contextualize the various elements included in the painting. In this work, a process fundamental to what Debord calls the society of the spectacle is enacted: in Wesselmann's terms, objects *trade* on one another,

54. **Tom Wesselmann**,
Still Life #28, 1964

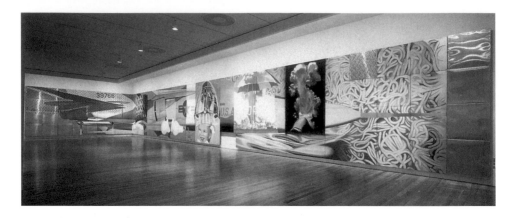

55. **James Rosenquist**, *F-111*, 1965 (installation view)

56. **James Rosenquist**, *F-111*, 1965 (detail)

moving from one mode of representation to another. In this sense the term 'trade' refers not only to commercial modes of exchange but also to transformations in the nature of meaning.

Such a translation of objects into commercial images is equally evident in James Rosenquist's large canvases of the early and mid-1960s in which close-up fragments of bodies, food, machines, and commodities are either juxtaposed in discrete rectilinear blocks or interpenetrate in fractured fields. The function of a billboard is to communicate clearly from a distance, but Rosenquist's paintings create the opposite effect: they cause a viewer to look so closely that things become out of focus and begin to lose their determinate shapes. The most sophisticated interpretations of Rosenquist's art have identified this tendency to scramble stable oppositions between figure and ground – a strategy dramatically different from those practices of Pop artists who isolate and monumentalize commercial icons. In his

best known work, for instance, *F-111* (1965) which is an 86 foot (26 m) long, multi-panel painting typically installed in a room surrounding the viewer, it is extremely difficult to grasp the central motif – an Air Force fighter plane – as a coherent entity. The painted version of the F-111 is longer than lifesize but it is regularly eclipsed or interrupted by objects drawn from everyday life – an angel food cake, light bulbs, a blonde girl under a hair dryer, and 'Franco-American' spaghetti – as well as an ominous red mushroom cloud, the quintessential sign of dystopian militarism. Many critics have perceived an anti-war sentiment in *F-111* deriving from its pairing of motifs of consumerism with those of militarism. This association is by no means coincidental since the disappearance of the object into spectacular rhetorics of advertising – that process which Debord called a transformation of experience into representation – is closely related to the glamorization of violence which makes militarization possible, and even desirable, for much of the American public. Like Warhol's silkscreen paintings of Coca-Cola or Campbell's Soup, where the ideological associations of packaging and marketing eclipse the use-value of the product along with the economic conditions of its production, Pop artists' representations of war, such as Rosenquist's *F-111* or the comic book heroics of Lichtenstein's *Whaam!* (1963) or *Brattata* (1962), demonstrate the transformation of war – in which people and property are destroyed – into an appealing commercial spectacle. If one of Pop art's primary accomplishments was to demonstrate the power of commercial icons, then Rosenquist and Lichtenstein suggest that the force of such icons reaches far beyond the supermarket shelf, and even – perhaps especially – into the precincts of the Pentagon.

49

57. **Roy Lichtenstein**, *Whaam!*, 1963

Remapping the Street II

Pop art strategies for embodying the intensively commercialized public spaces of postwar America and the 'iconicity' of commodities were famously distant and ironic. In their different ways Oldenburg, Warhol, Lichtenstein, Wesselmann, and Rosenquist all reframed existing visual rhetorics rather than inventing new ones. They did so in two ways – by incorporating commercial images in their art, and by adopting commercial processes to represent this content, including silkscreening, Ben Day dots, and billboard painting. We will now consider a group of artists who responded to the postwar society of the spectacle in a different way – by plunging into it with a camera and charting its human and man-made topographies. These artists, often referred to as street photographers, represented public space not through its already mediated images as Pop artists did, but rather by recording their personal encounters with its diversity and idiosyncrasy. If the posture of Pop was bemused detachment, the street photographer was, by definition, positioned in the midst of his or her image. And yet, as in Pop, much of the most powerful street photography emits an atmosphere of alienation and anonymity. As the beat writer Jack Kerouac put it in his 1959 introduction to Robert Frank's landmark book *The Americans*, the artist 'sucked a sad poem right out of America onto film, taking rank among the tragic poets of the world.' This 'sad poem' emerges from Frank's sensitivity to a moral void at the core of America's frenetic mobility, which he captured in powerful images of people 'imprisoned' in their cars or isolated in public spaces. If Pop sought to reflect a 'community of the sign' arising from shared identifications with commercialized brands and national celebrities, Frank (b. 1924) and the younger artists he influenced gave photographic evidence of one of the fundamental effects of such a model of community – the breakdown of older modes of sociality rooted in face-to-face contact and interchange.

The influential photo historian and curator John Szarkowski has argued that photographers like Frank, as well as younger artists including Garry Winogrand (1928–84), Lee Friedlander (b. 1934), and Diane Arbus (1923–71) represent a 'liberation' of documentary photography from its earlier forms of patronage, either in the service of a social project like the 1930s Farm Security Administration in which the government sponsored photographers to document Depression-era America, or on assignment for commercial magazines such as *Harper's Bazaar*, *Vogue*, and later *Life*, which were among the most significant

employers of photographers at mid-century. By the 1960s federal support of artists had long ended and the picture magazines were being eclipsed by television. Szarkowski argues that these changed conditions resulted in the introduction of a personal aesthetic sensibility within documentary photography. As he put it in the wall label for his 1967 exhibition 'New Documents' at the Museum of Modern Art in New York:

Most of those who were called documentary photographers a generation ago … made their pictures in the service of a social cause … to show what was wrong with the world, and to persuade their fellows to take action and make it right.… A new generation of photographers has directed the documentary approach toward more personal ends. Their aim has not been to reform life, but to know it.

What the photographers in Szarkowski's 'New Documents' exhibition — Arbus, Friedlander, and Winogrand — most poignantly 'knew' about life was a profound experience of alienation. In *The Americans* Robert Frank had already made devastating statements of this sort. In two consecutive photographs near the middle of the book, for instance, both exposed in New Orleans, he evoked a fierce sense of isolation within a crowd. *Trolley – New Orleans* is a closely cropped image of five 58 rectangular train windows from which individual adults – and in the central aperture two children – look out toward the photographer. Whites occupy the three forward windows while African-Americans are present in the rear ones, presumably in observance of Jim Crow laws which segregated whites from blacks in American public spaces through the early 1960s. This racial sorting is made excruciating in the picture by the contrasting looks of a white woman in the second seat from the left who meanly glares out at the photographer, and a black man in the second seat from the right who seems to implore him sadly. No matter what these looks signify, they heighten the social asymmetry which exists behind the neutral geometry of the windows. As in the best of Frank's photographs, this one poignantly demonstrates the difference between a crowd and a community. Such a distinction is brought home in the next picture in the book, taken on Canal Street in New Orleans. Here, in a com- 59 pressed group of rushing pedestrians, individuals are shown to be physically adjacent, but emotionally isolated.

In their distinct ways Szarkowski's 'new documentarians' evoke and expand Frank's ethos of shattered community, often by accentuating the alienation of the anonymous encounters

58. **Robert Frank**, *Trolley – New Orleans*, 1955–6. Robert Frank's photographs ostensibly capture the randomness of urban American life, but poised within them is often a biting manifestation of racial and class inequities.

59. **Robert Frank**, *Canal Street –*
New Orleans, 1955–6

recorded by their cameras. A haunting example of such a picture is Friedlander's justifiably famous *New York City* (1966), in which his own shadow is cast ominously onto the back of a woman he is following in the street. The predatory effect of this work, which at once conveys the vulnerability of a woman in the city and the implied sadism of the photographer pursuing her, is reminiscent of Winogrand's offhand but often confrontational pictures of women collected in his 1975 book, *Women are Beautiful*. If Frank's *Trolley – New Orleans* demonstrated the inequality among races which fractures American communities, Friedlander and Winogrand's pictures of women demonstrate corresponding asymmetries of power and privilege according to gender. Such pictures hint at an atavistic mode of pursuit which troubles the surface of polite urban life – a kind of desublimation which is evoked metaphorically in a series of pictures of people and animals included in Winogrand's first book, *The Animals* (1969). These images taken in zoos often center on the bars or screens which divide communities of animals from crowds of people, humorously suggesting an equivalence between an artificial preserve for exotic creatures and the human zoo – the city – which surrounds it.

Such an extreme encounter with otherness, choreographed between species in Winogrand's *The Animals*, is also found in Diane Arbus's photographs. Arbus's subjects included drag queens and nudists, midgets and the mentally retarded, but many of her most affecting photographs from the 1960s exhibit a more subtle quality of otherness. In a 1971 interview the artist declared, 'There's a point between what you want people to know about you and what you can't help people knowing about you....

60. **Lee Friedlander**,
New York City, 1966

61. **Garry Winogrand**,
New York, 1963

Something is ironic in the world and it has to do with the fact that what you intend never comes out like [sic] you intend it.' Arbus catches such ineffable moments of slippage between her subjects' ostensible self-image and their appearance to the camera. In pictures as straightforward as *A family on their lawn one Sunday in Westchester* (1968) or *Elderly Couple on a Park Bench, NYC* (1969) the grotesque is projected onto the most ordinary, suggesting that otherness and alienation are the most familiar of conditions.

The photographers discussed thus far all demonstrate the erosion of traditional forms of community by picturing, if sometimes only inadvertently, fractures along the lines of race and gender. In this sense they provide a salutary complement to Pop's ironic assertion of commercial culture's homogeneity. If Andy Warhol insisted that every Coke was the same no matter who drank it, the differences among consumer-citizens are elicited and explored in the best of street photography. Nonetheless, the social perspectives of Frank, Friedlander, Arbus, and Winogrand remain partial: each of these artists is white and therefore, in the United States, belongs to a majority or normative identity which is granted disproportionate power and privilege. Their poetry of alienation is therefore founded to some degree on the fact that they were able to move through urban space 'unmarked' and therefore relatively unnoticed.

Two African-American artists, Roy DeCarava (b. 1919) and Romare Bearden (1914–88), established a different perspective on community in the 1960s by focussing on the vibrant African-American neighborhood of Harlem in New York City. Roy DeCarava's 1955 book, *The Sweet Flypaper of Life*, with a fictional narrative by Langston Hughes linking together the photographs, was produced contemporaneously with Frank's *The Americans*, but while the latter represented the collapse of social bonds across an entire nation, the former demonstrated the power of human associations within a single neighborhood. The narrator of *The Sweet Flypaper of Life* is an elderly grandmother whose ruminations form the pretext of a panoramic view of Harlem life expanding outward from a single extended family. Indeed, throughout his career DeCarava consistently conveyed social values and aspirations through exemplary figures in his richly toned and eerily monumental prints. In the well-known picture *Mississippi freedom marcher, Washington D.C.* (1963), for instance, he documents an epochal civil rights demonstration through the close-up of a young woman whose expression of calm concentration suggests a deep well of determination at the core of political dissent.

If DeCarava's vision of Harlem pivoted on exemplary individual protagonists, fictional or otherwise, Bearden's important series of mid-1960s photomontages showed individual identities to be hybrid and even contradictory without thereby sacrificing a strong sense of community. Bearden, a prominent modernist painter, began making these works in 1964 as part of his participation in Spiral, a group of African-American artists committed to making a visual response to the burgeoning civil rights movement. The photomontages began as small collages composed of scraps drawn from magazines, and were subsequently re-photographed and enlarged in order to give them the scale and importance of paintings. This technique accorded well with Bearden's efforts to communicate the complexity of African-American history by dynamically juxtaposing visual references to African tribal arts, Christian ritual, folkways of the black south, and northern urban life. A work like *The Dove* (1964), a street scene presided over by the avian symbol of the holy spirit positioned as an ordinary pigeon, is typical of Bearden's representations of a community simultaneously coming together and falling apart. The work represents a sidewalk crowded with passers-by, each composed as a mosaic of several different

62. **Romare Bearden**,
The Dove, 1964

photographic elements. This anatomical and optical hybridity often resembling the abstracted rhetoric of African masks, has a contradictory effect: on the one hand it enlivens each character by endowing him or her with many different facets, but on the other, it divides each figure against itself. Given that these montaged 'effigies' are composed of media fragments, Bearden implies that even a neighborhood as tightly knit as Harlem cannot be insulated from the consequences of its representation in the world beyond. In other words, the residents of this community internalize not only their folk or religious traditions, but also the media stereotypes of blackness predominant in the United States.

This section began by drawing a distinction between Pop art's evocation of a 'community of the sign' emerging from a mass identification with brands and celebrities, and street photography in which the actual interactions of men and women in various public spaces is recorded directly. The work of the Los Angeles artist Edward Ruscha (b. 1937), and particularly his photographic books of the 1960s, reconciles this contradiction by dissolving public space into a continuous stream of surfaces and signs. In *Every Building on the Sunset Strip* (1966), for instance, an accordion-fold book which opens out to almost 25 feet (7.6 m), every facade on the legendary Sunset Strip is recorded in sequence. Even-numbered addresses run across the top of the elongated page, while odd-numbered buildings are represented upside down along its bottom edge. Between these two 'strips,' reminiscent of comic book sequencing, is a wide blank band which runs through the work like the graphic equivalent of the street it represents. In a manner closely related to many of Ruscha's paintings and prints, such as *Standard Station, Amarillo, Texas* (1963) or *Hollywood* (1968), in which architectural signs are made iconic, *Every Building on the Sunset Strip* renders public space as a run-on sentence composed of the architectural and scriptural forms of the modern city, but emptied of its inhabitants. While *Every Building on the Sunset Strip* is technically a work of 'street photography' it, like Pop art, evacuates the pleasures and traumas of person-to-person interaction which the street photographers previously discussed were intent on capturing: Ruscha exposed these images early on a Sunday morning so that no people would be around. Like each of the artists considered in this chapter, Ruscha demonstrates that by the 1960s, public space was as much a function of representation – an uninhabitable icon – as it was a physical place.

63. **Ed Ruscha**, *Every Building on the Sunset Strip*, 1966

Chapter 4: Objects, General and Specific:
Assemblage, Minimalism, Fluxus

Assemblage

In Pop paintings the pictorial surface of commodities – their 'self-presentation' in advertising and packaging – is extracted and reformulated. The icons which result tend to eclipse a commercial object's useful function in favor of its ideological associations. A great many artists during the 1960s – including several Pop artists – sought to explore this fundamental division between surfaces and functions – or images and use-values – by investigating the nature of 'objectivity' in their art. Marcel Duchamp (1887–1968), whose early twentieth-century readymades began to be widely known and extremely influential among American artists in the late 1950s and 1960s, was a significant inspiration for this activity. Simply put, the readymade, invented in the years between 1913 and 1915, consisted of an ordinary manufactured item such as a snow shovel or a urinal which was 'reassigned' as art through both the artist's inscription or signature, and his recontextualization of the mass-produced thing within the institutions of art. One of the legacies of this strategy was to give license to artists to use materials drawn from commercial culture in their work – a freedom much indulged in American art of the 1960s and beyond. But perhaps more importantly, Duchamp's gesture drove a wedge between the form of an object and its function: a snow shovel may have uses other than clearing snow, and a urinal may exit the bathroom in the service of art. Beyond the equivalence established by the readymade between artworks and commodities, it was this mobility and multi-dimensionality in the meaning and functioning of things that postwar Americans, beginning with the generation of Jasper Johns and Robert Rauschenberg, learned from Duchamp.

In a series of paintings made between 1959 and 1962, variously titled *Device Circle* or *Device*, Johns reframed the readymade by endowing it with three distinct but simultaneous roles – as image, tool, and text. In one of these works, *Device* (1961–2), two wooden rulers are attached to a canvas and wiped across its painted surface like a compass to imprint two smooth half-disks.

64. **Marcel Duchamp**,
In Advance of the Broken Arm,
1915, original lost; 1945 version

65

In this work the readymade thing – the ruler – is both an image appearing within a picture and a mark-making tool (a device). Through the appearance of the stencilled word 'DEVICE,' near the bottom of the canvas, the rulers are given a third manifestation, as language. Duchamp's readymades are typically understood as things whose functions have changed once – from snow shovelling to sculpture, for instance. But Johns's 'devices' are a different kind of readymade: they demonstrate that the meaning of objects remains unstable and multivalent. In a notebook text of 1960 Johns wrote:

$A = B$

A is B

A represents B

In this tripartite formula the artist encapsulated his theory of things. A readymade may simultaneously serve as the equivalent of another object, as when a ruler is employed as a 'paintbrush' (A = B); or it may appear as the thing itself (A is B). Finally, the ruler may be evoked through a completely different order of representation as when it is named by the word 'device' (A represents B). This expansion from 'readymade' to 'device' provides a catalogue of the object's various aspects and modes of signification in postwar art. In consumer society, commodities function as elements in a shared public language (see pp. 75-85). By exploring the nature of spectacle, Pop developed one type of response to this condition. The three sculptural practices we will consider in this chapter focus more acutely on how commodification changed the very nature of things: in Assemblage discarded objects are recycled and then recoded through fresh juxtapositions, in Minimalism the perceptual foundation of three-dimensional form is explored in tandem with its base materiality, and in Fluxus things are animated as events.

If Pop was largely concerned with the shiny and new, artists associated with Assemblage – three-dimensional collages composed of found elements – produced their work from the underside of consumer society. In a statement of 1962 Edward Kienholz (1927–94), one of the most prominent practitioners of Assemblage, identified an underground economy from which he gathered the elements of his sculpture:

There is an enormous strata of junk here that is usable.... In the morning on trash day ... I stop to pick up a bunch of stuff that has been thrown away, toasters and stuff. I take it all into the Thrift Store and

65. **Jasper Johns**,
Device, 1961–2

99

the guy says, 'Ah, that's about a $10 or $12 load,' and he gives me $10 to $12 credit. Really, I've got this great deal with him where I trade him for stuff I want.

Making junk into art is a different kind of statement from transferring a new object from a hardware or plumbing supply store into the context of art, as Duchamp had done with his ready-mades. From its earliest formulation, Assemblage was interpreted by critics and curators like William Seitz, who organized a landmark exhibition on the subject at the Museum of Modern Art in New York in 1961, as a powerful statement of social dissent. And indeed, in many of Kienholz's works a direct association is established between discarded objects and discarded lives. In *The Illegal Operation* (1962), for instance, a disastrous backroom abortion is suggested in a tableau of sleazy furnishings, used medical instruments, and the vulgar evocation of a female torso represented by a bag of concrete obscenely

66. **Edward Kienholz**,
The Illegal Operation, 1962

leaking matter through a vaginal cleft. During the late 1950s and early 1960s, while living in Los Angeles, Kienholz was one of many West Coast Assemblage artists who, according to Peter Plagens, were the practitioners of the 'first home-grown California [sic] modern art.' This sculptural tendency was closely associated with San Francisco- and Los Angeles-based countercultures of Beat artists epitomized by the writer Jack Kerouac who rejected American consumerism in favor of a spiritual form of vagrancy and eroticism beautifully epitomized in his ecstatic novel *The Dharma Bums* (1958).

As *Illegal Operation* suggests, Assemblage art often projected a form of bodily abjection onto the 'economic abjection' of its junk materials. In San Francisco, Bruce Conner (b. 1933) made sculptures whose perverse distortions of women's anatomies were as unsettling as those of Kienholz. In *LOOKING GLASS* (1964), the lower half of a wooden support is covered with tattered photographs of pin-up girls while the area above is composed of

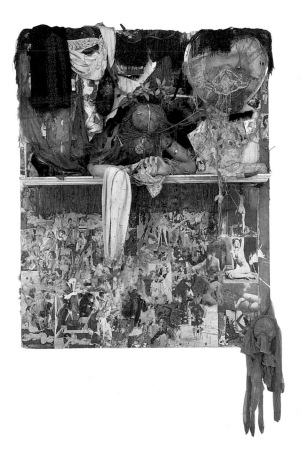

67. **Bruce Connor**,
LOOKING GLASS, 1964

various organic protrusions built from materials like women's underwear, a high-heeled pump, fragments of a mannequin, and cheap costume jewelry. One of Conner's signature strategies is to wrap his constructions with women's stockings which veil the contents of a work while establishing a connective tissue between them. He also used nylons to form pendulous elements reminiscent of hanging organs, as in the bottom right corner of LOOKING GLASS. Like Kienholz, Conner represents bodies – often the hyper-sexualized bodies of women – in the process of falling apart. In describing how hallucinogenic states of mind inspired his sculpture, he has said, 'I experienced myself as this very tenuously held-together construction – the tendons and muscles and organs loosely hanging around inside – and it seemed at any moment … you could fall apart.' If, as Freud argues, fetish objects such as stockings, underwear, and high-heeled shoes are meant to reassure a desiring heterosexual man that he won't 'fall apart' in the face of his psychic fears of femininity, then Conner's and Kienholz's nearly pathological representations of women demonstrate a model of *psychic* exchange which parallels the underground economy of obsolete and discarded things from which the assemblages are built.

The ambience of putrefaction characteristic of Kienholz's sculptures can easily distract a viewer from other dimensions of his art. In 1963, for instance, he initiated a series of 'Concept Tableaux' in which assemblages are proffered through a brass plaque and a typed document 'signed' with the artist's thumbprint. The plaque bears the title of the proposed work, the name of the artist, and the date; the document includes a description of the piece and an eccentric price structure stipulating a large sum to purchase the concept, a modest additional fee for making a drawing based upon it, and finally an hourly wage plus expenses for the artist to construct the work (some of the tableaux were eventually realized). The proposed works were typically environmental: *After the Ball is Over #1* (1964) would populate an actual house in Fairfield, Washington, with a sculptural family, and *The Cement Store #1 (Under 5,000 Population)* (1967) would forever engulf the interior of a small town grocery store in concrete. In both of these proposals real estate would be 'junked' by canceling its functionality.

Such gestures of economic re-purposing are ineluctably tied to Kienholz's revisionist art economy in which the invention of ideas is handsomely rewarded but their realization is compensated as an ordinary form of labor like construction work. Indeed,

THE CEMENT STORE #1
(under 5,000 pop.)

This tableau will be made from an existing grocery store in a town anywhere in the United States with a population under 5,000. The building must be made of either cinder blocks, cement blocks, adobe bricks or form poured concrete. The building, businesses and inventory must be purchased and left intact. The windows will be replaced by clear plexiglass or bullet proof glass to withstand internal pressures and resist malicious breaking. The doorway will be board formed in such a way to allow the door to swing both ways. A section of roof will be removed and the interior of the store will be filled with concrete completely covering all merchandise, cash register, records, etc. The roof section will then be replaced and repaired. The board forms at doorway will be removed, the hardened concrete now making it impossible to enter the building. The store will be left with little or no explanation other than it is now some sort of an art object and no longer subject to improved property taxes.

PRICE: Part One $15,000
 Part Two $1,000
 Part Three Cost plus artist's wages

68. **Edward Kienholz**, *The Cement Store #1 (Under 5,000 Population)*, 1967. Kienholz's 'Concept Tableaux' proposed large-scale works which could extend the dark vision of his sculptures to existing sites, such as a small town grocery store. Although his work is typically regarded as highly emotional and visceral, these projects demonstrate a close relationship to the expanded aesthetic practices that are often labelled 'conceptual' (see Chapters 5 and 6).

Kienholz's fascination with alternate models of exchange is manifest in a series of small, nearly monochromatic watercolors which he first made in order to barter for specific objects, as in *For Rockwell Portable Saw 596* (1969), but later transformed into a private currency by stamping each sheet with a different denomination ranging from $1 to $10,000 and then selling them for those wildly divergent prices. In these drawings, as in the 'Concept Tableaux,' the market's valuation of an artist's labor is shown to be deeply irrational. Kienholz self-consciously projects the economy of excess which allowed him to scavenge the streets and then barter for his 'art materials' at thrift stores onto the production and circulation of his own artistic 'goods.'

The conceptual links that Kienholz and Conner establish between the refuse of consumer society and the repressed contents of the mind is typical of Assemblage art in California. Their strongly thematic mode of composition is equally exemplary: Conner accumulated related fetish objects and Kienholz established whole environments such as a bedroom, a whore-

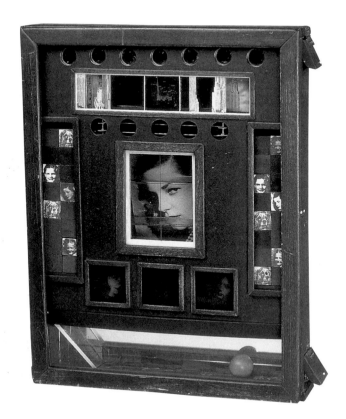

69. **Joseph Cornell**, *Untitled (Penny Arcade Portrait of Lauren Bacall)*, 1945–6. Cornell kept elaborate files on celebrities like Lauren Bacall, and later used such materials as the contents of boxes like this one which resembles a game. The artist's tableaux typically suggest the illogical juxtapositions of dream narratives or fetishistic fixations.

house, and a restaurant populated by rotting or mutated figures. Joseph Cornell (1903–72), who was probably the best known Assemblage artist in New York from the 1930s through the 1960s, similarly constructed boxes whose diverse elements, often including souvenirs, toys, novelty items, maps, and various mechanically reproduced pictures and texts, typically pivoted on a singular theme such as a great painting or a celebrity.

However, among younger artists in New York, combinations of found objects tended to be more arbitrary. On the East Coast figures like Jasper Johns, Allan Kaprow, and Robert Rauschenberg made use of Assemblage techniques in order to break apart and refigure the traditions of modernist painting. Rauschenberg's important Assemblage works, such as his pathbreaking *Monogram* (1955–9) establish (like Kaprow's Happenings) a model in which unrelated things, such as a stuffed Angora goat ringed by a discarded tire standing on a wooden platform, are used to create a composition as 'abstract' as a work by Pollock or DeKooning. While efforts have been made to

70. **Robert Rauschenberg**, *Monogram*, 1955–9

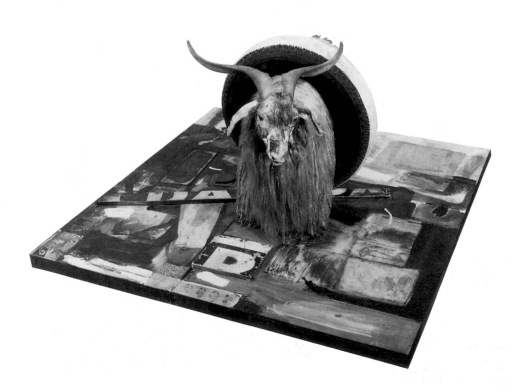

project coherent messages onto *Monogram*, no single such reading seems to encompass the contradictions of what Rauschenberg called his 'combines.' Indeed, like Johns's 'devices' in which objects could serve many purposes at once, the effect of *Monogram* is the endless proliferation of possible meanings and functions rather than their tidy codification. If Kienholz and Conner's constructions are premised on the capacity for discarded or obsolete commodities to attain new connotations within unsettling scenarios or tableaux, Rauschenberg dissolves the conventional meanings of things without assigning them new ones. In this sense his combines, constructed largely from recognizable elements, contribute to – and transform – postwar traditions of painting by demonstrating that abstraction may encompass the alienation of a thing from its conventional function, and not only the invention of non-objective form.

Minimalism

Jasper Johns reframed the readymade by showing that objects may *be* one thing but *do* something else. Susan Sontag took this distinction a step further in her influential essay, 'Against Interpretation' (1964), by advocating an art and a criticism based on what an artwork *does* rather than how it symbolizes something beyond its own physical presence. From such a perspective, illusion is extinguished in favor of affect. If Assemblage art responded to the explosion of postwar consumption by dredging up the economic and erotic 'unconscious' of the commodity, then Sontag's insistence on form versus content, or 'doing' rather than 'saying,' offers a different kind of corrective to the glut of spectacle that consumer society ushered in – one rooted in the re-education of perception. In 'Against Interpretation' she wrote:

Ours is a culture based on excess, on overproduction; the result is a steady loss of sharpness in our sensory experience…. What is important now is to recover our senses. We must learn to see more, to hear more, to feel more…. Our task is to cut back content so that we can see the thing at all.

If 'content' in commercial culture consists of the spectacular rhetoric of packaging and advertising as it was monumentalized in Pop art, then Minimal objects of the early and mid-1960s sought, as Sontag recommends, to strip this content away. Minimalism is characterized by three-dimensional geometric forms so basic, and surfaces so ordinary and unadorned, that many critics of the time refused to accept them as art. It took little

craft, for instance, to construct the large plywood boxes painted grey which Robert Morris (b. 1931) exhibited at the Green Gallery in New York in 1964–5. These blank forms exemplify the paradox of Minimalism, for in order to '*see* more' as Sontag put it, artists like Morris, Donald Judd (1928–94), Carl Andre (b. 1935) and Dan Flavin (1933–96), typically showed less. When a viewer entered the Green Gallery in 1964, he or she probably felt some puzzlement regarding what was on view: was the long rectangular beam on the floor, for instance, a displaced architectural element or a sculpture?

It was just such a crisis in category that motivated Donald Judd to begin his now canonical essay, 'Specific Objects' (1965), by declaring, 'Half or more of the best new work in the last few years has been neither painting nor sculpture.' When a thing fits easily into a category – as when a ruler is used to make measurements rather than to form half-circles in a painting – then a specific type of meaning has been secured for it. But Minimalist sculptures such as Morris's blank plywood boxes do not easily fit into any particular medium and therefore must be encountered without preconception. In the absence of any aesthetic taxonomy to rely on, the viewer can only judge what is there in the room – and in this sense Minimal art's objects, as simple as they are, exhort their viewers to '*see* more,' or at least to see beyond the prevailing conventions of art.

This quality of defamiliarization was self-consciously developed in a variety of ways by artists associated with Minimalism.

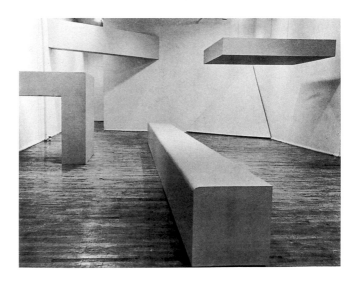

71. **Robert Morris**, exhibition at the Green Gallery, New York, December 1964-January 1965. Left to right: *Untitled (Table)*, *Untitled (Corner Beam)*, *Untitled (Floor Beam)*, *Untitled (Corner Piece)*, and *Untitled (Cloud)*

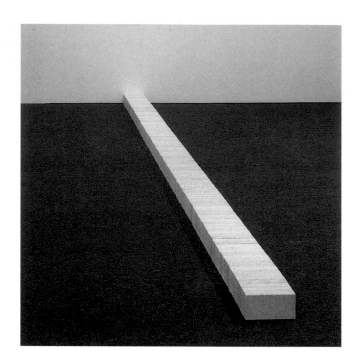

First, as already mentioned, basic geometric forms were favored which were often considered too simple to qualify as sculpture. Judd made several variations on the box and Andre arranged gridded 'carpets' of flat metal squares placed on the floor. Second, in lieu of traditional sculptures consisting of heterogeneous parts ordered hierarchically, Minimalist works were typically arranged as a series of identical – and often readymade – units. The serial repetitions of Andre's *Lever* (1966), consisting of 137 firebricks placed face-to-face in a line on the floor, is exemplary. In *Lever* as in most Minimalist works, the 'ground' against which forms appear is the actual floor of the gallery, and the viewer is consequently embraced within the 'composition' rather than standing outside of it. Third, the scale of Minimalist works typically places them somewhere between the human body and the monument. It is often difficult to determine whether they function as architectural members or as sculpture. And fourth, the materials favored by Minimalist artists were typically associated with industrial design rather than fine art: these materials included Morris's plywood, Judd's aluminum and Plexiglas, Andre's use of firebricks, styrofoam and various metals, and Flavin's construction of sculpture from fluorescent lights. In the case of Judd, the works themselves were fabricated not by the

artist but in factories to his specifications. In Minimalist objects, then, every fundamental sculptural quality – shape, composition, scale, and material – was manipulated in order to produce a radically ambiguous kind of thing.

We have been concentrating on how Minimalist objects *appear*, but the question Sontag begs is what these things *do* as works of art. As suggested above, the categorical indeterminacy of such works – their refusal to settle comfortably into any particular medium or message – shifts the burden of interpretation onto the viewer who must 'invent' a meaning for them. Unlike Pop painting whose content is instantly legible, Minimalist objects are intended to make their viewers acutely self-conscious of their own processes of perception. Morris, for instance, regarded his work as an exercise in gestalt – that optical and psychological mechanism through which the human eye distinguishes a shape from its background. As the artist himself noted, his plywood constructions are both immediately intelligible as simple shapes, but also infinitely changeable as the viewer's physical position shifts and the quality of light within a particular exhibition space modulates with the time of day. As Morris stated in his essay 'Notes on Sculpture, Part 2' (1966): 'There are two distinct terms: the known constant and the experienced variable.' Minimalism thus holds together two ostensibly opposing models of the object: the 'known constant,' or mental picture of a shape like the cube, and the 'experienced variable' of a particular person's encounter with a particular object at a particular time and place. Again and again Minimalist objects staged this paradoxical linkage of conceptual simplicity and perceptual complexity.

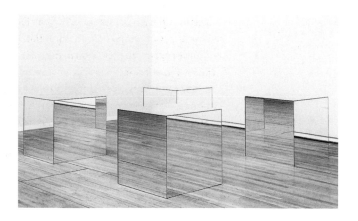

73. **Robert Morris**,
Untitled, 1965/71

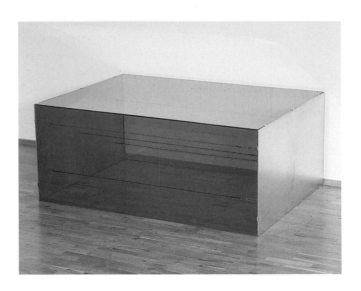

In Donald Judd's *Untitled* (1966), a basic parallelepiped com-
posed of two steel end-plates and four wider faces of amber
Plexiglas, there is a constant play of transparency and reflection.
From some positions the Plexiglas is opaque and virtually indis-
tinguishable from the steel, whereas from other perspectives it is
translucent, almost dematerialized. The solidity of the object is
therefore directly dependent upon the conditions of its percep-
tion: it is not only a 'known constant,' but also a perpetually
shifting pattern of light.

In Judd's open boxes where a four-sided metal shell is lined
with colored Plexiglas, the interior of the volume is co-extensive
with its exterior. As the artist Robert Smithson wrote of Judd's
objects in 1965, 'Every surface is within full view, which makes
the inside and outside equally important.' Indeed, in Judd's work,
as in much of Minimalist art, surfaces fold into one another,
turning objects inside out. As a result, volume and mass – those
qualities typically associated with 'objectness' – tend to dissolve
into a subtly shifting play of optical illusion generated by the
capacity of various materials to filter, block, or reflect light. This
opposition between three-dimensional volumes and the surfaces
which delineate them is fundamental to the mature work of Carl
Andre and Dan Flavin.

Andre's floorpieces, initiated in 1967 and composed of grids
of metal 'tiles' which the viewer is invited to walk over, were called
'razed sites' by the critic David Bourdon in an allusion to their
extinction of volume. Here, sculpture is imagined as all surface,

and this surface is particularly difficult to grasp, for when a viewer stands on a floorpiece and looks out, s/he cannot see, but only 'perceive' the work through tactile contact with her or his feet. In Andre's work the perceptual 'event' which was primarily optical in Judd's boxes is supplemented by a physical perambulatory dimension. Flavin's works, on the other hand, demonstrate the capacity of surfaces – as fields of light – to detach themselves from the object altogether. In *monument 4 those who have been killed in ambush (to P.K. who reminded me about death)* (1966), red

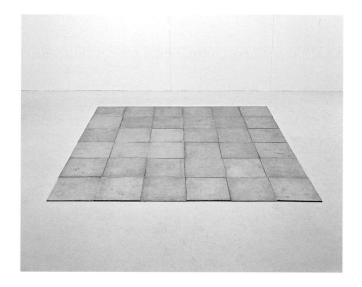

75. **Carl Andre**,
Monchengladbach Square, 1968

76. **Dan Flavin**, *monument 4 those who have been killed in ambush (to P.K. who reminded me about death)*, 1966

fluorescent lights span the corner of a gallery, dissolving the rectilinear architecture into a bloody nimbus of light. As the artist declared in 1964, 'I knew that the actual space of a room could be disrupted and played with by careful thorough composition of illuminating equipment.'

This opposition between surface and volume parallels the relationship between a constant shape and variable perception which characterized Morris's sculptural renderings of gestalt relationships. 'Seeing' itself becomes a form of 'doing' since it is through the mechanisms of perception that stripped down objects, seen as though for the first time, attain both conceptual and physical reality. But Minimalism's emphasis on surface also accomplished a shift from *objects* to *spaces*, as in Andre's floorpieces which demarcate a special zone within the gallery, or Flavin's sculptures which project an atmosphere of light beyond the glowing tubes that generate it. With respect to Sontag's call for a re-education of perception, Minimalist surfaces seem to offer a renewed vision, innocent of commodification. Whereas Pop is derived from the spectacular ideological veneer of packaging and advertising produced in a corporate world inhabited by the viewer but outside his or her direct control, in Minimalism surfaces function as the raw material for individual acts of looking. In theory, those who regard the ambiguous objects of Minimalism become active participants in the production of the work's meaning.

In the various ways outlined, then, Minimalist works situate the viewer within a force field that extends beyond the objects themselves, much as Kienholz's tableaux had encompassed a population of surrogate figures. However, unlike much Assemblage art, where disused or obsolete commodities are combined to furnish a nightmare of decay and despair, Minimalism promised a renewed relationship to the world existing outside of readymade commercial ideologies. Such a prospect is clearly utopian and, as art historian Anna Chave has suggested, the industrial rhetoric of Minimalism is perhaps as closely tied to the values of corporate culture as Pop was. In Minimal art, however, these values were not articulated mimetically, but rather encoded in industrial forms, materials, and modes of fabrication. To return to Sontag's fundamental distinction in 'Against Interpretation,' Minimalism sought to dramatize the intimate relation between people and things characteristic of consumer society through a strategy of 'doing' in which the links between objects, the world they circulate within, and the psychology of perception which determines their ideological significance, was *enacted* rather than *symbolized.*

Most critics and historians agree that Minimalism's significance lies in its redefinition of art as a relationship between viewers, spaces, and things, rather than as a discrete and self-sufficient object. It is such a move from sculptures to encounters that Michael Fried famously condemned as 'theatricality' in his now canonical essay of 1967, 'Art and Objecthood.' However, as will become clear in the next chapter, such a shift was widespread in American art from the 1960s onward. Two artists, Sol LeWitt (b. 1928) and Eva Hesse (1936–70), delineate opposing limits of its practices, LeWitt by introducing a hyper-rational mode of seriality, and Hesse by giving geometric form an organic dimension.

In LeWitt's *Modular Structure (floor)* (1966/68), consisting of thirty-six open cubes painted a neutral white and linked together in a large square-shaped grid resting on the gallery floor, sculpture is rendered as a device for dividing space into equal units rather than as a discrete object with its own volume and mass. LeWitt's impulse toward spatial mapping is matched by his fascination with the permutation of form. *Serial Project #1 (ABCD)* (1966), for instance, also runs through a simple set of variations on a basic shape – the cube – sited on a gridded platform. LeWitt's gesture toward measurement suggests that space may be quantified rationally, and consequently possessed by the viewer either materially or intellectually.

In Hesse's *Repetition Nineteen III* (1968), consisting of nineteen fiberglass cylinders which vary significantly from one another in their 'posture' and the texture of their surfaces, diversity is imagined not as a function of external rules of permutation but rather as the differing 'personalities' of individual things.

78

79

77. **Sol LeWitt**, *Modular Structure (floor)*, 1966/68

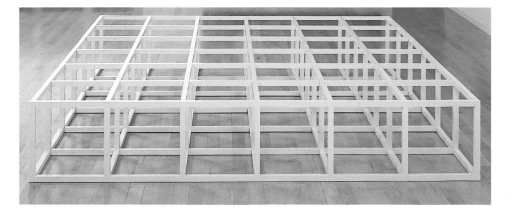

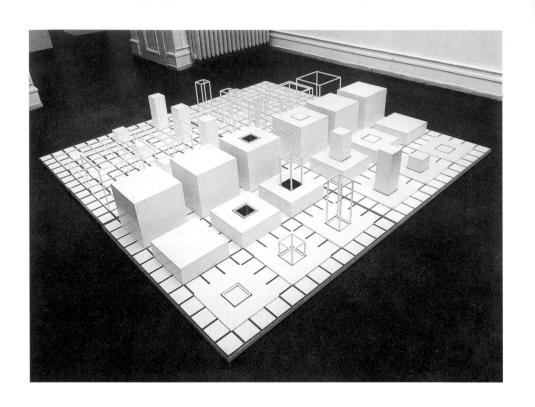

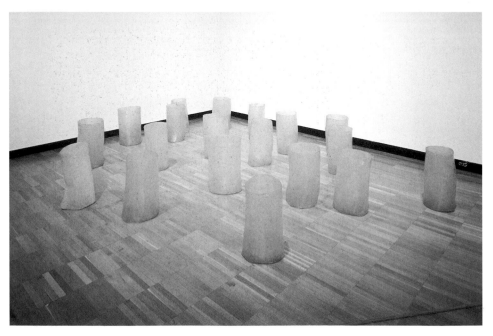

Repetition here is endowed with a bodily dimension – the fiberglass holds light almost like flesh – and the units gather in a loose constellation like a crowd. Hesse's works have often been called obsessive, and indeed in *Accession II* (1967–8), she threaded vinyl extrusions through 30,670 holes on the sides of a perforated steel box to create an interior at once fascinating and sinister in its evocation of a hairy orifice. Such objects heighten the psychological undergirding of Minimalism's romance with geometry and repetition.

As a comparison of Hesse's work with LeWitt's indicates, the apparent rationality of serial composition is haunted by allusions to psychic compulsion and organic reproduction. Indeed, even LeWitt's works, and particularly his elaborate wall drawings based on highly specific instructions, possess an obsessiveness more often attributed to Hesse's art. While stripped of explicit content, the formal rhetoric of Minimalism should not therefore be mistaken as experientially simplistic: its elementary vocabulary of form could *do* a great deal to explore the complex relationship between people and things.

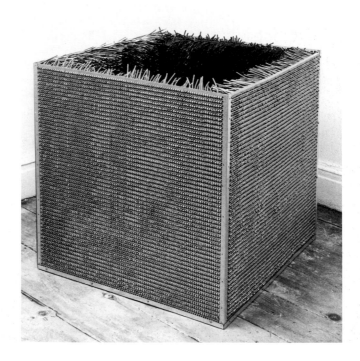

SMOKE PAINTING

Light canvas or any finished painting
with a cigarette at any time for any
length of time.
See the smoke movement.
The painting ends when the whole
canvas or painting is gone.

1961 summer

If Minimalist artists orchestrated sculptural encounters between viewers and objects which were meant to foreground the optical and psychological mechanisms of perception, others during the 1960s developed an interactive paradigm of art-making based on what they called 'events.' Positioned somewhere between performance and sculpture, the event, unlike early Happenings, pivoted on a limited number of actions which were so simple, and so closely related to everyday life, that they could easily escape notice. As Yoko Ono (b. 1933) put it in a lecture of 1966, 'Event, to me, is not an assimilation of all the other arts as Happening seems to be, but an extrication from the various sensory perceptions ... the closest word for it may be a "wish" or "hope."' In the early 1960s Ono developed a series of textual instruction works which were ultimately collected in her 1964 anthology, *Grapefruit*. *Painting in Three Stanzas* (1962), for instance, reads as follows:

Make a small hole in the canvas with a cigarette, hang a sack that
contains wet cotton and seeds behind the canvas, and water every day.
The first stanza – till the canvas is covered by the vine
The second stanza – till the vine withers
The third stanza – till the canvas is burned to ashes
Photograph the canvas at the end of each stanza.

Many of Ono's instruction works were realized, but it was not necessary to carry them out physically for the work of art to exist: the text could and often did stand on its own. These pieces are closely related to event scores by the composer La Monte Young (b. 1935), who organized a series of concerts in Ono's downtown loft in New York during the spring of 1961. Like many progressive musicians and visual artists of this period, Young was influenced by John Cage, whose composition classes at the New School between 1958 and 1960 were enormously inspiring for those who wished to introduce chance operations and the contents of everyday life into their art. Young's scores, like Ono's instructions, could either be performed or stand on their own. His *Composition 1960 #10*, which stipulated, 'Draw a straight line/ and follow it' was memorably interpreted in 1962 in Wiesbaden, Germany, by the video art pioneer Nam June Paik, who dipped his head in a mixture of ink and tomato juice for the occasion and dragged it across a long sheet of paper.

George Brecht (b. 1926) produced some of the most pithy event scores of the 1960s. His now famous 1961 *Word Event*, for instance, contained the single word, 'Exit,' which, presented in

81. **Yoko Ono**, *Smoke Painting score*, 1961

82. **Yoko Ono**, *Smoke Painting*, 1961

Ono's instruction works, which did not need to be realized in order to exist, introduced poetic conceits into the activities of everyday life. Like musical scores, her proposals allow a certain flexibility of interpretation.

83

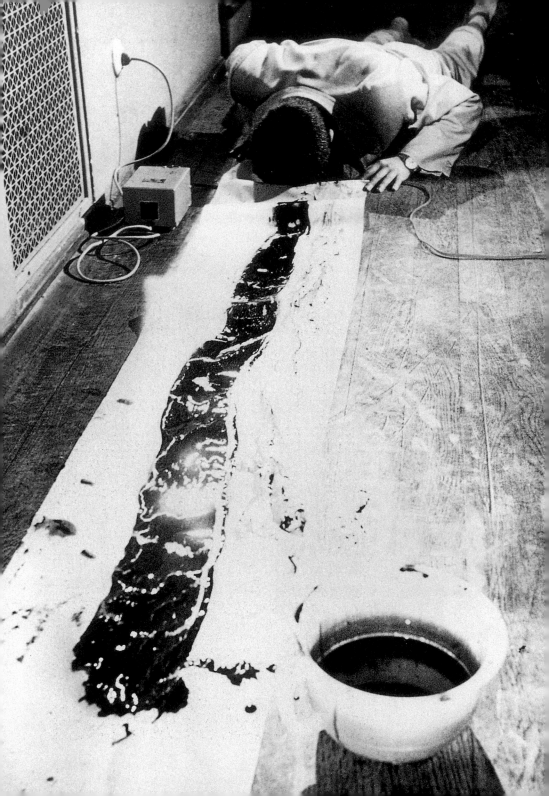

83. **Nam June Paik**, *Zen for Head*, performance of La Monte Young's *Composition 1960 #10*, Städtlisches Museum, Wiesbaden, August 9 1962. Video art pioneer Nam June Paik was trained as a musician and early in his career he frequently participated in avant-garde music festivals. By using his head to realize La Monte Young's score – 'Draw a straight line/and follow it' – Paik indirectly alluded to the functions of dream and philosophy which are lodged in our minds.

isolation, functioned both as a noun and a verb, simultaneously signifying a place (the doorway), an action (a departure), and an imperative request (to leave). By ritualizing the simplest actions and drawing attention to the most ordinary things, Brecht's scores caused viewers to see their surroundings more vividly. His *Three Chair Events*, for instance, focused attention on a kind of object that could easily be overlooked:

Sitting on a black chair
Occurrence.
Yellow chair.
(Occurrence.)
On (or near) a white chair.
Occurrence.

84. **George Brecht**, *Three Chair Events*, Martha Jackson Gallery, New York, 1961. Brecht often used chairs in his works, both as settings for ordinary activities and as anthropomorphic figures. By placing such simple furnishings in different environments, he demonstrated how an object's meaning may be determined by its context and by our expectations of it.

This score was realized at the Martha Jackson Gallery in New York in 1961 where a white chair was dramatically lit like a work of art in the exhibition space, a black chair was placed in the bathroom, and a yellow one outside on the sidewalk. Brecht said of this installation that 'the most beautiful event' was 'when I arrived [and] there was a very lovely woman wearing a large hat comfortably sitting in the [yellow] chair and talking to friends.... It was Claes Oldenburg's mother.'

Event scores function as art by drawing attention to humble objects and simple, though often absurd, actions. From one perspective, then, the event, which is premised on causing viewers to perceive their ordinary environments in extraordinary ways, is closely aligned with Minimalism's goal of renewing the innocence of perception. But unlike Minimalist objects which were specially constructed or arranged, event scores pivot on ordinary things like cigarettes and chairs. Art threatens to dissolve into life to a degree not possible with the self-consciously ambiguous objects of Minimalism. As in Assemblage art, commodities are given new purposes, but in more utopian and playful ways. Ono, Young, and Brecht approached things with an attention and mindfulness characteristic of Zen Buddhism whereas in the constructions of Kienholz and Conner discarded objects evoke unsettling fears and desires. As Ono put it in the statement quoted above, the effect of an event was an intensification of or an 'extrication from various sensory perceptions.' She declared later in the same lecture, 'I think it is nice to abandon what you have as much as possible, as many mental possessions as the physical ones, as they clutter your mind....' Indeed, as in Zen philosophy, the mindfulness induced by object events could paradoxically result in a kind of immolation of things, as in *Smoke Painting*, or 81, 82 in the art of Raphael Montañez Ortiz (b. 1934) who ritually destroyed a number of objects, including a sofa and a piano, in order to release their 'spirit.' Ortiz saw destruction as a form of creation in reverse and therefore regarded it as the key to a renewal of perception. Like Ono, he saw liberatory potential in causing things to disappear.

With the exception of Ortiz, all of the artists mentioned thus far were associated with Fluxus, a rubric invented by the designer and art entrepreneur George Maciunas in 1961. Less a movement than an innovative matrix of performance and publishing activities aimed at promoting new sorts of objects and events, Fluxus included a wide range of artists working in several nations from around the world. Maciunas's initial idea was to

85. **Raphael Montañez Ortiz**,
Piano Destruction Concert, 1966

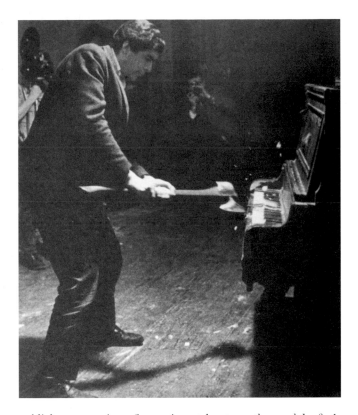

publish a magazine of experimental art on the model of *An Anthology*, a collection of event scores, essays, and poetry edited by La Monte Young which was initiated in 1960 but not published until 1963. In order to fund his proposed periodical, Maciunas organized a series of concert events in Europe and New York between 1962 and 1964 – including the occasion on which Paik performed Young's *Composition 1960 #10* with his head. These raucous festivals, full of absurd and nihilistic actions, generated a good deal of notoriety for Fluxus both in the media and in the art world. Ultimately, instead of editing a journal, in 1964 Maciunas began to publish multiples – often whimsical games and other devices, organized in Plexiglas boxes. In 1964–5, for instance, Ono conceived *Self-Portrait*, a Fluxus object which consisted of a small mirror placed inside an envelope on which the title of the work and the name of the artist were imprinted. As in much Fluxus art, a modest gesture – regarding oneself in the mirror – serves to deflate artistic pretensions – in this case, the conventions of formal portraiture. In a paradox typical of Fluxus, the rhetorical simplicity of Ono's work carries

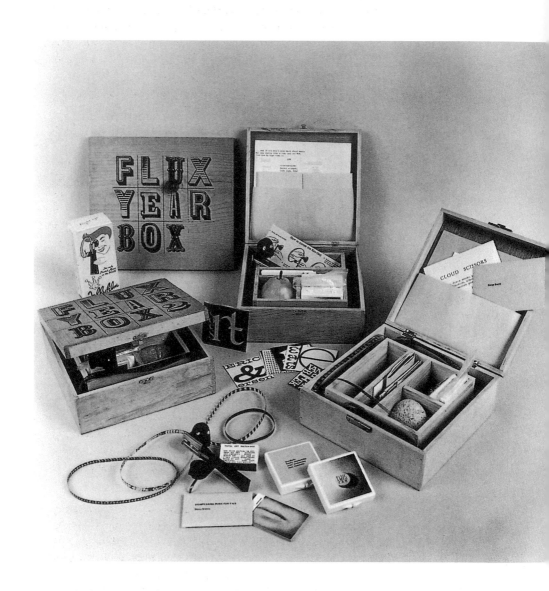

significant conceptual complexity: since the mirror reflects the image of whoever holds it, the notion of a *self*-portrait is expanded out from the artist herself to embrace each of its viewers. As Benjamin H. D. Buchloh has argued, the function of Fluxus objects is often centered on play, and in this sense they challenged the regimentation and monotony which underlie the superficial choices of consumer society by taking literally, and acting upon, the diverse pleasures it promises.

Despite its ostensible rejection of commodified relationships, one of the most significant aspects of Fluxus, as Buchloh also notes, is its tongue-in-cheek adoption of corporate modes of marketing and distribution. Maciunas sold Fluxus artworks through mail order via advertisements in his publication *V TRE* and elsewhere. He conceived of a Fluxshop in his New York loft as well as branches in other cities. While these ventures were hardly successful in financial terms, they did present an alternative to elite art networks by making inexpensive artworks available beyond the commercial gallery. Fluxboxes or Fluxkits, Maciunas's compendia of small works which often resembled three-dimensional anthologies, were typically composed of inexpensive elements. As with Ono's *Self-Portrait* it was the concept, not the materials, that gave these works their value. Maciunas often went so far as to 'license' the name of artists, receiving ideas from various figures in his vast international network of contacts which he then designed and produced himself. As Fluxus artist Dick Higgins put it in a reminiscence of 1990:

George liked to be the boss; but he was smart enough to know that he couldn't be the boss and tell the Fluxus artists what to do, because they'd quit…. So he became the chairman instead. That meant that he couldn't tell people what they had to do, or what they must not do … instead he could tell the world what Fluxus was, and anyone who wanted to do that kind of thing was Fluxus.

Maciunas's interest in re-defining the object of art and the conditions of its dissemination was shared by many Fluxus affiliates who took such processes as themes for individual artworks. Robert Watts (b. 1923), for instance, invented and produced various sheets of postage stamps in 1961 and 1962 – some picturing the faces of unconventional heroes like W. C. Fields and others including erotic images – with which he stocked an actual readymade stamp machine. This mode of mimicry remained lighthearted and ironic as it engaged with serious issues. The postage stamp carries both the authority and the

86. Flux Year Box 2, c. 1968, published by the Fluxus impresario George Maciunas, resemble sophisticated toyboxes which contain a wide array of miniature artworks by different artists. Typically whimsical and often delightful, these compendia undermine the high seriousness generally attributed to artworks, while suggesting an alternative mode of distributing the artist's work.

87

88

87. **Robert Watts**,
Safepost/K.U.K. Feldpost/
Jockpost (W. C. Fields), 1961
(detail)

88. **Robert Watts**, *Stamp Vendor*,
1961

identity of a nation within global networks of communication, so by manipulating this form of 'informational currency,' Watts questioned the core values of American culture. Indeed, he developed this concern with the mobility of information and intellectual property in a 1964 project, *Addendum to Pop*, which consisted of documentation of the artist's unsuccessful effort to obtain patent rights for the term 'Pop art.' By testing the economic status of an aesthetic label under the law, Watts implied that the supposedly ineffable value of an artwork is based on the same mechanisms of market manipulation that determine the worth of other kinds of commodities in a consumer society.

Two fundamental strategies therefore characterize the art of Fluxus: objects are reframed as events, and networks of circulation are incorporated within the artwork. No artist unites these two practices more effectively than Nam June Paik (b. 1932), a Korean who eventually made his home in New York. Paik's early manipulations of TV sets, such as his 'Exposition of Music –

Electronic Television' (1963) at the Galerie Parnass in Wuppertal and his one-person exhibition at the New School in New York in 1965, which included *Magnet TV* (1965), were all premised on transforming ordinary broadcast programming into a special 'event' by rewiring TV sets or disrupting their signals through magnets. As Maciunas described Paik's exhibition in Wuppertal, 'He had 12 TV sets also "prepared" – rewired, with signals from generators, radios, tape recorders fed-in. So some show distorted images, some just abstractions, like a single line, the thickness of which you can control by TV dials. VERY NICE distortions.' In these works an electronic event, reminiscent of the scores of Ono, Young, and Brecht, was premised on the transformation of broadcast television – a commercial information network – into abstract art.

In their different ways all of the artists considered in this chapter – in the distinct contexts of Assemblage, Minimalism, and Fluxus – explored the place of commodities in the world, and in relation to individual viewers. In Paik's work the public sphere is identified as the electronic stream of programming and advertising carried by a particular kind of commodity – television sets – into virtually every home in the United States. By manipulating this signal by, for example, placing a magnet on the set and bending the broadcast pattern into a whorl of light, Paik modestly suggested that anyone who dares may intervene in the corporate economy of information if only by jamming its messages and transposing them as a different mode of communication founded in a different kind of eloquence. Indeed, one of the characteristics of the Fluxus event was to transform information into objects. As will be seen over the next two chapters, this equivalence between concepts and things would motivate much of the best American art of the 1970s.

89. **Nam June Paik**, *Magnet TV*, 1965. Photo by Peter Moore © Estate of Peter Moore/VAGA, New York/DACS, London 2003. Paik transforms the television signal into an abstract pattern by applying a strong magnet to the television set. In doing so, he both transforms commercial information into a non-objective pattern and suggests that viewers can 'talk back' in various ways to the messages broadcast on TV.

Question:

Would the fact that Governor Rockefeller
has not denounced President Nixon's
Indochina policy be a reason for you not
to vote for him in November ?

Answer:

If 'yes'
please cast your ballot into the left box
if 'no'
into the right box.

Chapter 5: Art as Information: Systems, Sites, Media

In 1970 two exhibitions took place in New York, 'Information' at the Museum of Modern Art and 'Software' at the Jewish Museum, which together marked a widespread shift in the nature of art objects. In the previous chapter we saw how a spectrum of practices, including Assemblage, Minimalism, and Fluxus, responded in various ways to the growing centrality of the commodity as a signifying unit: in such works commercial things functioned almost like words which were combined or re-contextualized to form new messages. Artists included in 'Information' and 'Software' took a further step by redefining the artwork as a pure act of communication, often having little or nothing to do with traditional aesthetics. As in Assemblage art and Fluxus, in these new approaches meaning arose from the context of an object's presentation and, as in Minimalist sculpture, the content of the work was as much a product of perception as the result of material fashioning.

Unlike those practices discussed in the previous chapter, however, in which something like a traditional sculpture persists, many artists of the late 1960s and 1970s began to regard material things as irrelevant to an experience of art which, in their view, centered on an exchange of information. As Kynaston McShine, the curator of 'Information,' put it in his catalogue essay, 'With the sense of mobility and change that pervades their time, [the exhibiting artists] are interested in ways of rapidly exchanging ideas rather than embalming the idea in an "object."' McShine suggests two important issues here: first, he asserts that by 1970, objects had come to seem practically obsolete, and second, he claims that a dynamic exchange of information would only be 'embalmed' if given permanent form. Indeed traditional modes of experience were doubly challenged during the period of this exhibition. The advent of an 'information' economy, based on emerging computer technologies combined with the ubiquitous spread of electronic media like television, made information into a substance as 'real' and as subject to exchange in financial markets as any solid commodity. The social transformations enabled

90. **Hans Haacke**,
MoMA-Poll, 1970

by the commodification of data and the construction of a media public sphere also gave rise to many productive forms of dissent during the 1960s and '70s, pivoting on identity-based claims for equality and expanded democracy. Widespread resistance to the Vietnam War – itself 'brought home' through television and magazine images – along with Civil Rights struggles in the 1960s among African-Americans, Chicanos, women, and gay and lesbian people made it clear that oppositional politics was deeply rooted in personal acts of communication.

The contribution to 'Information' made by Hans Haacke (b. 1936) serves as an example of how these technological and social transformations intersect. Haacke's work was structured as a poll of museum visitors. As he described it in his statement for the exhibition catalogue:

Two transparent ballot boxes are positioned in the exhibition, one for each answer to an either-or question referring to a current socio-political issue. The question is posted with the ballot boxes. The ballots cast in each box are counted photo-electrically and the state of the poll at any given time during the exhibition is available in absolute figures.

The question which Haacke posted on a simple placard on the wall above the transparent ballot boxes is one that shrewdly established connections between geo-politics and art-world politics. In an institution heavily supported by the Rockefeller family, Haacke asked of museum goers, 'Would the fact that Governor Rockefeller has not denounced President Nixon's Indochina policy be a reason for you not to vote for him in November?' Instead of encountering an object of contemplation or aesthetic delectation, spectators were therefore confronted with a question which, for those aware that the governor of New York was also a trustee of the Museum of Modern Art, was intended to shatter the presumed innocence or neutrality of the museum. Even for those unaware of the Rockefellers' very prominent and philanthropic role at MoMA, Haacke's work shifts the nature of art-viewing from the 'pure' acts of perception solicited by Minimalist sculpture to a politicized mode of giving and receiving information in which the spectator is asked to take sides on one of the most volatile issues of the day. This political dynamic is nested within a mode of data gathering equally central to postwar life – the practice of polling which is fundamental to American policy-makers. Haacke's *MoMA-Poll* is a work of art which literally embraces the viewer as part of a quantifiable (and commodifiable) data stream which in other contexts could have been commissioned by

130

Governor Rockefeller himself or his campaign staff. The fact that such political and informational networks are materialized in the transparent poll boxes which explicitly recall the geometric rhetoric of Minimalism further affirms Haacke's conviction that the language of art is lodged within broader social and political conflicts.

Adopting a term from computer science that was introduced to him by the critic Jack Burnham, who organized 'Software,' Haacke regarded his works as 'systems' rather than objects. In a 1971 interview, for instance, the artist declared, 'I believe the term system should be reserved for sculptures in which a transfer of energy, material, or information occurs, and which do not depend on perceptual interpretation.' Haacke's own understanding of such systems embraced not only the model of sociopolitical interchange orchestrated by *MoMA-Poll*, but also natural forms of energy transfer. For 'Earth Art,' another watershed exhibition of 1969, presented at Cornell University, Haacke made a work called *Grass Grows*, which consisted of a mound of earth placed in a gallery, seeded with fast-growing rye which grew and died in the course of the exhibition. Interestingly, the artist drew close analogies at this time between natural systems and sociological ones, declaring in the same 1971 interview that 'the way social organizations behave is not much different' from natural ones, and that technology and nature 'obviously follow

91. **Hans Haacke**, *Grass Grows*, 1969

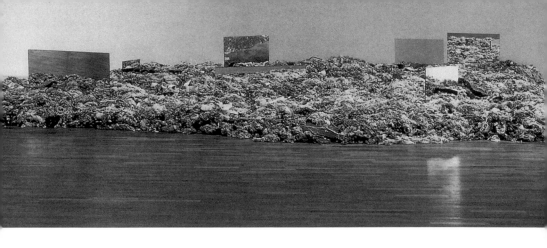

92. **Robert Morris**, *Threadwaste*, 1968. In allowing form to collapse into virtual incoherence, Morris's 'scatter art' suggests that the only way such a spillage of matter can be considered an 'object' is if the viewer transforms it into one through an act of perception. While the form of *Threadwaste* is strikingly different from Morris's earlier Minimalist-oriented work, the theoretical issues at stake are thus closely related.

the same rules of operation.' The word 'system' suggests a closed circuit of interlocking actions, but many artists working in this period were engaged with open-ended *processes*, in which artworks were produced as the residue of simple and often aimless procedures carried out by the artist on humble materials. Unlike Haacke's energy *transfers*, Process art tended to *expend* energy through a potlatch of informational waste.

In 1968, Robert Morris, one of the primary practitioners and theorists of Minimalism, made a work called *Threadwaste* in which the fibrous substance of the title – an industrial form of lubricated packing material used in freight trains – was spread on the gallery floor along with other bits of discarded matter. This sea of dross was punctuated by a number of two-sided mirrors which simultaneously extended the expanse of material through reflection, and punched optical holes within it. If Haacke's adoption of systems dissolved things into interlocking transfers of information or organic energy, Morris's work seems to dramatize the draining away of objects into flows of waste – a seepage of energy which many artists of the time identified with the scientific and informational concept of entropy. As Morris contended in his influential essays, 'Anti Form' (1968) and 'Notes on Sculpture, Part 4: Beyond Objects' (1969), works like *Threadwaste* were meant to undo the gestalt opposition between figure and ground which had characterized the work of Minimalism. In the latter essay he declared, 'Some new art now seems to take the conditions of the visual field itself (figures excluded) and uses them as the structural basis for the art ... here the "figure" is literally the "ground."' In other words, in place of an *object*, *Threadwaste* offers a *field* of matter which, rather than

resolving itself into an image, functions as a kind of visual noise or peripheral vision in which form remains inchoate. Morris thus associates the collapse of optical figuration with the underbelly of industrial production – in this instance represented by thread-waste. And yet, as in Minimal art where the perceptual event of producing or recognizing form was essential, the inclusion of mirrors in *Threadwaste* suggests an impulse toward image-making since, in them, scenes are framed and doubled through reflection, the most primal form of 'representation.' If the disordered matter which constitutes *Threadwaste* enacts a dispersal of form, through the presence of these mirrors it nevertheless maintains the desire, even the instinctual drive, to frame images.

In 1967–8 Richard Serra (b. 1939) compiled a long list of verbs cataloguing those actions to which he might submit materials like lead – a metal soft enough to yield itself to several of the operations he imagined. These included 'To Roll; To Crease; To Fold; To Store; To Bend; To Shorten; To Twist; To Twine; To Dapple; To Crumple: To Shave; To Tear,' and many more. In a 1969 text, the artist Dan Graham implied a connection between such simple actions and the informational model of 'systems' aesthetics advocated by Haacke. Graham wrote, '[Serra's] works are described by a simple verb action performed on the material by the artist, available to the viewer as residue of an in-formation (the stage of the process described in applying the verb action to the material place where it is present) time.' Graham's pun here is sharply illuminating in its elision of information defined as communication and 'in-formation' as a process of fashioning matter. Indeed Serra carried out several of the imperatives on his list: he rolled lead, and bent and cut it.

Perhaps Serra's most affecting works of the late 1960s, however, were the *Props*, in which two elements are balanced in an often excruciating tension. In one of these works from 1969, a lead tube is propped against a wall, poised on a flat lead plate that is positioned on the floor. As Rosalind Krauss has argued, because the viewer is never certain that the *Props'* precarious balance will hold, the moment of 'composition,' which in traditional sculptures remains securely in the past, is indefinitely protracted. Like a house of cards – the subtitle of another of Serra's *Props* – these works perpetually threaten catastrophic collapse, and this ongoing tension amounts to what Krauss has called in another context 'a perpetual climax.' Such an erotics of process in which the imperative of image-making is either nearly evacuated in works like Morris's *Threadwaste* or endowed with heightened

93

94. **Lynda Benglis**, *For Carl Andre*, 1970. In titling her biomorphic and inescapably scatological sculpture *For Carl Andre*, Benglis signals a sharp departure from the crisp geometry of Andre's Minimalism. Benglis's simple process of accretion results in a work which is alternately sensual and repulsive in its allusion to bodily excretions.

tension, as in Serra's *Props*, attained a fluidity redolent of bodily functions in a series of poured sculptures by Lynda Benglis (b. 1941) in the late 1960s and early 1970s. Benglis's *For Carl Andre* (1970), for instance, an excremental pile built of layers of brown polyurethane foam, makes the scatological dimension of Process art explicit, thereby linking the collapse of form with the abject waste products of the body.

If we take the implication of Dan Graham's pun seriously – that information as communication is inextricably linked to 'in-formation' as a process whereby undifferentiated matter approaches or withdraws from the status of form – then the relation between Haacke's 'systems' aesthetic and the various enactments of Process art already described, fall into alignment. Whereas systems point to the formal interrelatedness of matter, social relations, and technology, Process art dramatizes the tensions or failures in the translation from matter into form. Process art establishes incomplete or irrational systems. And indeed, many artists dwelled not on the oppressive efficiency of the new communications technologies, but rather on their breakdowns and blindspots.

93. **Richard Serra**, *Shovel Plate Prop*, 1969

One of the most prominent of these artists was Bruce Nauman (b. 1941) who, with an impressive array of artistic procedures, charted the psychological dimensions of information exchange. Nauman's art dramatized how perceptual data may orient (or disorient) a person in her or his environment. As Marcia Tucker concisely put it in 1970, Nauman 'is involved with the amplification and deprivation of sensory data....' In other words, his art tends to give too much information – or too little. Sometimes his amplifications take the form of materializing spaces which, in the ordinary course of events, are beneath the threshold of most observers' perception. In a concrete sculpture titled *A Cast of the Space Under My Chair* (1965–8), Nauman generated a form which is superficially similar to Minimalist

95. **Bruce Nauman**, *A Cast of the Space Under My Chair*, 1965–8

136

objects in its crisp geometry, but conceptually distinct from them in its efforts to thicken space into a kind of tumor. Rather than dramatizing the contingency of perception through the establishment of a strong gestalt relationship between a geometric figure and the room it occupies, Nauman's piece reverses the relation by evoking an invisible solid through the shape of the void it describes.

In several of his video installations dating from around 1970, in which a closed circuit camera and monitor capture the image of the viewer only to disorient her or him by feeding back less or different information from what s/he may expect, Nauman establishes a kind of vertigo. In one of several spaces built into an elaborate installation at the Nick Wilder Gallery in Los Angeles 96 in 1970, the viewer could enter a long corridor with two stacked monitors at the end. The top monitor showed a pre-recorded image of the corridor while the bottom one broadcast a live image from the same angle. Since the live camera feeding the bottom screen was mounted high inside the entrance of the corridor, the viewer could see only an image of the back of her or his head which diminished as s/he moved closer to the monitors. In other words, as the viewer advances, her or his image withdraws: the consistency of perceptual information, which we take for granted in our movement through the world, is severely undermined.

This dislodging of the individual from her or his place in the world, which is analogous to the reversal of solid and void in *A Cast of the Space Under My Chair*, is elaborated linguistically in a series of flashing neon signs which Nauman has produced through much of his career. In *Eat/Death* (1972), for instance, the 97 word EAT in yellow neon is superimposed on DEATH in blue neon. Nested inside the word which denotes life's extinction is the term which signifies its sustenance. Here the figure/ground relationship exists not only between colors, but also between letters of a single word and the organic states of being that these various configurations of letters denote. Nauman's art is therefore founded not in a particular medium, but in a consistent philosophical fascination with the relation between sensory data and subjective experience. But unlike Haacke's systems, which embrace the viewer in streams of information, Nauman's perceptual 'amplifications' and 'deprivations' serve to alienate rather than to control.

Overleaf:

96. **Bruce Nauman**, *Corridor Installation (Nick Wilder installation)*, 1970 (detail)

97. **Bruce Nauman**, *Eat/Death*, 1972

Site

Pop art, Assemblage, and Fluxus artists who manipulated commercial objects, or Minimalists who reinvented them altogether, did so in order to communicate through the shared public language of consumer society. Indeed, the history of American art since World War II may be described as a succession of strategies for enlarging this commercialized public sphere, both by multiplying the kinds of visual statements that can be made there and by diversifying those who are authorized to make them. But rather than simply reframing consumerism from within, the artists discussed in the previous section established a model of communication which sought to circumvent the commodity system altogether. By adopting an aesthetics of 'information' these artists left themselves with little to sell, and this self-conscious refusal of the art market signified a more thoroughgoing resistance to the commercialization of public life. Moreover, the deployment of 'systems' or 'processes' in place of traditional forms of object-making constituted a philosophical challenge to the nature of things: Does an artwork composed of streams of information consist of ephemeral acts of communication or the physical residue of such acts?

Rather than providing an answer to this insoluble conundrum, a number of artists during the late 1960s and 1970s, including Robert Smithson (1928–73), made the question itself the subject of their art. Smithson's *Nonsites*, for instance, perform a double displacement: first, particular landscapes are identified as 'sculptural' materials, but second, such landscapes are caught within an endless chain of representations so that their material and topographical contours are difficult to determine. In Smithson's art the earth itself appears as a form of information which is marked over time by a succession of transformations and traumas.

Indeed, in pieces like *Nonsite (The Palisades, Edgewater, New Jersey)* (1968), Smithson chose locations heavily marked by human industry and technology. In this work a place – the 'site' – is represented by two components which together constitute the 'nonsite': a typewritten statement illustrated by a map, and a cage-like aluminum bin containing a cascade of trap rocks native to the Palisades. The textual component of the *Nonsite* clearly articulates Smithson's interest in landscapes redolent of industrial decay. In it he writes, 'On the site are the traces of an old trolly [sic] system.... The trolly was abolished on August 5, 1938. What was once a straight track has become a path of rocky

A NONSITE (THE PALISADES)

The above map shows the site where trap rocks (from the Swedish word trapp meaning "stairs") for the Nonsite were collected. The map is $1\frac{7}{16}$" X 2". The dimensions of the map are 18 times (approx.) smaller than the width 26" and length 36" of the Nonsite. The Nonsite is 56" high with 2 closed sides 26" X 56" and two slatted sides 36" X 56" -- there are eight 8" slats and eight 8" openings. Site-selection was based on Christopher J. Schuberth's The Geology of New York City and Environs -- See Trip C, Page 232, "The Ridges". On the site are the traces of an old trolly system that connected Palisades Amusement Park with the Edgewater-125th St. Ferry. The trolly was abolished on August 5, 1938. What was once a straight track has become a path of rocky crags -- the site has lost its system. The cliffs on the map are clear cut contour lines that tell us nothing about the dirt between the rocks. The amusement park rests on a rock strata known as "the chilled-zone". Instead of putting a work of art on some land, some land is put into the work of art. Between the site and the Nonsite one may lapse into places of little organization and no direction.

Robert Smithson 68

98. **Robert Smithson**, *Nonsite (The Palisades, Edgewater, New Jersey)*, 1968

99. **Robert Smithson**, detail of *Nonsite (The Palisades, Edgewater, New Jersey)*, 1968, showing typewritten text

Smithson's work causes us to question how we can know a 'site': Is it through samples drawn from a place, or through more abstract representations such as text or maps?

crags – the site has lost its system.' The rise and fall of the trolley line, like the incomprehensibly gradual geological processes which Smithson habitually compared to cycles of industrialization, constitutes a grand process of formation and erosion – or in-formation to adopt Dan Graham's term for Serra's sculpture.

On one level, then, Smithson recognizes the procedures of Process art in modern landscapes and appropriates them almost like a readymade. However, in the *Nonsites* he demonstrates how these geological processes are contained both physically and conceptually by the cultural disciplines of engineering, science, and mechanical reproduction. As compendia of the various modes of comprehending the land – including textual histories, maps, photographs, and rock samples – the *Nonsites* suggest that earth is as much a texture of words and pictures as it is of rock and soil. Indeed, in his 1968 text, 'A Sedimentation of the Mind: Earth Projects,' Smithson writes of the bins containing rocks which are a component of all of the *Nonsites*:

> *The container is in a sense a fragment itself, something that could be called a three-dimensional map. Without appeal to 'gestalts' or 'anti-form,' it actually exists as a fragment of a greater fragmentation. It is a three-dimensional perspective that has broken away from the whole, while containing the lack of its own containment. There are no mysteries in these vestiges, no traces of an end or a beginning.*

Rather than adopting the earth as a metaphor of wholeness, Smithson shows it to be radically fragmentary, marked as it is by incomplete processes, both natural and cultural, which constantly break form into shards, not unlike the rock samples piled into his bins.

Even in Smithson's best known work, *The Spiral Jetty* (1970), whose concentric arcs extend out into the Great Salt Lake in Utah, the viewer's frame of reference is perpetually shifting. In an analogy between part and whole typical of Smithson's art, the overall spiral shape of the jetty mimics the crystalline formation of each of its component stones; and in another shift in scale, the red bacteria of the waters in this section of the lake (to which Smithson was particularly drawn) seem to transform the spiral into a single great organism swollen by blood. *The Spiral Jetty* is one of the best known works of postwar American art and yet relatively few people have visited its site; instead most know it through photographs and the documentary film Smithson made to accompany it. This film is not merely an adjunct to the earth-work, but its metaphorical twin. As the artist wrote in a 1972

100. **Robert Smithson**,
The Spiral Jetty, 1970

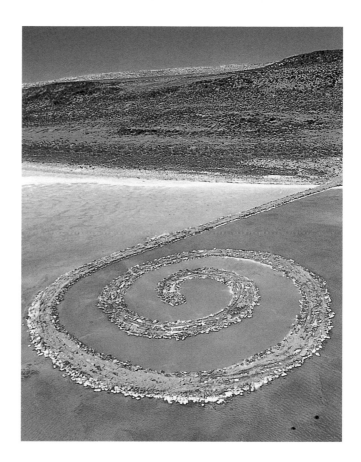

text, 'For my film (a film is a spiral made up of frames) I would have myself filmed from a helicopter (from the Greek *helix, helikos* meaning spiral) directly overhead in order to get the scale in terms of erratic steps.' As this text makes clear, Smithson's elaborations on a form like the spiral occasion a wild proliferation of meanings and metaphors – leading from the jetty to the film to a helicopter and back to the jetty – each superimposed on the others. For him, the *Jetty* collapses all conceptual and physical distinctions:

This site was a rotary that enclosed itself in an immense roundness. From that gyrating space emerged the possibility of the Spiral Jetty. No ideas, no concepts, no systems, no structures, no abstractions could hold themselves together in the actuality of that evidence. My dialectics of site and nonsite whirled into an indeterminate state, where solid and liquid lost themselves in one another.

Smithson thus eloquently dispels an understandable misconception about his art: that a work like *The Spiral Jetty* is merely a large abstract sculpture rendered on the 'ground' of the landscape like a huge gestural painting.

Many earthworks, such as *The Lightning Field* (1977) by Walter De Maria (b. 1935) or the breathtaking *Double Negative* (1969–70) by Michael Heizer (b. 1944), similarly address the site by drawing out qualities latent within it. Like Minimalist sculpture, each of these works establishes a perceptual event, but unlike Minimalism, the experience is partly conditioned by the contours and dimensions of a carefully chosen landscape. *The Lightning Field* is a grid of four hundred stainless steel poles capable of conducting lightning in a New Mexico desert, and *Double Negative* consists of two massive cuts aligned across a remote valley in Nevada. These works transform the perceptual experience of their locations but, unlike Smithson's *Nonsites* or *Spiral Jetty*, they do not reframe the landscape altogether as a product of its alternate representations in maps, photographs, text, or science.

As articulated by Smithson, then, a 'site' is not a timeless or unchanging landscape but is rather a locus of competing

101. **Walter De Maria**, *The Lightning Field*, 1977. De Maria enlists the natural 'process' of weather in his *Lightning Field*. Even in the absence of a storm, his grid of stainless steel poles maps the uneven topography of the desert into measurable units.

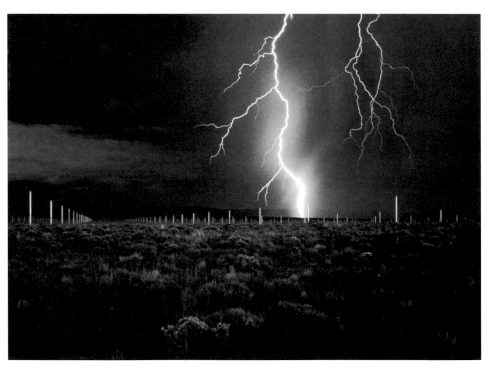

representations – it is information 'in formation.' In Smithson's art two kinds of informational processes mesh with one another: the incomprehensibly slow geological transformations of the earth, and the comparatively fast human technologies for marking and mapping an environment. Along with the other artists discussed in this chapter, Smithson recognized that if art is an act of communication, then the substance or pretext of this informational exchange could be anything, ranging from a poll-box in a New York museum to the Great Salt Lake in Utah. Consequently the lesson of earth art is not simply that land may be used as a sculptural medium, but also that the procedures of system-based or Process art may be extended as practices of 'mapping' which address not only materials in the gallery, but environments – or sites – anywhere in the world.

Salt Flat (1969) by Dennis Oppenheim (b. 1938) embraces rural and urban locations in a single work. In this piece, documented by a series of photographs and an explanatory caption, Oppenheim made the 'same' mark in three dramatically different environments. He spread 1000 pounds of baker's salt into a 50 x 100 foot (15.2 x 30.5 m) rectangle on an asphalt surface in New York City; he placed an identical configuration composed of salt-lick blocks on the ocean floor off the Bahamas; and he excavated a rectangle of these dimensions in the Salt Lake Desert. The meaning of Oppenheim's 'mark' – the salt rectangle – is conditioned by its various locations, whether in the 'asphalt desert' of New York, or within the shifting contours of the desert or sea where the salt will disperse through the action of wind or water. Like Smithson's bins in the *Nonsites*, these salt configurations function like fragments of a map: it is as though a piece of gridded territory had been extracted from one place and transported to another. The force of *Salt Flat* derives from its demonstration that the universality of measurement, as exemplified by the repeated unit of the map, always masks the particularity of a place and its materials. Salt may be 'native' to the city, the desert, and the sea, but the nature of its belonging in each of these places is completely different.

Such strategies of dislocation are essential to other site-specific practices of the 1970s which were not directly tied to the earth. In 1974 Gordon Matta-Clark (1943–78) cut through the center of a modest suburban house in Englewood, New Jersey, which was scheduled to be demolished. He cracked the building open like an egg by lowering half of its bisected structure onto a newly bevelled foundation. Some have argued that Matta-Clark's violation of this elementary house constitutes a 'rape' of

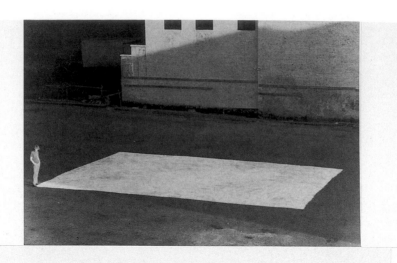

SALT FLAT. 1969. 1000 pounds of baker's salt placed on asphalt surface
and spread into a rectangle, 50' X 100'. Sixth Ave., New York, New York.
Identical dimensions to be transferred in 1' X 1' X 2' salt-lick blocks
to ocean floor off the Bahama Coast. Identical dimensions to be
excavated to a depth of 1' in Salt Lake Desert, Utah.

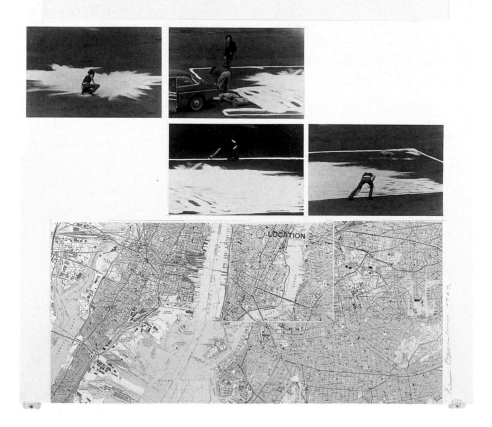

103. **Gordon Matta-Clark**,
Splitting, 1974

domesticity while others contend that the work is a commentary
on the depredations of real estate development and urban
renewal. Indeed Matta-Clark, who was trained as an architect,
was well aware of what he called the 'containerization of usable
space' as both an economic and social form of regulation. *Splitting*
alludes to these suburban realities through the same procedures
of inscription and displacement used by Smithson and
Oppenheim. As the artist commented in an interview of 1974, 'A
great deal of visual information was released, so that even though
it was hard to get to the roof and basement, they were liberated
from being hidden areas.' This 'information' included not only a
new perspective on the mechanics of the structure itself but also a
new sculptural and perceptual 'object' which called into question
conventions of the house, both as a commodity subject to
exchange and as a home.

In the art of Michael Asher (b. 1943), the museum or gallery
is similarly addressed as a medium – at once a space to be manipu-
lated and an institution to probe. Like Haacke and others, Asher's
work dramatizes the museum's fundamental role in conferring
artistic status on any number of ordinary materials or actions.
In his 1979 project for the Museum of Contemporary Art
in Chicago, for instance (which has since relocated to a new

102. **Dennis Oppenheim**,
Salt Flat, 1969

104

104. Michael Asher, *Museum of Contemporary Art, Chicago, June 8 – August 12, 1979* (exterior and interior views)

building), he removed the exterior aluminum panels from either side of a glassed-in gallery on the front facade of the building and installed them inside the gallery. Hung in a grid like Minimalist paintings or sculpture, and visible from the street through vast windows, these erstwhile pieces of cladding appeared as works of art. Like Oppenheim's *Salt Flat*, the MCA project demonstrated how a thing's value differs according to its conditions of exhibition. In a stunning literalization of the museum's criteria of judgment, Asher called attention to the architectural and conceptual borderline between what may be admitted 'inside' the institution and what remains 'outside' both its walls and its aesthetic categories.

As Asher's project demonstrates, the question of site is indistinguishable from the question of boundaries – including those which divide institutions and discourses as well as those which divide one place from another. Mel Bochner (b. 1940) and Robert Barry (b. 1936) press this definition of site to its logical conclusion by inventing procedures which take the boundary – and its potential indeterminacy – as their object. In Bochner's *Measurement Room* (1969) at the Galerie Heiner Friedrich in

105. Mel Bochner, *Measurement Room*, 1969

Munich, lines of tape and Letraset mark the width and height of the walls, doorways, and window apertures in an otherwise empty gallery. By superimposing a full-scale 'blueprint' onto the actual contours of a space, Bochner demonstrated how differently experience can be measured depending upon whether one dwells on kinaesthetic sensation or geometric specification. Who is to say, for instance, that the quality of light in the Galerie Heiner Friedrich is not as accurate a measurement of its space as its quantification in feet and inches? If Bochner thus demonstrates that there is no necessary congruency between perception and measurement, his works also suggest a related conclusion: that the reality of a room – like the reality of any thing – consists not in some intrinsic quality, but in the relations between its elements. In this sense the linear segments in *Measurement Room* function as vectors tying together its diverse aspects. In a series of texts written in 1967–70, Bochner claimed, '*A fundamental assumption in much recent past art was that things have*

106. **Robert Barry**, *Inert Gas Series: Helium*, March 1969. Barry's work, in which a specified amount of helium was released into the atmosphere, is invisible to the human eye, but chemically perceptible. This work is performative in nature but, like much other sculpture of the time, it challenges our definitions of an object. What kind of thing is a cloud of gas dispersing into space?

stable properties, i.e., boundaries.... Boundaries, however, are only the fabrication of our desire to detect them ... a trade-off between seeing something and wanting to enclose it (italics sic).' Indeed, *Measurement Room* invokes the rhetoric of boundaries, but not in order to enclose a thing. 'Wall-works,' Bochner declares in the same text, '.... spread *along* the surface. They cannot be "held," only seen.'

The paradoxical desire to present a work of art which is without boundaries was explored by Robert Barry in a series of pieces in which he released a particular volume of inert gas into the atmosphere. The infinite dispersal of these invisible substances served as a metaphor for a new kind of open-ended objectivity. As Barry stated in an interview of 1969, 'We are not really destroying the object, but just expanding the definition.... Like art, that keeps on being expanded, that seems to include more and more things.'

Feedback

The shift away from art objects and toward systems, processes, and sites was part of a larger cultural development during the postwar period – namely the 'triumph' of television as the pre-eminent purveyor of information in the United States. One of the guiding themes of this book is that contemporary public life in the US is conducted largely through the mass media. In other words, television serves as the nation's primary public arena. And yet, virtually all of the programming on TV – including entertainment, news, and especially commercials – is crafted according to corporate rather than governmental or other civic interests. This one-way mode of 'public' communication allows for little in the way of feedback. But feedback – in the dual sense of electronic 'noise' and meaningful response – is precisely what artists produced with video during the 1960s and '70s.

Even before relatively inexpensive video equipment like the Portapak became available in 1965, Nam June Paik's 'prepared TVs' (see pp. 125-6) generated the first type of feedback – visual 'noise' – by deforming broadcast signals with magnets or by rebuilding the circuitry of individual TV sets. In 1970 Paik and Shuya Abe, a Japanese electronics engineer, completed the Paik-Abe synthesizer, which could permanently distort and colorize video signals. Not only did the resulting patterns break apart and energize broadcast information in a kind of televisual fission, but these transformations constituted acts of intervention within the broadcast circuit by symbolically disrupting the passive consumption of TV. Indeed, in many of Paik's early works such as

89

Participation TV (1963), the viewer adopted an active role in manipulating the television signal. In other words both types of feedback converge in Paik's amended TVs as well as in his individual videotapes whose quick cuts, visual effects, and lively soundtracks resemble music videos *avant la lettre*. Paik presented such fast-paced tapes as his *Global Groove* (1973), made in collaboration with John J. Godfrey, in installations of walls or platforms entirely composed of monitors. By engulfing the viewer in a video habitat, these works established a physical analogue to the 'virtual' space of the media.

If Paik initiated feedback by transforming both the hardware and the software of television to create media environments for the spectator to inhabit, then Ira Schneider (b. 1939) and Frank Gillette (b. 1941) established such interchange by introducing the audience into the mosaic of broadcast TV. *Wipe Cycle* (1969–84) consisted of a bank of nine monitors surrounding a closed circuit video camera which recorded live images of viewers as they approached the work. These fragments of footage were played on 8- and 16-second delays, jumping from monitor to monitor and intercut with broadcast TV. Periodically all of the screens would be wiped clean. Gillette's description of the work

107. **Frank Gillette and Ira Schneider**, *Wipe Cycle*, 1969–84

108. **Nam June Paik**, *TV Garden*,
1974. Photo by Peter Moore
© Estate of Peter Moore/VAGA,
New York/DACS, London 2003

links it explicitly to an ethics of televisual communication: 'The intent of this [image] overloading (something like a play within a play within a play) is to escape the automatic "information" experience of commercial television without totally divesting it of the usual content.' In other words, *Wipe Cycle* was meant to break apart the monolithic 'information' of network TV through a spectator's unexpected encounter with her or his own act of viewing. In this instance video's capacity to function as an electronic mirror is used to loosen the grip of commercial programming on the viewer.

In an influential essay of 1976 Rosalind Krauss identified the psychological dimension of such mirroring – narcissism – as the foundation of video art. While she was largely critical of video's narcissistic impulse, Krauss did note certain strategies of auto-reflection which possessed critical force. In *Vertical Roll* (1972) by Joan Jonas (b. 1936), for instance, the artist performs a number of simple actions such as jumping and clapping. Watching the tape, the viewer can never forget the corresponding 'jump' of the video apparatus – the vertical roll resulting from a desynchronization of signal and monitor. The insistent pulse of the vertical roll, enhanced by a sharp percussive soundtrack, roots Jonas's 'narcissism' in a social and technological form of doubling – the manic reproduction of television. Through most of the videotape the artist's body is fragmented – presented, for instance, in isolated hand gestures or jumping legs and feet. This bodily fragmentation is sometimes enhanced by the independent roll of the video screen, as when the jumping artist seems to 'land' along with the picture itself at the bottom of the monitor. The desynchronization Jonas effects is therefore double – in placing the signal and monitor out-of-sync she produces a metaphor for the split between a body and its televised image.

Vertical Roll was part of the 1972 performance *Organic Honey's Vertical Roll* featuring Organic Honey, a hyper-feminine persona dressed in a chiffon dress, feathered and jeweled headgear, and a doll-like mask. Through live action, film, video, and sound this work *spatialized* Jonas's encounters with herself. As the artist described it, the performance 'evolved as I found myself continually investigating my own image in the monitor of my video machine.... I became increasingly obsessed with following the process of my own theatricality....' In other words, a private moment of mirroring is expanded in at least two ways – through its performance before an audience, and through the parodic adoption of stereotypical emblems of femininity such as chiffon,

109. **Joan Jonas**, *Vertical Roll*, 1972

110. **Joan Jonas**, *Organic Honey's Vertical Roll*, 1972

feathers, and a baby-doll physiognomy. Just as Michael Asher mapped the conceptual and physical spaces of the museum in his project for the MCA in Chicago, so Jonas deployed a variety of media to probe the conceptual and physical spaces of femininity. Like many artists who used video in its early days, Jonas was therefore not exclusively a video artist, but an artist who used video as an outgrowth of or a supplement to other practices.

104

Both Richard Serra and Lynda Benglis also made important videotapes in which a body was placed out-of-sync through mechanical reproduction. In Serra's *Boomerang* (1974), the artist Nancy Holt was videotaped trying to speak while simultaneously listening to the slightly delayed audio replay of her own voice – an instance of desynchronization which ultimately led to her confusion and a breakdown in communication which ended the tape. In Benglis's *Now* (1973), the artist established an infinite regress in which she appears on the screen before multiple generations of her own recorded image. As *Boomerang*, *Now*, and *Organic Honey's Vertical Roll* suggest, the video mirror situates psychological narcissism squarely within technologies of mechanical reproduction which proliferate rather than focus

111. **Richard Serra**,
Boomerang, 1974

112. **Lynda Benglis**, *Now*, 1973

images of the performer. Not only is the one-to-one relationship between body and image shattered, but the 'mirror' reflects back not an 'inner self,' but the kind of motley collection of exaggerated gender stereotypes that compose Organic Honey.

Rather than evoking a narcissistic collapse of the self into its reflection, then, the mirroring video art performs tends to heighten the difference between a person and her or his mechanical reproductions. In many cases, as in the 1970 corridor installation by Bruce Nauman, where a viewer seems to flee his own videotaped back, this alienation is experienced as a form of surveillance. Like Nauman, Peter Campus (b. 1937) and Dan Graham (b. 1942) made media installations in which a closed circuit video apparatus 'captures' bodies within public space. In Campus's 1977 installation *aen*, a surprise encounter is orchestrated between the viewer and his or her image which is suddenly projected larger than life and upside down in a darkened gallery. By restricting the focal field of the camera to a narrow band of the room running along the entrance wall, Campus monumentalizes peripheral vision. Rather than confronting the spectator head on, the camera, which is mounted in a corner at shoulder height,

96

113

casts a sidelong glance, recording the viewer only as s/he enters or exits. The effect is both violent – seeing oneself hung upside down as a grainy televisual effigy – and intimate since the only way to remain before the camera's eye is to stay very close to the wall, virtually touching the projection of oneself.

Such a transformation of the viewer into s/he who is viewed had been explored more clinically – almost as a sociological experiment – in Dan Graham's series of *Time Delay Rooms* (1974). In all of these proposed works, only some of which were realized, interactions between audience members co-exist with an overlay of closed circuit video feedback. *Time Delay Room 1*, for instance, consists of two adjoining rooms divided by a wall and connected by a doorway. Each room is surveyed by a closed circuit video camera and each houses two monitors. In Room A

the monitors show two different images of the audience in Room B, one live and the other on a short delay, while in Room B the audience sees itself on delay on one monitor and the audience in Room A live on the other. The *Time Delay Rooms* thus situate video's narcissistic impulse within a social and spatial setting of surveillance and observation – by others as well as by oneself.

As in many video installations the strategy of delay, which replays events from the very recent past, extracts a viewer from her or his ongoing experience – through a kind of flashback – as the camera simultaneously extracts an image from the body. In works like these, video feedback opens a fissure between a self and the representations produced from or by it. Whether in Jonas's *Organic Honey*, the ghostly projections of *aen*, or Graham's displaced audiences, video art demonstrated that every act of mechanical reproduction occurs within a particular spatial, social, and psychological topography. As in much of the art discussed in this chapter, the ostensibly amorphous currency of information is shown to be site-specific, its contingent meanings pointing the way to a contemporary politics of representation.

113. **Peter Campus**, *aen*, 1977

114. **Dan Graham**, *Time Delay Room 1*, 1974

In very different ways, Campus's and Graham's closed circuit video installations incorporate viewers as integral elements, but they do so in order to alienate spectators from their own mediated images. While disorienting, this process provokes social and philosophical questions regarding the distortions endemic to mass media communication.

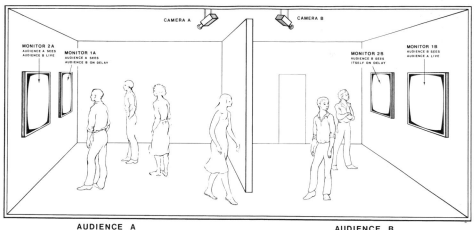

im-age (im′āj), *n.* [OF. F. *image,* < L. *imago (imagin-),* copy, likeness, image, semblance, apparition, conception, idea, akin to *imitari,* E. *imitate.*] A likeness or similitude of something, esp. a representation in the solid form, as a statue or effigy; also, an optical counterpart of an object as produced by reflection, refraction, etc. (see phrases below); also, form, appearance, or semblance (as, "God created man in his own *image,* in the *image* of God created he him": Gen. i. 27); also, an illusion or apparition (archaic); also, a counterpart or copy (as, the child is the *image* of its mother); also, anything considered as representing something else; a symbol or emblem; also, a type or embodiment (as, "An awful *image* of calm power . . . now thou sittest": Shelley's "Prometheus Unbound," i. 296); also, a mental picture or representation, as formed by the memory or imagination; an idea or conception; also, a description of something in speech or writing; in *rhet.,* a figure of speech, esp. a metaphor or a simile.—**real image.**

Chapter 6: The Artist's Properties:
 From Conceptual Art to Identity Politics

A wide range of art objects of the late 1960s and 1970s were produced by chanelling flows of information into systems, processes, and feedback loops. Such transformations in the art *work* presupposed equally significant changes in the art *worker*. No longer aspiring to be masters of a particular medium, many artists began to function as 'managers' or 'producers' of information. For those associated wi th the practices known as Conceptual art – including several of the figures discussed in the previous chapter – this changed relationship between an artist and his or her product became an essential component of aesthetic practice. While later in the 1970s many artists would emphasize the experiences and conditions of particular identities based on gender, ethnicity, race, and sexuality, earlier Conceptual artists – who were predominantly white men – tended to adopt a more universalizing rhetoric in their philosophical propositions about art. In his pivotal essay of 1969, 'Art After Philosophy,' Joseph Kosuth (b. 1945) explicitly stated this position. Kosuth reasoned that since art consists of formal languages or codes, its nature is fundamentally linguistic: 'In other words,' he writes, 'the propositions of art are not factual, but linguistic in *character* – that is, they do not describe the behaviour of physical, or even mental objects; they express definitions of art, or the formal consequences of definitions of art.' Implicit in this passage are the two most influential characterizations of Conceptual art made by Kosuth: that art should consist of the artist's linguistic propositions, and that the content of art should be its own ongoing definition.

The propositional nature of Conceptual art has led many critics to consider its procedures as a 'dematerialization' of the art object. In actuality, however, such practices manifested a new kind of materiality well suited to documenting the intellectual and physical properties of the artist. The work of Lawrence Weiner (b. 1942), for instance, often appeared as linguistic instructions. In 1968 the curator/gallerist Seth Siegelaub, whose international activities did much to crystallize Conceptual art as a movement, published a collection of Weiner's phrases in a small

115. **Joseph Kosuth**, *Titled (Art as Idea as Idea): 'Image,'* 1966

book titled *Statements*. Many of these terse texts functioned as anonymous and curiously anti-imperative prescriptions for producing post-Abstract Expressionist paintings, such as 'ONE QUART EXTERIOR GREEN INDUSTRIAL ENAMEL THROWN ON A BRICK WALL' or 'AN AMOUNT OF PAINT POURED DIRECTLY UPON THE FLOOR AND ALLOWED TO DRY.' In Weiner's *Statements* the actual process of making a painting is rendered unnecessary: it is the *proposition* that functions as art rather than its translation into matter, and for this reason such works have been considered 'immaterial.' But the statements themselves have their own mode of materiality – as language and as a book. Rather than doing away with materiality altogether, Weiner, like most Conceptual artists, replaced traditional artistic media like painting with the 'materials' of information – primarily text and photography. Kosuth himself also substituted information for painting in a well-known series of works from the mid-1960s in which he copied and enlarged a

116. **Lawrence Weiner**, *Statements*, 1968 (cover and sample pages). Like the scores produced by Fluxus artists, Weiner's works consist of statements that may or may not be acted on but, unlike such figures as Yoko Ono or George Brecht, Weiner appropriates the ostensibly neutral rhetoric of law and business.

number of dictionary definitions of symbolically charged words like 'image' and exhibited them on the wall like canvases. Rather than *dematerializing* art, then, Kosuth and Weiner *re-materialized* it, using language and photomechanical reproduction.

115

Despite the anonymity of Weiner's statements or Kosuth's dictionary definitions, propositions cannot arise unless someone makes them and this means that in Conceptual art the artist's intellectual intention – and in many cases also his physical presence – was elevated to the importance that his expression had customarily been accorded in works of art. Like the shift from traditional artistic media to text and photography, this emphasis on intention and presence marks a fundamental change in the nature of the Conceptual art 'object.' As Kosuth puts it in 'Art After Philosophy,' 'A work of art is a tautology in that it is a presentation of the artist's intention, that is, he is saying that a particular work of art *is* art, which means, is a *definition* of art.'

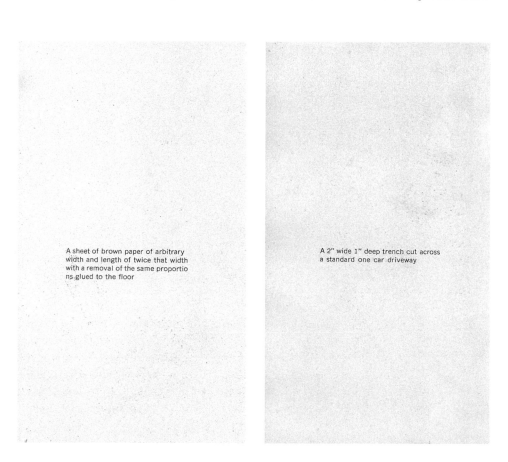

A sheet of brown paper of arbitrary width and length of twice that width with a removal of the same proportions glued to the floor

A 2" wide 1" deep trench cut across a standard one car driveway

163

Kosuth's point is simple: when the work of art becomes tautological, the role of the artist is to guarantee with his *intention* both the authenticity of a particular piece and also the very definition of art which it illustrates. Nor is this insistence on the centrality of intention limited to Kosuth. Soon after Weiner began 'exhibiting' his statements, he decided to append the following proviso to all of his works:

The artist may construct the piece.
The piece may be fabricated.
The piece need not be built.
Each being equal and consistent with the intent of the artist, the
decision as to condition rests with the receiver upon the occasion of
receivership.

Whereas, on the one hand, this pseudo-contractual covenant appears to shift the responsibility for producing Weiner's projects from artist to 'receiver' (a category encompassing collectors and curators as well as viewers), this choice is *granted* by the artist and *guaranteed* by his intention. The work of Conceptual art may remain indeterminate precisely because this indeterminacy is 'consistent with the *intent* of the artist' [my emphasis].

Sol LeWitt, who along with Kosuth was an early theorist of Conceptual art, wrote in an important 1969 text, 'A work of art may be understood as a conductor from the artist's mind to the viewer's. But it may never reach the viewer, or it may never leave the artist's mind.' Here again material gesture is displaced by a virtually telepathic act of communication – a possibility which Robert Barry literalized in the same year in another project organized by Seth Siegelaub for the Simon Fraser University in Vancouver. Barry described his 'telepathic piece' as follows: 'During the exhibition I shall try to communicate telepathically a work of art, the nature of which is a series of thoughts; they are not applicable to language or image.' As immaterial as it may seem, such communication could not take place without the presence of the artist.

The work of Kosuth, Weiner, LeWitt, Barry and others thus only appears to evacuate the 'subjective' from their art, for they return again and again to the artist's personal intention and physical presence. Consequently, the Conceptual artwork is offered as a contract between artist and viewer. As Benjamin H. D. Buchloh has argued with regard to Conceptual artworks, the creator of Conceptual art functioned as a pseudo-legal entity serving as the guarantor of a work's authenticity. It makes sense

therefore that in 1971 Siegelaub, whose exhibition and publishing activities were fundamental to establishing an international profile for Conceptual art, produced 'The Artist's Reserved Rights Transfer and Sale Agreement' with the attorney Bob Projansky. A parallel between this literal contract and the contractual redefinitions of the artist's role undertaken by Kosuth, Weiner and others is suggested by the Agreement's publication in the catalogue for the major international exhibition 'Documenta V' in 1972 as a pseudo-artwork, or what Siegelaub called a 'Contract-poster.' The objective of the contract was to insure an artist's rights to control the reproduction and exhibition of his or her art. Although it was available free of charge to anyone, including traditional painters and sculptors, the urgency of establishing such rights of authorship in 1971 must have derived from the shift from objects to linguistic propositions characteristic of Conceptual art. Indeed, anyone could produce an unauthorized version of a Weiner, Kosuth, Barry, or LeWitt as attested by the fact that the first exhibition of a Weiner text on a wall – which was later to become one of the artist's preferred modes of presentation – was initiated by a collector who duly solicited Weiner's permission.

The notion of art as a sequence of philosophical propositions thus has a double edge. Whereas, on the one hand, it suggests a scientific or logical universality in which the individual voice of the artist is eclipsed by faceless social authorities, like Joseph Kosuth's dictionary, it also leads the viewer back to the artist's intellectual and physical person. Much of Conceptual art might therefore be understood as an effort to chart the boundaries of the self as a logical, sociological, or legal entity – just as objects themselves were redefined as a function of social and material processes during these years and by these and related artists. This rethinking of selfhood was carried in two complementary directions during the late 1960s and 1970s – toward activist agitation for artists' rights on the one hand, and toward a dramatization of the artist's presence through the manipulation of his body as an aesthetic property on the other.

Prominent among agitators for artists' rights were the Art Workers' Coalition (AWC), which emerged in 1969, and its more radical wing, the Guerrilla Art Action Group (GAAG). Like many oppositional groups of the 1960s, the AWC was a loosely formed coalition of artists who met periodically and whose program remained fluid. The organization crystallized in 1969 around the Greek artist Takis's removal of his work *Tele-*

Sculpture (1960) from 'The Machine as Seen at the End of the Mechanical Age' exhibition at the Museum of Modern Art in New York. Although MoMA owned the piece, the artist had explicitly asked that *Tele-Sculpture* not be exhibited in this context. When the museum refused to comply with his wishes, Takis seized the work from MoMA's galleries. Solidarity with his effort to influence the public life of his own art inspired the AWC's series of demands to MoMA and other prominent New York museums. These included making gallery admission free, diversifying boards of trustees, exhibiting Black, Puerto Rican, and women artists, and extending programming into communities of color. The AWC also demanded accountability on the part of museum professionals regarding their aesthetic choices and programs, and advocated policies whereby artists retained rights over the presentation of their art after its sale, including the institution of rental fees when works were to be shown in museums, and a percentage of profit in the event of re-sale.

The GAAG, whose core members included Poppy Johnson, Jon Hendricks, and Jean Toche, embraced both of the strategies

117. **Guerrilla Art Action Group**, action in front of the Metropolitan Museum of Art, New York, ridiculing the exhibition 'New York Painting and Sculpture: 1940–1970,' October 16, 1969. The Guerrilla Art Action Group applied many of the techniques associated with body art and conceptual art to actions intended to protest art world politics which, in their view, reflected the broader cultural conflicts characterizing American life in the 1960s and '70s.

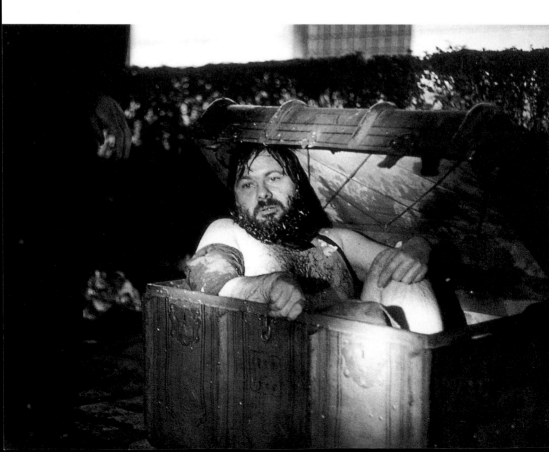

emerging from Conceptual art mentioned earlier – political demands based on artists' rights and a preoccupation with the artist's physical presence. In their manifesto of March 18, 1970, Johnson, Hendricks, and Toche proclaimed, 'Our art actions are a concept,' suggesting a direct lineage between their agitational goals and the philosophical stakes of Conceptual art. They end the text by declaring, 'Our concern is with people, not property, or any form of property. We question the … fact that property – how to defend property and how to expand property – always seems to have priority over people and people's needs.' In the first GAAG action of 1969 the line between the artist's person and his or her transformation into property was heightened traumatically. On the opening night of the exhibition 'New York Painting and Sculpture: 1940–1970' at the Metropolitan Museum in New York, Hendricks, dressed in black tie as a 'curator,' and Toche playing the character of 'artist,' undertook a guerrilla performance on Fifth Avenue amidst well-dressed patrons entering the museum to attend the opening party inside. The 'curator' stuffed the 'artist' into a trunk and proceeded to humiliate him by covering him with the kinds of fancy hors d'oeuvres, ranging from shrimp to caviar, that were being served inside to the arriving patrons. The goal of the piece was to provoke the curator of the exhibition, Henry Geldzahler, into taking a stand on the influence of corporate sponsorship (Xerox had contributed $150,000 to the project). In other words, the artists were protesting their transformation into an elite commodity 'sold' to the public by big business.

Testing the limits of the body through a spectacular performance, as GAAG had done in its protest, was a strategy also used by some of the most prominent male body artists of the 1970s. Vito Acconci (b. 1940), for instance, whose video and performance pieces probed his own physical and psychological limits as well as those of others, laid claim to his naked flesh in a work of 1970 titled *Trademarks*. In this piece Acconci was photographed while biting as many parts of his nude body as he could reach with his mouth. The indentations made by his teeth were then inked and pressed against paper to make prints – a traditional product of the artist. By titling this work *Trademarks*, Acconci marks his own body as a legally sanctioned product while suffusing the gesture with an atavistic and auto-erotic urge to 'consume' himself in a manner different from the production of art. As Acconci himself put it in a 1971 interview: 'The look of the piece was me constantly turning in on myself.... Therefore, I was … making a

118

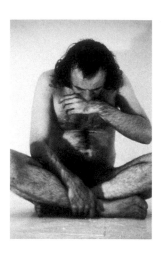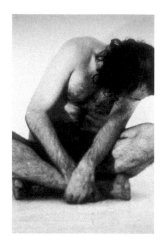

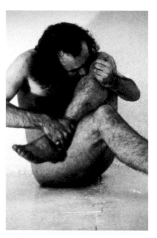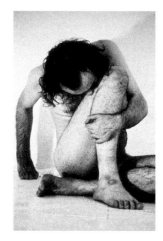

118. **Vito Acconci**,
Trademarks, 1970

168

closed system and then presenting the possiblity of opening that system with the print.' Like the video artists discussed in the previous chapter, Acconci, who himself made significant works in that medium, creates a feedback loop – but here the material basis of the closed circuit is his own flesh, his 'trademark' material. In the art of Chris Burden (b. 1946), the dimension of pain and endurance, which is one component of Acconci's *Trademarks*, is further heightened. In his most notorious piece, *Shoot* (1971), Burden had himself shot in the arm by a friend before a small group of people. Despite the melodrama of this action, the resulting artwork consisted only of sober photographic and textual documentation of the event, suggesting a virtually clinical assessment of the limits of subjectivity.

The actions of Acconci and Burden serve as complements to the propositional art discussed at the outset of this section. If in making an art of statements Joseph Kosuth and Lawrence Weiner established a contractual relationship with the viewer in order to underwrite their 'intellectual property,' the art of

119. **Chris Burden**, *Shoot*,
F-Space, Santa Ana, California,
November 19, 1971

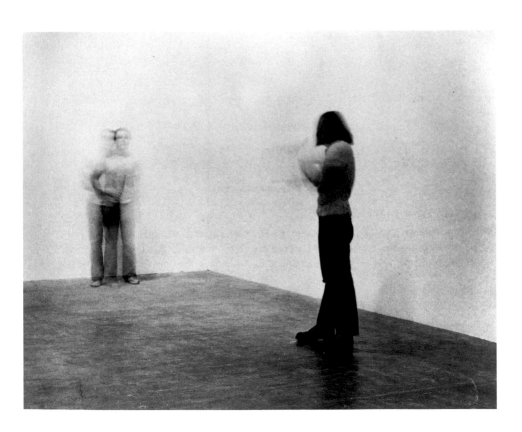

VARIABLE PIECE No. 20
Bradford, Massachusetts

On January 23, 1971, for eleven minutes, the specific physical location of the artist was photographically documented at exact 30 second intervals as, at each of those instants, he relocated himself within an extremely fluid spatial environment. 23 photographs join with this statement to constitute the form of this piece.

January, 1971 Douglas Huebler

Acconci and Burden establishes what Kathy O'Dell has called a 'contract with the skin' in which the artist's 'physical property' – his body – is assessed through an ostensibly masochistic act. As in the Conceptual art strategies which emphasize mental *intention*, those procedures which pivot on physical *presence* explore the conditions of selfhood in a world flooded with information.

The so-called dematerialization of art thus encompasses two kinds of displacement. First, artworks were reinvented as extensions of an artist's intellectual and physical 'property,' and second the consequent emphasis on propositions or body art required a shift from traditional practices like painting and sculpture to new information-oriented media like photography, video, and text. On account of their resemblance to reportage, such media were often called 'documentation,' underlining their secondary status as evidence. A number of ostensibly diaristic works of the 1970s which resemble surveillance more closely than confessional autobiography, demonstrate these dual displacements. In *Variable Piece no. 20* (1971), for instance, Douglas Huebler (1924–97) had himself photographed every thirty seconds for a period of eleven minutes while playing basketball. The resulting artwork consists of twenty-three 'surveillance' photographs and an explanatory text. Since these pictures center on the artist's body, rather than attempting to map the progress of the game from play to play, they offer an incomplete lexicon, or archive, of Huebler's unconscious athletic poses. The artist's experience is at once rendered banal – he is participating in an ordinary amateur basketball game – and impossible to capture in the relatively impoverished information of photo and text.

From 1968 to 1979 On Kawara (b. 1933) undertook an analogous project documenting the diurnal rhythms of his body. In *I Got Up At* Kawara sent two postcards every day to two people of his choosing, stating the time he woke up along with the date and the address where he was staying on that day. In this work Kawara framed the intimacies of the body – its changing patterns of sleep and wakefulness – within the 'objective' logic of the calendar, the clock, and the postal system. By creating what the critic Josh Dechter has poetically called an 'archive of the self,' Kawara's work, like Huebler's and others associated with Conceptual art, articulates the convergence of the 'information artist' and the 'artist as information.'

121

120. **Douglas Huebler**, *Variable Piece no. 20*, 1971

DOWNTOWN COLUMBUS

THIS EXCITING AERIAL PHOTOGRAPH LOOKS
WEST TO DOWNTOWN COLUMBUS, OHIO AND
SHOWS THE NEW BUILDINGS AND DYNAMIC
GROWTH OF OHIO'S CAPITAL CITY.

OCT 13 1973

I GOT UP AT
9.58 A.M.

On Kawara
Imperial '400' Motel
665 W. Broad St.,
Columbus, Ohio,
U.S.A.

Photo by Lane Aviation Corp.
85765-C

Pub. by Aladdin Studio, 221-7253, Columbus, Ohio 43201

LIBERTY FOR ALL

US AIR MAIL 15¢

Post Card

KONRAD FISCHER
4 DÜSSELDORF
NEUBRÜCKSTR. 12

W. GERMANY

AIR MAIL

MADE BY
DEXTER PRESS, INC.
WEST NYACK, NEW YORK

dp

Feminist Personae

Many male Conceptual artists regarded their aesthetic propositions and their physical presence as private property. But during the 1960s and '70s the Women's movement demonstrated that the privilege of 'possessing' one's own body had not been shared equally by men and women through history. Around 1970 feminists like art historian Linda Nochlin began to ask why, given the prevalence of the female nude, there had been so few women *artists* celebrated for their depiction of the nude or any other subject. In other words, women began to question why the representation of their persons and their experiences had been predominantly framed by men for whom feminine desirability was more significant than the intellectual or creative potency of women. Inspired by the widespread questioning of women's roles across society, many artists began to explore the objectification of their bodies as a form of oppression, in sharp contrast to the free philosophical speculation which their male colleagues applied to their own aesthetic intentionality and physical presence. Often such works were painful reiterations of explicit or implicit violence directed toward women, as in *Rape Scene* (1973) by Ana Mendieta (1948–85), in which the artist

121. **On Kawara**,
I Got Up At 9:58 A.M.,
1973 (recto and verso)

122. **Ana Mendieta**,
Rape Scene, April, 1973

positioned herself slumped over a table, underwear around her ankles and blood-streaked buttocks exposed, forcing her unsuspecting audience to encounter a scene of sexual violation. Unlike Chris Burden's *Shoot*, where the artist's test of his own endurance served to bolster rather than to undermine his self-possession, Mendieta's performance represents feminine subjectivity as threatened by forces outside of itself.

119

Using the photographic and textual techniques of Conceptual art, *Carving: A Traditional Sculpture* (1972) by Eleanor Antin (b. 1935) similarly embodies the external pressures and threats brought to bear on women's lives, but here the 'violence' is internalized and ideological. *Carving* consists of 144 mugshot-like photographs of the front, back and both sides of Antin's nude body taken daily to document her weight loss of ten pounds over the course of thirty-six days. By subtitling this work *A Traditional Sculpture*, Antin links her personal regimen to the cultural ideals of physical beauty which animate high art as well as popular culture. Like On Kawara in *I Got Up At*, Antin makes documentation of her body, but unlike the freedom implicit in Kawara's differing hours of awakening and his geographical mobility, Antin imagines herself as under surveillance – not by any single authority, but by the ubiquitous codes of feminine

123. **Eleanor Antin**, *Carving: A Traditional Sculpture*, 1972 (detail)

beauty. *Carving* suggests that embodying ideals of beauty requires grueling effort and that this effort is compulsory – like the punishment meted out to a criminal.

If Conceptual art defined the artist as a quasi-legal entity constituted by its intellectual and physical property, feminist artists worked to articulate those gender-based inequities which determined who could and who could not possess this property. One way of dramatizing this difference was to insist upon the painful objectification of women's bodies as in *Rape Scene* and *Carving*. But Mendieta and Antin, as well as others like Lynn Hershman (b. 1941), Adrian Piper (b. 1948), and Hannah Wilke (1940–93), also approached the question of selfhood from a more playful perspective – as a question of assumed personae, rather than stable identities. Throughout the 1970s Antin adopted several alter-egos in her performances and videotapes. She crafted a male character, the King of Solana Beach, who surveyed his 'kingdom' – a beach community near San Diego – dressed in a long black beard, floppy hat and cape, and, as a counterpoint to this appropriation of ancient male privilege, Antin made several works in which she explored the historical and psycho-sexual attributes of that paradigmatic feminine helper, the nurse. Later in the 1970s, she invented the character of Eleanora Antinova, an

124. Eleanor Antin,
photodocumentation of *The King of Solana Beach*, 1974–5

126. **Adrian Piper**, *The Mythic Being, Cycle I: 4/12/68*, 1974. In 'exhibiting' her Mythic Being persona as a classified ad among announcements for art shows in the *Village Voice*, Piper acknowledged the role of celebrity and commerce in the artist's persona at the same time as, in masquerading as a macho black man, she called attention to the intersections of race and gender which condition identity.

African-American ballerina who danced for the famous impresario Diaghilev in his Ballets Russes. Through these various transvestisms of gender, ethnicity, and profession, Antin dramatized unequal distributions of privilege while nevertheless suggesting that individual identity remains malleable.

If Antin's alter-egos consistently embodied aspiration, Lynn Hershman's persona, Roberta Breitmore, whom the artist describes as a 'portrait of alienation and loneliness,' exemplifies the failure of normative femininity. Breitmore's character, projected onto Hershman's body in real life situations through props such as wig and wardrobe, and documented through a series of altered photographs, is a divorcee who in moving to San Francisco (Hershman's place of residence) haplessly stumbles through experiences like placing an ad for a roommate, undergoing psychotherapy, and joining Weight Watchers (only to gain rather than lose weight). Hershman has likened her multi-year evocation of Roberta Breitmore to an anthropological investigation. And indeed, like Antin's characters, Hershman's persona is emphatically not autobiographical but rather meant to serve as a heuristic object dramatizing the trials and disappointments of American women in the mid-1970s.

By projecting various characters onto their persons, feminists like Antin and Hershman suggest that identity is not simply the physical manifestation of an 'inner' personality. This denaturalization of subjectivity accomplished by driving a wedge between psychological models of selfhood and physical appearance is intended to serve powerful political purposes. For if feminists recognized that women had been oppressed through history by

125. **Lynn Hershman**, *Roberta Interviewing B.P. in Union Square, November 1, 1975*, 1976. In documents which resemble surveillance photographs, Hershman tracked her fictional persona, Roberta Breitmore, as she moved through everyday activities like interviewing potential roommates.

the stereotypical and objectified roles they were expected to play, then there is a liberatory potential in demonstrating that these roles may be transformed – and, with effort, changed.

Both Adrian Piper and Hannah Wilke made important works in the 1970s which articulated the lack of congruency between emotional states and stereotypical identities. In a series of Piper's impersonations of the 'Mythic Being,' for instance, a macho African-American persona wearing a prominent Afro, facial hair and reflective sunglasses is jarringly endowed with the thoughts and musings of an intellectual African-American woman (Piper 'herself'). In a series of advertisements placed monthly in the art section of the *Village Voice*, Piper reproduced a photograph of herself as the Mythic Being paired with a thought balloon quoting a randomly chosen passage from her journals of the previous fourteen years. The surreal juxtaposition of an ostensibly aggressive 'male' persona and his vulnerable 'feminine' reflections was mirrored by an additional private component of the work in which each month Piper memorized the autobiographical passage quoted in her ad. By repeating this fragment of her own history over and over again like a mantra, she sought to alienate her own thoughts. As Piper stated in a text of 1974, '[The passage] becomes an object for me to contemplate and simultaneously loses its status as an element in my own personality or subjecthood.' In other words, just as the macho surfaces of the Mythic Being are undercut by his 'thoughts,' Piper undermines her own self-possession by objectifying her relation to her own intimate diaries. The fact that she does so in the context of an art advertisement suggests that this process of self-objectification is a fundamental element of aesthetic practice.

Piper's complex shuttling between psychological interior and physical envelope is embodied literally in Hannah Wilke's *S.O.S.-Starification Object Series* (1974), in which the artist puns on tribal procedures of scarification as a form of social mapping on the body's surface. *S.O.S.* consists of an array of photographs of a topless Wilke provocatively striking stereotypical poses, some excessively 'feminine' and others aggressively 'masculine.' In each picture Wilke marks her body with patterns composed of crescents of masticated chewing gum whose vaginal forms suggest an exfoliation of the most private – and tabooed – regions of the body. Indeed, Wilke has stressed this slippage between inner and outer psychological and physical states in a text of 1976 in which she writes, 'Starification-scarification/Jew, Black, Christian, Moslem ... internal wounds, made from external

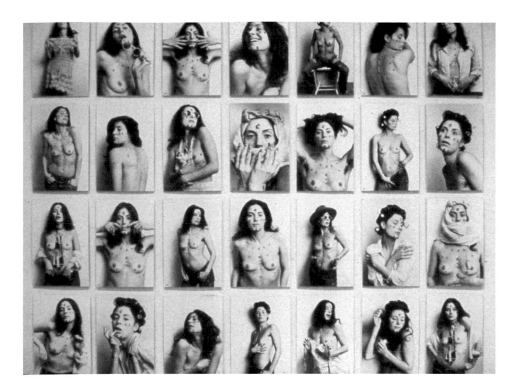

127. **Hannah Wilke**, *S.O.S.-Starification Object Series*, 1974

situations.' In making the wound erotic, Wilke suggests a very serious politics of pleasure. By naming her procedures of self-marking 'starification' she implies that it is through the exigencies of attracting attention through beauty – by becoming a 'star' – that, as Eleanor Antin suggests in *Carving*, a woman experiences ideological wounding.

Wilke's deployment of vaginal forms points to one of the central debates among feminist artists of the 1970s and '80s – namely, how to represent femininity without limiting its definition to a simple-minded biological determinism in which a woman's identity is elided with her anatomy. Building from the insights of the philosopher Judith Butler, art historian Amelia Jones has delineated this paradox as a clash between the political necessity of establishing coalitions among women based on shared experience and the countervailing desire to shatter those conventional notions of femininity which may provide a basis for collective identification. For feminists, then, the concept of 'woman' had to be simultaneously defined and broken down.

'Womanhouse,' a collection of installations and performances produced in a refurbished Los Angeles house in 1971–2,

123

exemplifies the complexity of this paradox. Undertaken by the students of Judy Chicago and Miriam Schapiro's pioneering Feminist Art Program at the California Institute of the Arts, 'Womanhouse' exaggerated the roles of women as mothers and housekeepers in order to both embrace an undervalued form of feminine labor and to demonstrate its roots in oppressive stereotype. To this purpose, site-specific works were made in different rooms in the house, ranging from kitchen to bedroom. Viewed as pendants, two bathrooms in 'Womanhouse' – Chicago's *Menstruation Bathroom* (1972), littered with feminine hygiene products and blood-smeared tampons, and Camille Grey's *Lipstick Bathroom* (1972), completely saturated with bright red lipstick – exemplify the crossing of biological and cultural modes of identity. In Chicago's work the 'management' of menstruation through a wide array of commodities meant to sanitize it is dramatized, and in Grey's piece, a cosmetic is 'misused' to transform the intimate space of the bathroom into a kind of womb.

128. **Judy Chicago**,
Menstruation Bathroom, 1972

129. **Camille Grey**,
Lipstick Bathroom, 1972

130. **Judy Chicago**,
The Dinner Party, 1979

131. **Mary Kelly**, *Post-Partum Document, Documentation II: Analysed Utterances and Related Speech Events*, 1975. Kelly's *Post-Partum Document* represents the child's acquisition of language as a journey through various modes of social and medical assessment. In this section of the multi-part work, typesetting serves as a metaphor for both the psychological imprinting experienced by children, and a mother's translation of her son's utterances.

In both works the line between the biological and the social – as represented by intimate products marketed to women – is shown to be enormously porous. Later in the decade, Chicago's notorious *Dinner Party* (1979) emerged as the epitome of so-called 'cunt art' in which feminine identity and anatomy were nearly elided. *The Dinner Party*, composed in part of thirty-nine plates with explicitly vaginal imagery honoring thirty-nine women from prehistory to the early twentieth century, was also rooted in and complemented by a serious research effort aimed at identifying and reclaiming hundreds of female historical figures, another 999 of whom are commemorated on the work's porcelain tile floor. Although it was enormously popular with the general public, Chicago's *Dinner Party* drew criticism from many feminists for what they believed to be its 'essentialism,' or its association between women and an essential biological quality like the possession of a vagina.

While such complaints typically underestimate the complexities of Chicago's work, they point usefully to the tension between biological and social or psychological determinants of selfhood which characterize most of the feminist art discussed in this section. If *The Dinner Party* has been consigned to essentialism, *The Post-Partum Document* (1973–9) by Mary Kelly (b. 1941) represents an opposing end of the spectrum. *The Post-Partum Document* is a complex and multi-layered meditation on the

UTTERANCE /SIYEH BE-BE DERE/
GLOSS 'SEE BABY THERE'
FUNCTION EXISTENCE
AGE 19.0 MAR 6 1975

T7 26.4.75

```
      CONTEXT: M(mother) getting K(son) dressed.        09.30 HRS.
      SPEECH EVENT(S)                    /siyeh be-be dere/R23
23.1 K. /shu/ shu/ (trying to dress himself)
     M. That's right, shoes.
        What's this? (picture of K's first birthday)
     K. /ah/ be-be dere/ be-be/ be-be/ be-be/ (excitedly)
        /siyeh be-be dere/
     M. Let's put it back now. (R wants to save it)
     K. /weh da be-be/ weh da be-be/
     M. All gone.
     K. /ma-ma/ weh da be-be/ (crying)
     M. Shh, be quiet. (deciding to let him have it)
     K. /dere/ e be-be/ e be-be dere/
     MOST FREQUENT UTTERANCES:   /weh da be-be/ siyeh be-be dere/
     MEAN LENGTH OF UTTERANCE: 2.38                    19 months
```

mother-child relationship from the period of a child's infancy through his acquisition of language. Despite its ostensibly biological topic – child-rearing – and Kelly's documentation of her own son's development, this work is first and foremost a psychoanalytically inflected and philosophical investigation into the social determinants of the relationship between mother and child. *Documentation II: Analysed Utterances and Related Speech Events* (1975), one of six series composing *The Post-Partum Document*, exemplifies the work's complex model of language. *Documentation II* traces the transition from single-word utterances to patterned speech which occurred during the child's seventeenth and eighteenth months. Each individual piece within the series consists of two components: a typewritten sheet of 'raw data' enumerating the context and content of the child's speech event joined to a vertical section of a typesetting tray in which blocks of type (with reversed characters) are displayed above an imprint of the text they spell out summarizing the data below within the following categories: Utterance, Gloss, Function, and Age. These visually modest works, entirely composed of letters and words, constitute several layers of socio-linguistic relationships. The raw data records a 'conversation' between a child and his mother, in which the mother prompts and instructs him. In her analysis of a phrase, which is transcribed in the upper section of the work, the mother shifts her role from interlocuter to interpreter of her child's otherwise incoherent utterance. She, for instance, concludes in one piece that 'Ma-Ma' may be glossed as 'Help me, see this, be there' and that this statement signifies an assertion of the child's existence. But in adopting this pseudo-scientific rhetoric, Kelly (while all the while addressing the viewer in her role as an artist) shifts her voice from that of the nurturing mother to that of the expert in developmental linguistics, or the family doctor, concerned not with the personality of an individual child, but rather with his position within the norms and averages for language acquisition for his age group. Kelly thus demonstrates how the biological drives which animate motherhood are captured and channelled within a sophisticated array of social discourses.

Reframing the Stereotype

One of the primary stakes in the feminist debates around essentialism and so-called 'cunt art' was an effort to redeem negative stereotypes. Instead of accepting cultural norms that rendered women's sexuality both shameful and the exclusive property of

men, feminists embraced their bodies as a site of struggle and a source of identity. But given the hurtful and negative connotations of a word like 'cunt,' why use it at all? Why reiterate a brutal stereotype which crudely reduces a woman to a sexual object? The answer is simple, if unfortunate: most minority groups in the United States have had little choice but to confront those stereotypes which delimit their public identities. Conceptual art certainly explored and articulated the artist's relationship to his intellectual and physical property, but as women and people of color are well aware, one does not necessarily 'possess' one's own 'properties' as a self. By definition, a stereotype is an image which is beyond the control of any particular individual: it is an oppressive *public* property. In a culture where the experience of community is largely produced through identification with mass media representations, gaining control over such stereotypes can be an urgent political project.

During the late 1960s, the demands for legal reform characteristic of the Civil Rights Movement of the 1950s and early 1960s gave way to more radical cultural claims, like those of Black Power, which asserted the values and aesthetics of African-American life as separate from – and a profound challenge to – Anglo America. Some artists, such as Dana Chandler (b. 1941), developed a powerful graphic vocabulary of African-American dissent which was closely linked to assertions of potent masculinity. But others, such as Betye Saar (b. 1929), David Hammons (b. 1943), and Faith Ringgold (b. 1930) recognized

132. **Dana C. Chandler, Jr.**, *American Penal System... Pan-African Concentration Camps and Death Houses*, 1971. With the force and visual economy of a poster, Chandler's work elides racism with emasculation. Here stereotypes are turned against themselves in the service of a political cause.

that before one could arrive at a new iconography of African-American life, destructive stereotypes needed to be addressed.

A delicate balance is necessary when confronting visual stereotype. On the one hand, an artist must quote the offending image, and on the other hand he or she must endow it with new and affirmative meanings. In her important work of 1972, *The Liberation of Aunt Jemima*, Betye Saar transformed a mythic image of black subservience into an emblem of power and defiance. Aunt Jemima is known to virtually every American as the persona used to brand a popular pancake mix and syrup. Her character is based on the exaggerated figure of the 'Mammy' invented by whites during the era of slavery as the epitome of a

compliant and motherly household servant whose duties typically included caring for her master's children. Like other offensive characterizations of African-Americans, such as the Sambo or Uncle Tom, the Mammy was 'memorialized' or parodied in a wide range of collectible objects like figurines or cookie jars. *The Liberation of Aunt Jemima* centers on one such object: a notepad in the shape of a Mammy mounted in a shallow box which, instead of containing a pad of paper, frames an additional image of the stereotypical servant gripping a crying white baby. Saar heightens one of the fundamental characteristics of a stereotype – its widespread circulation – by lining the box with a grid of product labels illustrating Aunt Jemima. However, rather than merely demonstrating the ubiquity of the image, the artist shifts its polarity by leaning a rifle against the Mammy's left side to balance the broom in her right hand, and by mounting a large black fist – the emblem of black power – in front of the notepad.

If Saar recoded a stereotype by transforming it from a figure of subservience to one of defiant militancy, in works of the same

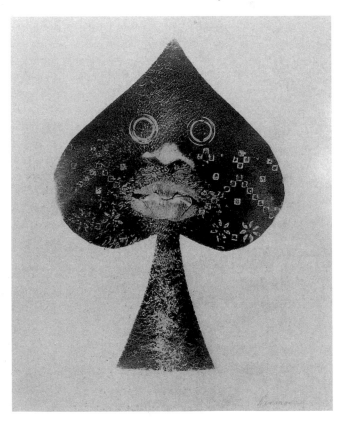

134. **David Hammons**,
Spade, 1974

period David Hammons defamiliarized a racist slur – namely the term 'spade' – through punning and abstraction. As Hammons claimed with faux naïveté in 1986, 'I was trying to figure out why Black people were called spades, as opposed to clubs. Because I remember being called a spade once, and I didn't know what it meant; nigger I knew but spade I still don't. So I just took the shape, and started painting it.... I got all of these shovels and made masks out of them.' If Saar cited the conventional image of Aunt Jemima in order to reverse its values, Hammons shattered the fixity of the term 'spade' as a racist epithet by demonstrating the fluidity and arbitrary nature of its connotations. *Spade* (1974) 134 is one of a series of haunting body prints Hammons made by coating himself with margarine or grease, pressing against paper and then applying pigment to the surface where it could adhere only to oily areas, giving the impression of a figure imprisoned inside the page. In *Spade* a smashed face, made almost comical through a pair of perfectly round cartoon eyes, is cut into the familiar shape of a playing card spade. In this work Hammons simultaneously suggests a literal act of imprisonment in which the the self is pressed into the contours of a graphic stereotype, but also a parodic transformation of the virulent spade-as-stereotype into the innocuous spade-as-playing card. The series of sculptures Hammons made with shovels – another kind of spade – similarly

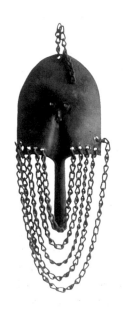

135. **David Hammons**, *Spade with Chains*, 1973

defamiliarized the slur by evoking its violence while simultaneously deflating it with mordant humor. *Spade with Chains* (1973), for instance, consists of an upturned shovel head resembling an African mask marked with round eyes and adorned with looping chains. In this work three registers of meaning are superimposed – an affirmative allusion to African art, a tragic reference to bondage and hard labor recalling American slavery, and a linguistic displacement from the connotative meaning of 'spade' as a slur to one of its alternative denotations as a shovel.

Undermining a stereotype is only half the battle. Equally important among African-American artists were efforts to invent an affirmative aesthetic vocabulary capable of encompassing black culture's alternate forms of community. Hammons accomplished this in a variety of ways. He made a series of tapestries recalling African arts by weaving discarded African-American hair gleaned from barbershops into open grids, and over several years he made informal sculptures on the streets of Harlem from discarded wine bottles placed on the branches of trees.

Faith Ringgold's paintings of the 1960s, like Saar's and Hammons's art, sought to identify and condemn racism. *Flag for*

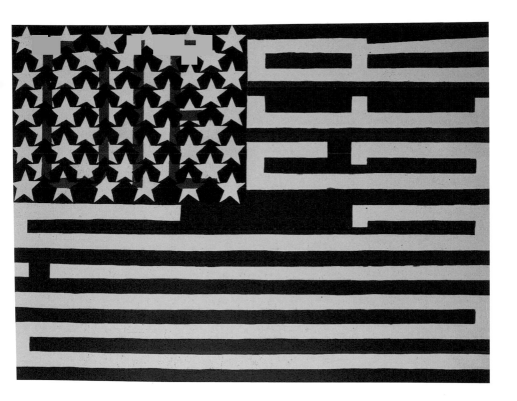

136. **Faith Ringgold**, *Flag for the Moon: Die Nigger Black Light #10*, 1969

the Moon: Die Nigger Black Light #10 (1969), for instance, interwove the painful imperative 'Die Nigger' into the stars and stripes of the American flag, suggesting that ethnic strife absolutely saturated national identity. In the 1970s and '80s Ringgold adopted techniques traditionally associated with women's crafts, such as soft sculpture and quilting, to chronicle aspects of African-American life. Her soft sculptures, derived from the formal vocabulary of African masks but representing typical characters from Ringgold's Harlem neighborhood, were often activated like props as part of the artist's lecture performances. Unlike paintings, these fabric works could be easily and inexpensively transported in the artist's luggage. Ringgold travelled widely in the United States using the lecture/performance format as an opportunity to communicate not only with art audiences, but also with students and community groups. In a work such as *The Wake and Resurrection of the Bicentennial Negro* (1976) for instance, which consists of two female mourners standing over two bodies – a deceased male junkie and his sister who 'died of grief' – Ringgold resurrected the young man in performance

137

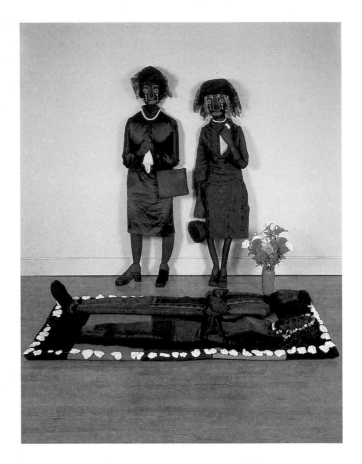

137. **Faith Ringgold**,
The Wake and Resurrection of the Bicentennial Negro, 1976. Ringgold's soft sculptures, which are constructed through craft-oriented techniques sometimes dismissed as 'women's work,' simultaneously allude to African art and African-American life. While they stand on their own in museums or galleries, the artist has animated these works in lecture-demonstrations in order to dramatize issues that affect African-American communities.

to discuss the destructive consequences of drug use among African-Americans.

Like the Feminist Art Program's 'Womanhouse,' which explored the subjugation of feminine labor in the very site of such oppression – the single family home – Ringgold's and Hammons's efforts to build alternative audiences and communities is essential to their art. In the 1970s, as to this day, the art establishment is overwhelmingly male and white. While museums, galleries, and critics have come to accept and even to celebrate the philosophical challenges to selfhood launched by Conceptual art, more explicitly politicized issues of identity are consistently met with skepticism. Beyond reframing vicious stereotypes, then, the art of women and people of color has had to seize public space in order to communicate its messages at all, often by establishing alternative institutions or through the organization of guerrilla actions. The Chicano artist's collective,

Asco [the Spanish word for 'disgust'], whose founding members included Harry Gamboa, Jr., Gronk, Willie Herrón, and Patssi Valdez, developed a variety of such strategies. In a series of 'walking murals' in the early 1970s the group staged flamboyant and politically astute street performances in the heart of the predominantly Chicano neighborhood of East Los Angeles. In *Stations of the Cross* (1971), for instance, they organized an updated Mexican Christmas pageant to protest the disproportionate number of Chicanos sent to fight and die in the Vietnam War. The festive and satirical parade, including a skull-faced Christ and a clown-like Pope, culminated in a parodic performance of final rites and the placement of a 15-foot (4.5 m) cardboard cross at the door of a Marine Recruitment center.

This literal seizure of the street through performance – which was particularly charged given the tense relations between the Los Angeles Police Department and East LA residents – was matched by another of Asco's series of works which imaginatively colonized the *media* public sphere. In *Decoy Gang War Victim* (1974), the group staged a photograph of a gang shooting and distributed it to various media outlets. This ploy was double-edged: on the one hand it was meant to forestall actual gang retribution by substituting a simulated murder for the real thing, but on the other, it was intended to dramatize the media's assumption of the worst about violence in the Chicano community. Indeed, one LA television channel broadcast the picture as news, poignantly making Asco's point that stereotypes have a life of their own and that to 'kill' them requires positive action. If Conceptual art of the 1970s sought to probe the physical and intellectual properties of the self, the women and artists of color discussed in these last two sections demonstrate that an identity is not necessarily one's own to possess: sometimes it is the 'public property' of stereotype that must be challenged and reclaimed.

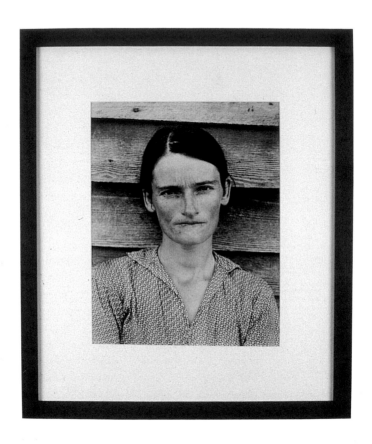

Chapter 7: Commodity Lifestyles:
From Appropriation to the Posthuman

Surfaces of Information

In their citation and transformation of oppressive stereotypes, the women and artists of color discussed in the previous chapter demonstrate that media worlds are fueled as much by *mis*-information as by information. Indeed, while many artists in the 1960s and '70s turned to text and photography as rational means of critiquing traditional aesthetics, others began to question the neutrality of such informational media. The artists addressed in this section came of age in a world saturated by commercially generated imagery, like advertising, in which pictures and words are deployed in order to persuade, or even to deceive, rather than to enlighten their audiences. Instead of carrying the special truth value that Conceptual artists conferred on photography, text, and video, these media were considered deeply conventional – and themselves commodified – by many artists of the 1980s. Like tourist snapshots that recreate postcard views, the typical late twentieth-century photograph was considered to be little more than the citation of a tradition – a picture of a picture, or according to the influential French philosopher Jean Baudrillard, a 'simulation.'

138. **Sherrie Levine**, *After Walker Evans # 4*, 1981

139. **Martha Rosler**, *The Bowery in Two Inadequate Descriptive Systems*, 1974–5 (detail)

The Bowery in Two Inadequate Descriptive Systems, an important work of 1974–5 by Martha Rosler (b. 1943), was one of the first to demonstrate the arbitrary nature of photographic and textual 'truth.' Keenly aware that pictures of urban vagrants are

muddled

fuddled

flustered

lushy

sottish

maudlin

among the clichés of documentary photography, Rosler set herself the task of representing the Bowery – that neighborhood of downtown New York mythically tied to the 'bum' – without falling into the bathos of victim photography. To do so she interspersed a series of unpeopled pictures of Bowery storefronts with pages resembling concrete poems composed entirely of colorful synonyms for drunkenness. Working from the assumption that the 'Bowery bum' is a standard type habitually misrepresented in documentary photography, Rosler's refusal to make photographs of such figures was meant to dramatize the broader failure of any signifying system, including both photography and text, to capture 'truth.'

By juxtaposing what she calls 'two inadequate descriptive systems' – one visual and one textual – Rosler's work on the Bowery suggests that images and words, while often linked, function as distinct codes with their own types of grammatical units and syntax. The *Blasted Allegories* of the late 1970s by John Baldessari (b. 1931) similarly articulate and juxtapose diverse 'descriptive systems.' The elements of the *Blasted Allegories* are

140. **John Baldessari**, *Blasted Allegories (Colorful Sentence) – Stern Stoic Streak (Y.O.R.V.B.G.)*, 1978. In this work Baldessari breaks down the codes of a particular commercial medium – television – and reconfigures them. In doing so, he suggests that any one of us may become an active spectator by reading the mass media in a wide variety of unanticipated ways.

drawn from an archive compiled by the artist of still photographs taken randomly from television: some are in black and white, others are in full color, while still others are monochromatically toned in the colors of the spectrum. These images are all labelled with a single word, filed away by the artist and later recombined according to a complex set of rules in new rebus-like sentences or equations. In these diagrammatic allegories, Baldessari evokes and superimposes several different codes including those of televisual narrative, the still photograph, color associations, and words. Although he had already made important Conceptual paintings in the 1960s which explored the relation between image and text, Baldessari's practice of re-photography in the *Blasted Allegories* and other works is closely linked to the procedures of artists like Sherrie Levine (b. 1947), Richard Prince (b. 1949), and Dara Birnbaum (b. 1946) who were central to 'appropriation art' in the late 1970s and 1980s. While the crux of Baldessari's allegories was their demonstration that, when extracted from its surroundings, any single image could carry a vast number of associations depending upon its new context or 'syntax,' in the work of Levine and Prince, who became notorious for simply re-photographing existing pictures and presenting them under their own names as works of art, such networks of association were telescoped into a single picture.

As 'unoriginal' as appropriated photographs may appear aesthetically, their rhetorical context is complex, and therefore functions as a fundamental dimension of their meaning. For instance, when Levine re-photographed book plates of famous modernist artworks by men like the documentary photographer Walker Evans, she projected several versions of artistic and economic 'ownership' onto a single picture. Works in the series *After Walker Evans* are in one sense or another 'authored' by Evans, by the photographer who shot the work for the book in which it was illustrated, and by Levine, not to mention the long tradition of documentarians who preceded and in various ways conditioned Evans's work. As Levine precisely articulated in an interview of 1985:

The pictures I make are really ghosts of ghosts; their relationship to the original images is tertiary, i.e., three or four times removed. By the time a picture becomes a bookplate it's already been rephotographed several times. When I started doing this work, I wanted to make a picture which contradicted itself. I wanted to put a picture on top of a picture so that there are times when both pictures disappear and other

138

*times when they're both manifest; that vibration is basically what the
work's about for me – that space in the middle where there's no picture.*

If Rosler's *Bowery* demonstrated the *inadequacy* of pictures,
Levine's appropriations manifest the photograph's special *fecundity*. In her art a single picture appears as many different pictures
depending upon the viewer's perspective and knowledge of art
history. In *After Walker Evans* the technical capacity of mechanical reproduction to replicate an image is manifested not only as
the relationship between an original work of art and its copies,
but also between patriarchal traditions of art-making (represented by Evans) and feminist challenges to them (as embodied in
Levine's re-photography). In such a context the act of copying is
both gendered and historically charged: both as an artist and as a
woman, Levine comes *after* Walker Evans.

But what of Levine's poetic notion of her pictures' 'vibration'
between appearance and disappearance – what she calls 'that
space in the middle where there's no picture.' In the same interview cited above, the artist poses a provocative rhetorical
question: 'What does it mean to own something, and, stranger
still, what does it mean to own an image?' As discussed in the previous chapter, one of the central dynamics in Conceptual art and
related practices was an exploration of the artist's intellectual
and physical properties on the one hand, and an acknowledgment
of how inequalities of gender and ethnicity produce different
gradations of 'self-possession' on the other. With her re-photographed pictures, Levine displaced the question of ownership from the artist's thoughts or body to the image itself. And
indeed, in the intensely visual economy in which we live, the
question of how images – including, but not limited to, works of
art – may be transformed into capital is sharply pertinent. What
Levine calls 'that space in the middle where there's no picture,'
represents the fragile intermediary state when an image is
temporarily outside of ownership or exchange. In other words,
by multiplying the 'owners' who attach themselves to a particular
photograph, Levine undermines all of their claims, causing the
picture to collapse as a form of property.

Richard Prince, who along with Levine was the most
significant artist exploring procedures of re-photography in the
late 1970s and early 1980s, has spoken of the 'personality' of pictures. In an interview of 1987 he stated, 'Advertising images are
presumptuous, as if they have their own ego.' If Levine withdraws
pictures from the nexus of authorship in order to strip them of

their value as commodities, Prince imagines the picture as its own author – as an 'ego.' To say that one of Prince's photographs derived from Marlboro ads, such as *Untitled (Cowboy)* (1991–2), has an ego is to suggest that, like a person, the photograph possesses autonomous agency and desire. And indeed, one of the goals of Appropriation art is to highlight the 'magic' of mechanical reproductions. Dara Birnbaum's single-channel video appropriations, such as *Technology/Transformation: Wonder Woman* (1978), function as televisual incantations in which a single trope drawn from a commercial drama – in this case Wonder Woman's transformation into a super-hero through spinning – is repeated over and over again, as though, following Prince, the 'presumptuous' image is bringing itself into being.

If, as Prince and Birnbaum's art suggests, the products of mechanical reproduction have their own personalities or egos, how might such qualities be characterized? From one perspective, Prince's Cowboys and Birnbaum's Wonder Woman exemplify particular attitudes toward gender – the heroism of American masculinity on the one hand and the desire for a powerful and avenging femininity on the other – which deeply structure popular culture in the United States. As widely disseminated stereotypes, these pictures indeed possess 'personalities'

141. **Richard Prince**,
Untitled (Cowboy), 1991–2

which help to condition the beliefs and attitudes of their viewers. But from another perspective, the 'personality' of pictures is closely tied to their visual rhetoric. When divorced from the context of advertising, qualities like the Marlboro ad's rich autumnal tones and the balletic posture of its cowboy provoke myriad associations unrelated to cigarettes. Indeed, Appropriation art entails at least two types of abstraction: first, it decontextualizes pictures by 'abstracting' them from their original contexts and associations, but second, it causes advertisements or reproductions to be encountered as works of art, drawing greater attention to their form. This relation between appropriation and abstraction is underlined by each of the three practitioners of re-photography discussed thus far. In the mid-1980s, Levine began making 'generic' paintings, typically composed of broad vertical

143. **Richard Prince**,
Competition Orange, 1988–9

stripes or checkerboard patterns which, on account of their design and scale, simultaneously recalled the language of modernist painting and domesticated objects like gameboards or crafts. In the late 1980s Prince made a series of monochromatic works whose fiberglass supports were shaped like automobile hoods suggesting that, like his pictures, these 'paintings' were detached and re-contextualized commercial surfaces. Finally, in her multi-channel video installations like *PM Magazine* (1982), Birnbaum habitually inserted video monitors within large, richly colored panels reminiscent of canvases.

While the turn to painting among artists engaged in procedures of re-photography may seem paradoxical, it accords well with Appropriation art's 'abstraction' of pictures from their accustomed environments. Advertisements persuade as much

144. **Dara Birnbaum**,
PM Magazine, 1982

through their seductive surfaces as through their explicit messages, and a great deal of photography and painting in the 1980s sought to derive an abstract language of surface from the blandishments of commercial imagery. In the 1980–81 series of abstract photographs by James Welling (b. 1951), which represent close-up shots of crumpled aluminum foil, a virtually scaleless topographical field is evoked which affords few hints as to the picture's referent. Here, the purely formal vocabulary of black and white studio photography – rich gradations of tone punctuated by light – is released from the camera's conventional burden of mimesis.

Even among painters of the 1980s, abstraction was often literally derivative in that non-objective form was 'derived' from commercial or mechanically reproduced sources rather than emerging from the 'creativity' of the artist. Such painterly strategies encompassed the complex imbrication of different appropriated, and often photographic, source materials within a painterly field characteristic of the work of David Salle (b. 1952); the inflated citation by Julian Schnabel (b. 1951) of the expressionist rhetorics of early twentieth-century avant-gardes; and the painstaking versions of abstract motifs drawn from earlier artists and rendered by Philip Taaffe (b. 1955) as collages built from individual lino-prints. However, it is the diagrammatic dayglo canvases by Peter Halley (b. 1953) which serve as the best analogue to Appropriation art's excavation of social codes. Halley's works resemble painterly 'logos' in which complex ideas are

145. **James Welling**, *August 16A*, 1980. Welling's photograph defies any secure perception of scale: the rich modulation of dark and light which plays across its surface evokes topographical maps as readily as it does the crumpled piece of aluminum foil from which it was made. Unlike the verisimilitude of most photographs, many of Welling's works, including this one, are rigorously abstract.

146. **David Salle**, *The Tulip Mania of Holland*, 1985. Salle was one of many artists working in the 1980s who revived expressionist modes of painting which had all but disappeared in the 1970s. His canvases are characterized by startling juxtapositions of everyday objects, like modernist chairs, with virtually pornographic images of women. Often such widely divergent pictures are not only set side by side, but woven through one another in overlapping layers.

embodied in simple, memorable forms. *Prison and Cell with Smokestack and Conduit* (1985) is typical of the artist's stylized lexicon of form including 'cells' – square shapes indicating a generic dwelling or workspace – and 'prisons' which, through the addition of a barred window, suggest an oppressive dimension of contemporary office towers or apartment blocks. Like many artists during the 1980s Halley was seriously engaged with theories of surveillance elaborated by the philosopher Michel Foucault who, along with Jean Baudrillard and other French and German theorists, was widely read in the United States during this decade. For Foucault the production and dissemination of 'information' is intimately linked to apparatuses of social control. Halley's paintings embody this dynamic by joining cells and prisons with abstracted 'conduits,' reminiscent both of plumbing and electronic cables, suggesting the paradox that physical alienation in the contemporary world is enabled by ever denser networks of communication. Moreover, by configuring his cells, prisons, and conduits like microchips, Halley establishes a homologous relationship between architectural space and the miniaturized topographies of electronics. In short, his painterly 'logos,' which themselves recall the language of corporate design, indicate a slippage between architectural space and the spaces of communication.

147. **Peter Halley**, *Prison and Cell with Smokestack and Conduit*, 1985. The day-glo colors of Halley's paintings give them the warmth and electric light of switched-on appliances. This quality enhances and emphasizes their references to technology and surveillance.

This intersection of physical and informational spaces articulated graphically in Halley's paintings has characterized much of the art and popular culture since the early 1980s, culminating in the term 'cyberspace' in which new networks of communication are imagined through architectural metaphors like 'chat rooms.' Even before the explosion of the Internet, artists like Jenny Holzer (b. 1950) had begun to produce 'architectures' of communication. These began modestly with Holzer's *Truisms* (1977–9) – alphabetized lists of politically charged and often contradictory statements like 'Abuse of Power Should Come as No Surprise.' These pithy messages, written by the artist herself, masquerade as received wisdom. Though they would ultimately appear in various formats, the *Truisms* were first distributed anonymously by Holzer as inexpensive offset posters pasted onto walls around New York City. This guerrilla gesture embodied two of the artist's ongoing strategies. First, she seized access to public speech by impersonating or colonizing various modes of advertising and signage. And second, she introduced messages of a political complexity and moral ambiguity seldom encountered in such contexts. If artists like Prince re-framed the *content* of advertising, Holzer's art adopts the *forms* of commercial speech in order to disseminate provocative texts about politics, ethics, and war paradoxically couched in the seductive rhetoric of advertising. In her deployment of everyday media like posters,

architectural plaques, magazines, public benches and, most famously, LEDs (light-emitting diodes) and Spectacolor signs, Holzer demonstrates that cities are composed as much of text and images as they are of streets and buildings. In this regard her programs for animated urban billboards, like the Spectacolor sign in Times Square in New York (1982) or a similar work for Piccadilly Circus in London in 1988–9, suggest that by the late twentieth century monumentality no longer inheres in great buildings or commemorative statues, but in the capacity to send messages to the largest possible public. Moreover, as in advertising, Holzer's appropriation of such monumental information portals introduces extremely intimate meditations into the most public of places. In London, for instance, she programmed texts from her *Survival Series* (1983–5) which include shattering imperatives like 'SAVOUR KINDNESS BECAUSE CRUELTY IS ALWAYS POSSIBLE LATER' or 'PROTECT ME FROM WHAT I WANT.'

148. **Jenny Holzer**, *Selections from Truisms*, 1982

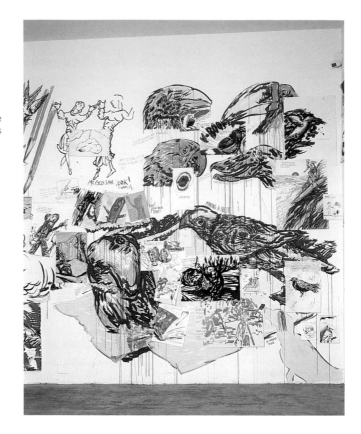

In both her public projects and her spectacular museum installations, Holzer fashions information architecturally. In the 1990s such spatializations of communications media assumed many forms. Some artists, like Raymond Pettibon (b. 1957), responded to the cacophony of mass media voices through a low-tech mirroring of their irrational proliferation. Pettibon's installations consist of many drawings, sometimes loosely layered above a giant wall painting. Executed in the language of cartoons or underground zines, these ostensibly casual works capture a paradoxical mix of heroism and evil, perversion and sentimentality. Pettibon's quotation of comics, film, and television give the impression of a huge refuse heap of signification, but other artists of the 1990s have established higher-tech versions of the media landscape.

In *electric earth* (1999) by Doug Aitken (b. 1968), eight channels of film transferred to laserdisc transform a suite of galleries into an edgy environment in which the animation of things

through electricity – from Coke machines to car windows – is associated with the picaresque wanderings of the work's 'protagonist' who jerks and dances through a dystopic urban landsape. As this character states, 'A lot of times I dance so fast that I become what's around me. It's like food for me. I, like, absorb that energy, absorb the information. It's like I eat it. That's the only now I get.' *electric earth* pivots on a question which is equally fundamental in assessing the role of the Internet in contemporary social life – namely, the relation between a person and the information s/he consumes. If the inhabitant of 'electric earth' eats energy, such a diet of electronic stimuli is essential to the appeal of the world wide web.

A number of artists who have engaged with the net as an aesthetic medium have explored its conventional protocols of sorting and serving up information – namely the web page and the search engine. Artists like Maciej Wisniewski (b. 1958) and Mark Napier (b. 1961) have invented alternate information portals which generate unconventional configurations of material allowing for different kinds of connections. Wisniewski's

150. **Doug Aitken**,
electric earth, 1999

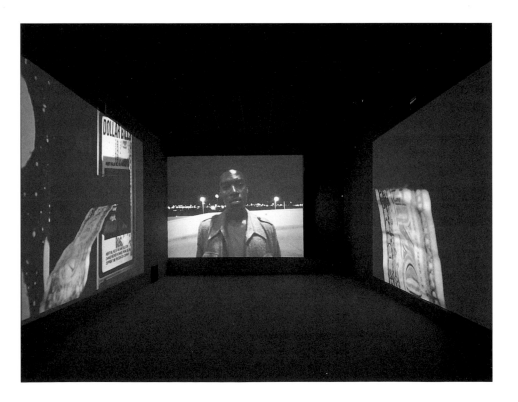

netomat (1999) enables a user to conduct a web search using a keyword of his or her choice, resulting in a melange of information fragments – including sound, picture, and text – drawn from diverse sites. Napier's *Riot* (1999) similarly transgresses the sanctity of the web page by scrambling together various sites in visually arresting configurations of text and image drawn from diverse and often contradictory sources. Like John Baldessari's *Blasted Allegories* of some twenty years earlier, or the re-photography with which this section began, these Internet works explore the rhetorical codes and the proprietary nature of a particular mode of communication in order to render them no more – or less – than a glittering array of surfaces.

140

138

151. **Maciej Wisniewski**, *netomat*, 1999

152. **Mark Napier**, *Riot*, 1999

Commodity Lifestyles

Rather than eschewing the marketplace as many Conceptual or Performance artists of the 1970s did, artists of the 1980s and '90s – as with Pop artists before them – regarded the market as a public sphere and commercial languages like advertising as modes of public speech. For Haim Steinbach (b. 1944), whose 1980s sculptures consist of readymade commodities arranged on wedge-shaped formica-clad shelves, shopping is not simply the gratification of a need or a desire, but an ideologically charged mode of positioning oneself socio economically. In other words, the preference for and the capacity to buy certain products or to create certain interiors, entails the adoption of a wholesale identity – a 'lifestyle.'

Not surprisingly, as shopping has become a dominant leisure-time activity in the United States, politics has changed as well. Citizens are more and more addressed as consumers, and elected officials and political parties are 'sold' like products or brands. In a 1987 interview, Steinbach hinted at such connections between identity, power, and consumption by stating, 'I think there are hierarchical judgments implicit in objects, and I think there is an equality between objects that goes across these hierarchies. It is my job to break these biases down.' Indeed, in works such as *ultra red #2* (1986), in which ostensibly unrelated products – digital

153. **Haim Steinbach**, *ultra red #2*, 1986. Steinbach arranges the commodities he has chosen on distinctive wedge-shaped shelves, often themselves brightly colored. Somewhere between a pedestal and a merchandising display, this mode of presentation signals the hybrid nature of his sculptures.

155. **Jeff Koons**, *New Shelton Wet/Dry Tripledecker*, 1981

alarm clocks, casseroles, and lava lamps – are juxtaposed on a tri-partite shelf, the artist both establishes hierarchies and works toward neutralizing them. The clocks and pots denote utility while the lava lamps connote a druggy form of leisure; the brightly colored pots are upscale and contemporary, the clocks are generic and dull, while the lava lamps are seedily retro. In terms of movement, the LED displays of the clocks mark the time with a crisp and regularized progression of numbers while the motion of the lava lamps is fluid and irregular. Despite the multi-valent associations and qualities encoded in these things, Steinbach bridges their differences by linking objects together through color. Each item in *ultra red #2* contains a prominent red element, and the sizzle of this evocative color establishes a formal equivalence or 'equality' between a set of products which otherwise represent contradictory values. In Steinbach's sculptures social differences collapse into formal similarities through the rhetoric of display: his work enacts an ironic democracy of the marketplace.

Shopping may be a social, or even a quasi-political, act but the psychic dimension of consumption – its solicitation and temporary gratification of individual desire – is equally fundamental. One historical distinction that may be drawn between the widespread deployment of readymade commodities in sculpture of the

154. **Mike Kelley**, *More Love Hours Than Can Ever Be Repaid* and *The Wages of Sin*, 1987

1980s and '90s and earlier practices, such as Marcel Duchamp's initiation of the readymade tradition in the early twentieth century, or the various forms of 1960s object sculpture discussed in Chapters 3 and 4, is the intense psychological identification established between people and things. In their deployment of readymade objects, for instance, Jeff Koons (b. 1955) and Mike Kelley (b. 1954) offer two opposing models of identification: Koons's commodities present idealized and unattainable states of being while Kelley's embody a form of abject empathy. Simply put, Koons's art of the early 1980s was engaged with the 'new' and Kelley's art of the late 1980s incorporated the 'used up.'

In Koons's sculptures consisting of vacuum cleaners encased in Plexiglas, like *New Shelton Wet/Dry Tripledecker* (1981), every- day appliances are maintained in a state of 'newness,' brightly illuminated from below as though preserved inside a refrigerator. Koons puns on the vacuum cleaner by placing it in an ostensibly airless chamber – a vacuum of a different sort – and thus fore- closes its proper function both literally and metaphorically. In an interview of 1986 Koons made his anthropomorphic associations with the vacuum cleaner explicit:

It's so easy to see that's new because it's not dirty. If it were used, its lungs would be dirty. It's a little bit of a breathing machine. You could think of the state of being 'new' as the individual. That's what I really want you to think about, how you can't be new. To have your own integrity you have to live and you're not immortal. But here the machine can just have integrity forever by not participating.

The commodity is thus both a mirror of the individual – some- thing with 'lungs,' a 'breathing machine' – as well as a terrifying negation of selfhood, in that it possesses a newness or perfection that no human being may retain after birth.

Mike Kelley's *More Love Hours Than Can Ever Be Repaid* (1987), a 'painting' composed of a motley array of thrift store dolls and afghans sewn onto canvas, is one of many works by the artist in which discarded handmade or plush dolls display evi- dence of 'love' – both the love expended in *making* and in *consuming* these anthropomorphic toys. By seizing upon an underground economy of discarded gifts and playthings, Kelley exhumes the messy emotions that attach to things. If Koons links consumption to the desire for unattainable states, Kelley specu- lates on what he called in a 1991 statement, '"love" wealth, or "guilt" wealth.' In other words, in his art, acts of exchange always involve the expenditure of emotional as well as financial capital.

The two models of consumption articulated by Koons and Kelley – the 'new' and the 'used up' – are combined in the work of Felix Gonzalez-Torres (1957–96), whose 'candy spills' consist of perpetually replenished piles of sweets available for spectators to take away. Like other of Gonzalez-Torres's 'portraits,' the magnitude of *'Untitled' (Lover Boys)* (1991), consisting of a mound of individually wrapped blue and white candies, was derived from the combined weights of its subjects – the artist and his lover. Since viewers are invited to take away individual candies from the pile, the surrogate 'bodies' it represents are offered up to be cannibalized piece by piece. As Gonzalez-Torres declared in a 1995 statement, 'I'm giving you this sugary thing; you put it in your mouth and you suck on someone else's body. And in this way, my work becomes part of so many other people's bodies. It's very hot.' This erotic dimension of consumption co-exists with an equally powerful critique of commodification in Gonzalez-Torres's sculptures wherein elements of the work are given away as gifts. Just as the body must take in nourishment and expel waste, so Gonzalez-Torres's candy spills undergo cycles of diminishment and replenishment: the artwork is both constantly used up and perpetually renewed.

156. **Felix Gonzalez-Torres**,
'Untitled' (Lover Boys), 1991

The associations Gonzalez-Torres establishes between acts of consumption, commodities, and bodies were pursued differently in a series of sculptures made by Robert Gober (b. 1954) for his 1991 installation at the Galerie Nationale du Jeu de Paume in Paris. As part of this complex work, two untitled works rested on the floor of a room 'decorated' with a wallpapered forest motif. These pieces consisted of lifelike casts of male bodies, cut at the waist and pressed against a wall. In one of these, the buttocks and legs, clothed only in white briefs, socks, and tennis shoes, are spotted with lesion-like drains. In a second, the figure is dressed in black trousers through which three candles rise incongruously from legs and buttock. In these sculptures, Gober suggests a metaphorical relationship between the body and consumption which is redolent of both sexuality and disease. On the one hand flesh is rendered as an elaborate drain, little more than a membrane through which fluids may pass, and on the other it is transformed into an anthropomorphic candelabra, vulnerable to ignition and extinction through flame.

In light of Gober's work of the 1980s, in which ordinary objects like sinks, doors, and playpens are uncannily endowed with human qualities, his later casts of fragmented bodies, like those exhibited at the Jeu de Paume, suggest the ultimate collapse of bodies into things. In these sculptures, human psyches and anatomies are no longer merely *reflected* in commodities as they had been in the work of Koons and Kelley, but are themselves thoroughly objectified. Although each of the artists discussed in this section understands that identifying with readymade objects may limit or impoverish experience, each acknowledges the central role of commodities in contemporary social and psychic life. Other artists in the 1980s and '90s regarded this encroachment of commercial values – both within the booming art market and in the economy at large – as thoroughly unacceptable.

Group Material, an artists' collective founded in 1979 and disbanded in 1997, sought to re-value both art objects and ordinary things by inventing new modes of exhibition display. After briefly running their own storefront gallery on the Lower East Side of Manhattan, Group Material began to organize eclectic exhibitions within host institutions. In the Whitney Museum of American Art's Biennial Exhibition of 1985, for instance, Group Material, which then included Doug Ashford, Julie Ault, Mundy McLaughlin, and Tim Rollins, executed 'Americana.' This installation included the work of over forty-five participants, ranging from progressive artists in the prime of their careers to others like

157. **Robert Gober**, *Visible: Untitled*, 1991. This work, showing a vulnerable male lower body with protruding candles, might be viewed as an indirect memorial to the losses caused by AIDS in the 1980s and '90s.

158

the kitschy sports painter LeRoy Neiman whose work is otherwise unlikely to have entered the Whitney Museum. This eclectic mix of artists was augmented by a variety of ordinary commodities and commercial imagery such as a Maytag washer and dryer and 'classic' American wallpapers. Like Haim Steinbach, Group Material explored the sociology or politics of display, but unlike the former, whose juxtapositions of products were narrowly confined within an individual artwork, Group Material's projects were collectively organized and thematically focused on specific issues such as national and local identity, gentrification, and AIDS policy. As the group stated in 1990, 'Each exhibition is a veritable model of democracy. Mirroring the various forms of representation that structure our understanding of culture, our exhibitions bring together so-called fine art with products from supermarkets, mass-cultural artifacts with historical objects, factual documentation with homemade projects.'

Group Material's 'democracy of objects' is a self-conscious analogue to procedures of political democracy in which diverse populations demand representation. Exhibitions like 'Americana' function as manifestos for object-equality but, in their eccentric juxtapositions, they cannot help but draw attention to social and political distinctions. Much of the best art of the 1990s has explored how such distinctions – what the anthropologist Arjun Appadurai has called 'regimes of value' – are established through diverse cultural institutions, ranging from the home and office to civic entities like libraries and museums. Already in the 1980s, Louise Lawler (b. 1947) had demonstrated that canonical works of modern or contemporary art may take on the character of pleasing decorative objects in the homes of collectors. *Pollock & Tureen, Arranged by Mr. & Mrs. Burton Tremaine, Connecticut* (1984), for instance, is a photographic vignette centered on the lower edge of an Abstract Expressionist monument adjacent to a fancy tureen. The colors of the Pollock seem to 'match' those of the soup dish, just as so-called 'sofa art' is keyed to the tones of living-room ensembles in middle-class department stores. The heroic claims of modernist art, Lawler suggests, are literally domesticated when the works end up in the luxurious homes of their patrons.

If domestic display tends to 'cozy up' great art, the rhetoric of museums typically drains artifacts of their social potency, rendering them either purely aesthetic or purely documentary. In his important installation, 'Mining the Museum,' (1992) at the Maryland Historical Society, Fred Wilson (b. 1954) recovered

159

158. **Group Material**, 'Americana,' 1985, installed at the 1985 Whitney Biennial. Group Material's exhibition projects were typically composed of ordinary objects alongside works by a wide range of artists who were not necessarily members of the group. One of their frequent installation strategies was the development of a timeline pertaining to a particular historical event or theme, which would be applied to the walls of a room and illustrated by artworks.

METALWORK
1793-1880

neglected objects hidden away in the institution's storage rooms and re-arranged existing gallery installations in order to represent highly charged histories of slavery which are generally suppressed by institutions such as the Historical Society. Like Group Material's projects, Wilson's art takes the exhibition as a medium. But in contrast to Group Material's faith in the possibility of an object-democracy, Wilson demonstrates that 'regimes of value' emerge from the social disequilibriums established by racism (as well as, in other contexts, sexism and homophobia).

The archaeological connotation encoded in Wilson's title – 'Mining the Museum' – suggests one useful perspective on commodity-oriented art of the 1990s. Archaeology is a science devoted to uncovering and reconstructing lost worlds which, as Michel Foucault argues in his seminal book, Archaeology of Knowledge, is as essential in writing history as it is in excavating ancient ruins. Perhaps because commodities embody contemporary ideologies as potently as painted vases carry the values of classical Athens, many artists of the 1990s have performed literal or metaphorical archaeologies.

In History Trash Dig (1995), the artist Mark Dion (b. 1961) removed approximately two cubic meters of soil from a very old waste dump in the Swiss city of Fribourg, sorted through it for objects, and then cleaned, catalogued, and displayed his 'finds' in a local exhibition venue, the FRI-Art Kunsthalle, alongside the tools he had used to unearth and clean them, and the residual pile of dirt from which the exhibited objects had been extracted. By juxtaposing his means with his ends, Dion put the science of archaeology, as a technique for endowing humble objects with meaning, at the center of his work. In her Import/Export Funk Office (1992), Renée Green (b. 1959) used analogous tactics of archiving and display to perform an archaeology of the recent past. Pivoting on the international dissemination of hip-hop culture, and particularly its enthusiastic embrace by the German cultural critic Diedrich Diedrichsen, Import/Export Funk Office functions as a library or multimedia center. It includes a room-like configuration of open bookcases displaying various relevant titles, which encircles video viewing stations offering tapes exploring hip-hop from different perspectives. Four 'Funk Stations,' where visitors can listen to audiotapes, are ranged around the perimeter of the room. Like Group Material's projects, Green's work centers on a strong central theme, and like Wilson, she addresses a cultural formation – hip-hop – which is both central to African-American life and American culture at large.

161

162

159. **Louise Lawler**, Pollock & Tureen, Arranged by Mr. & Mrs. Burton Tremaine, Connecticut, 1984

160. **Fred Wilson**, 'Mining the Museum,' 1992–3

While archaeological investigations are traditionally tied to specific sites, Green's *Import/Export Funk Office* centers on the geographical and conceptual *mobility* of hip-hop as a commercial form of entertainment and an attendant lifestyle. Such an awareness of the transitory and international nature of cultural products has been central to art of the 1990s, a period during which economic shifts, often closely linked to emerging information technologies like the Internet, have produced a fascination with globalization. Two works of the 1990s elaborate complementary perspectives on the international circulation of commodities and cultures – Allan Sekula's *Fish Story* and Simon Leung's *Surf Vietnam*. *Fish Story* (1989–95) is a series of related documentary projects including photos and text which identifies the shipping industry as the repressed complement to a 'wired' world characterized by instantaneous communication and efficient air travel. As Allan Sekula (b. 1951) eloquently writes:

What one sees in a harbor is the concrete movement of goods. This movement can be explained in its totality only through recourse to abstraction. Marx tells us this, even if no one is listening anymore. If the stock market is the site in which the abstract character of money rules, the harbor is the site in which material goods appear in bulk, in the very flux of exchange.

In his photographs Sekula captures the physicality of goods containerized and internationally shipped, and he dramatizes moments of labor activism in which the material conditions under which goods are exchanged are contested politically.

If Sekula sees harbors, ships, and ocean trade routes as the repressed 'other' to globalization's dematerialized networks of travel and communication, Simon Leung (b. 1964) takes the practice of surfing – both as sport and as a means of sorting information – as a metaphor for what he calls the 'residual spaces' of the Vietnam War. In his multi-phase project *Surf Vietnam* (1998) Leung had a series of ostensibly authentic surfboards fabricated onto which an enlarged copy of a 1992 article from the *New York Times*, 'Surf's Up at China Beach,' was decalled. This article recounted the 'return' to Vietnam of a group of young Southern California surfers for a competition at China Beach, a site made notorious in a scene from the 1979 film *Apocalypse Now*, showing a soldier surfing in front of a village under attack. If, on the one hand, the *Times* article announces a 're-colonization' of Vietnam through tourism, on the other hand the presence of a large population of immigrant Vietnamese adjacent to the fabled

163
164

161. **Mark Dion**,
History Trash Dig, 1995

162. **Renée Green**,
Import/Export Funk Office, 1992

163. **Allan Sekula**, *Panorama, Mid-Atlantic*, 1993, from *Fish Story*, 1989–95

164. **Simon Leung**, detail of *Surf Vietnam*, 1998, showing circular arrangement of surfboards created in collaboration with members of the Huntington Beach High School surfing team

Both Sekula and Leung respond to the conditions of globalization in the late twentieth and early twenty-first centuries. Whereas Sekula tracks the physical movement of goods around the world through his photographic and textual accounts of international shipping, Leung manipulates the surfboard as a figure of both informational mobility and human migration.

surfing community of Huntington Beach in Orange County, where the exhibition was first staged, represents an opposing geo-political transfer. Leung worked with diverse local community groups, including surfers, Vietnam War veterans, and Vietnamese immigrants, each of which devised a configuration from the nineteen surfboards (or in some cases other materials) which eloquently, though abstractly, embodied its perspective on Vietnam as a country and as a 'war.' Although the surfboards themselves remained constant, their installation changed regularly during the course of the exhibition as each participating community made its statement. As in all of the works discussed in this section, *Surf Vietnam* situates an object – the surfboard – within a dense social network. And like Group Material, Fred Wilson, and Renée Green, Leung demonstrates that the 'language of things' may – and should – be democratized by expanding the ranks of those who are allowed to 'speak' it.

Posthuman

In the course of this book we have repeatedly seen how the growing commercialization of public life in the United States has functioned both as an inspiration and a limit to American art since 1945. The previous section surveyed various practices in which democracy itself is understood as a contestation among things – wherein social differences are indexed by commodities, and commodities act as surrogates for the political and psychological representation of human selves. The term 'lifestyle' is particularly suggestive in this regard, since it implies that identities are derived from distinctive modes of consumption – a point made brilliantly by Barbara Kruger (b. 1945) in her 1987 photographic silkscreen centering on the updated Cartesian slogan, 'I shop therefore I am.'

Already in the early 1980s Kruger's graphically arresting works had questioned how identities are structured in relation to commodified lifestyles. Like advertisements, her pictures address viewers in pithy combinations of photography – usually vintage black and white pictures – and text, often highlighted in red. Unlike ads, however, the artist's propositions unsettle rather than confirm a spectator's ideological positions. In *Untitled (You thrive on mistaken identity)* (1981), an aggressive slogan is superimposed on the photograph of a woman's profile, blurred as if glimpsed through textured glass. The very materiality of the text's layout seems to evacuate the woman's identity: the word 'mistaken' is set within a rectangular box whose position across

165

166

the subject's face recalls police photographs in which a suspect's identity is protected by blocking the eyes. But the pictured woman's identity is ultimately destabilized through the dual connotations of the words which frame her image. If the 'you' of 'You thrive on mistaken identity' is taken to be male, Kruger's message amounts to an accusation of sexism – i.e. men prosper through their incorrect assumptions about, and consequent objectifications of women. But if the 'you' is presumed female, the work suggests a dynamic of *self*-misrecognition. From this perspective Kruger implies that because of the pressure placed on women to occupy the stereotypes of femininity, they can only 'thrive' by adopting 'mistaken identities.' The latter reading is made explicit in another work, *Untitled (You are not yourself)* (1982), in which the text 'You are not yourself' is superimposed upon a found photograph of a woman mournfully regarding herself in a shattered mirror. In these works Kruger renders the viewer's encounter with gender stereotypes traumatic: when transformed into a form of advertising, she suggests, identity can only be experienced as 'mistaken' or 'alienated.'

Kruger's work marks a transformation from the contentious explorations of the artist's properties characteristic of 1970s art, to the understanding of identity as a commercial or otherwise objectified property. In *ID* (1990), Lorna Simpson (b. 1960) recapitulates Kruger's position and extends it to questions of ethnicity. *ID* consists of a pair of framed black and white photographs, each labelled with a single word. The picture on the left represents an irregular oval of nappy hair on a black ground labelled with the single word 'identify.' Its partner photograph, labelled 'identity,' shows an African-American woman from behind, her head occupying approximately the same space as the disembodied hair in the other photograph. The difference between these captions amounts to much more than the distinction between a verb and a noun: to identify is to attribute qualities to someone based on pre-existing categories which may or may not be accurate or fair (as, for example, when an African-American is identified by her hair) whereas identity is presumed to be the 'natural' possession of a self. Identification, then, is a social process by which the psychological experience of identity is partly determined.

Struggles over the power to identify – both others and oneself – were central to the politics and the art-making of the 1980s and '90s. In 1986, for instance, a group of six gay men came together as the Silence=Death Project. The poster they designed, consisting

165. **Barbara Kruger**, *Untitled (I shop therefore I am)*, 1987

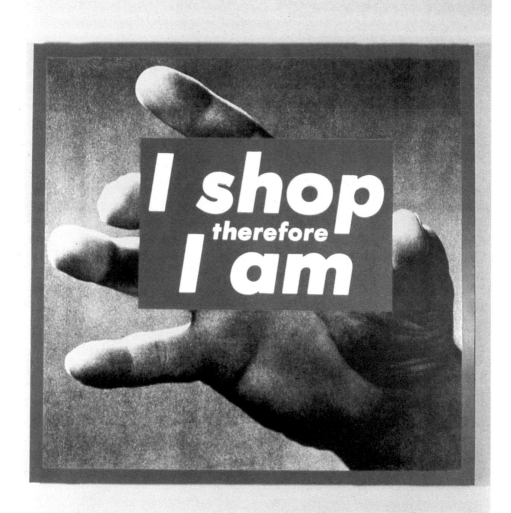

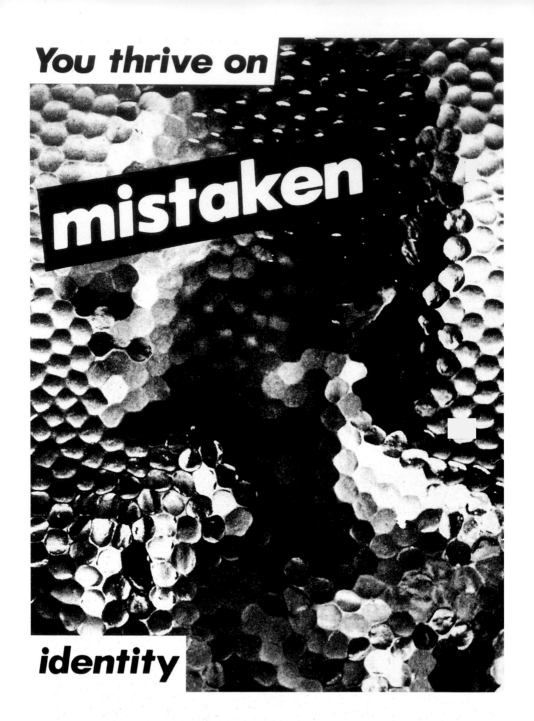

You thrive on

mistaken

identity

of a pink triangle on a black ground with the legend 'Silence=Death' in bold white type below, was a powerful response to the Reagan administration's pointed silence in the face of the burgeoning AIDS crisis of the 1980s. This pink triangle, which was to become the veritable logo of the AIDS movement through its adoption by the visually savvy activist group ACT UP, consisted of an emblem of *identification* – the Nazi symbol for homosexuals sewn onto the uniforms of death camp inmates – which Silence=Death inverted both literally (by reversing the orientation of the triangle from pointing down to pointing up) and metaphorically, by reframing it as a mark of voluntary rather than compulsory identification. In a complementary move, the Guerrilla Girls, an anonymous collective of women founded in New York in 1985 to assail the sexism and racism of the art world, veiled their identities in public by wearing novelty gorilla masks. This visual pun on 'guerrilla' versus 'gorilla' intentionally mis-identifies women, and especially women of color, as creatures lower on the evolutionary scale than humans. But here, as in the Silence=Death Project, a mode of identification associated with oppression and negative stereotyping is recuperated as an emblem of exuberant self-defined identity. The Guerrilla Girls deliberately obscured their *individual* identities in order to create a politically efficacious portrait of gender and ethnicity, which they delineated in great detail

168

169

166. Barbara Kruger, *Untitled (You thrive on mistaken identity)*, 1981

167. Lorna Simpson, *ID*, 1990

As in advertising, Kruger and Simpson combine text and photography to communicate a strong and legible message. But unlike advertising, which typically traffics in unexamined stereotypes, these artists provoke the viewer to question the nature of identity.

SILENCE=DEATH

Why is Reagan silent about AIDS? What is really going on at the Center for Disease Control, the Federal Drug Administration, and the Vatican? Gays and lesbians are not expendable...Use your power...Vote...Boycott...Defend yourselves...Turn anger, fear, grief into action.

Do women h
get into

Less t

through witty posters carrying statistical analysis of the unequal representation of women and people of color in the commercial and academic art worlds.

Progressive artists and activists were not the only ones to manipulate the mechanisms of identification in the late 1980s and early 1990s. On the contrary, since 1989, Christian fundamentalists have mobilized homophobia to influence cultural policy, in part by inciting political opposition to National Endowment for the Arts funding for exhibitions including art by gay men, lesbians, and others considered enemies of 'family values.' The so-called culture wars of the period, of which the NEA controversies are one chapter, set advocates of multicultural diversity against defenders of longstanding patriarchal and Anglo-American traditions in the realms of education and the arts. The visual politics of identity culminated in the 1993 Biennial at the Whitney Museum of American Art, organized by Elisabeth Sussman and widely excoriated by conservative critics. This

168. **Silence=Death Project**, 'Silence=Death,' 1986

169. **Guerrilla Girls**, *Do women have to be naked to get into the Met. Museum?*, 1989

Activist artists in the 1980s and '90s, like those associated with ACT UP and the Guerrilla Girls, were enormously sophisticated in their use of appropriation techniques common in advanced art to questions of social injustice.

ve to be naked to he Met. Museum?

n 5% of the artists in the Modern Art sections are women, but 85% of the nudes are female.

GUERRILLA GIRLS CONSCIENCE OF THE ART WORLD

w w w . g u e r r i l l a g i r l s . c o m

exhibition featured a range of art practices, including those of Lorna Simpson, Renée Green, Fred Wilson, and Simon Leung, which sought to represent how social processes of identification condition the experience of individual identity. The virulent response to the Biennial, like the culture wars in general, highlights a central paradox in identity politics. By claiming a political platform on the basis of a particular 'lifestyle,' artists, like activists, must traffic in the very stereotypes they wish to break down. Indeed, much of the best art of the 1980s and '90s acknowledges this dilemma by dwelling less on established categories of identity and more on the intersections and boundary transgressions among them. Such practices have been variously labelled postethnic, cyborgian, or posthuman by theorists influential in the 1990s. In different ways, each of these critical categories points to modes of selfhood based on voluntary action or association rather than essential biological traits or cultural stereotypes.

In his important 1995 book, *Postethnic America*, David Hollinger passionately advocates a model of ethnicity which acknowledges the hybridity and complexity within standard categories such as 'Asian-American' or 'Latino,' and he recommends a politics of affiliation in which a person is not automatically grouped into his or her ostensible community of descent. Rather than regarding technology as 'dehumanizing,' Donna Haraway's enormously influential essay 'Cyborg Manifesto: Science, Technology, and Socialist-Feminism in the Late Twentieth Century,' first published in 1985, claims a political potential for hybrid bodies enhanced through mechanical and electronic extensions. The posthuman encompasses these and other models of self-fashioning which range from the contemporary capacity to change one's physical envelope through exercise, surgery, and drug therapies, to the pleasure of assuming 'virtual selves' in cyberspace. From the mapping of the human genome to the construction of virtual communities on the Internet, the 'human,' in both its biological and social dimensions, has come to seem a highly malleable concept at the turn of the twenty-first century.

Though Barbara Kruger's pictures may render processes of identification traumatic by demonstrating that identity is always either mistaken or alienated, from a posthuman perspective, the breakdown of stable identities can actually be both pleasurable and politically efficacious. Laurie Anderson's marriage of live performance and high- and low-tech special effects makes it difficult to determine where the body of the artist ends and its technological extensions or prostheses begin. Anderson

(b. 1947) uses this blurring of physical boundaries to capture something fundamental in American life – a physical and social mobility which is alternately liberating and alienating. In her epic opera, *United States* (1983), a gorgeous array of projected images provides the backdrop for the artist's performance of haunting songs divided into thematic sections including 'Transportation,' 'Politics,' 'Money,' and 'Love.' Her signature tactic of transforming the character of her voice through electronic filters is an unsettling and exhilarating amplification of these themes of social and spatial dislocation. As the critic Craig

170. **Laurie Anderson**,
United States, 1983

Owens wrote in 1981, 'The author is supposed to speak through his characters; but Anderson's characters appear to speak through her. She is the medium which so many incorporeal voices require in order to communicate with us, the body they temporarily assume.'

Much of the most interesting video art of the 1980s and '90s explores such a colonization of the flesh by electronic technologies of communication. In *Crux* (1983–7), for instance, the body of the artist Gary Hill (b. 1951) is submitted to an act of video crucifixion. The work consists of five monitors configured as the points of a giant cross. Each monitor plays back footage of just one of Hill's extremities – his head, hands, and feet – as recorded while the artist walked through a ruined castle uncomfortably fitted with cameras strapped onto his body. Such an attenuation of human anatomy under the quasi-sacrificial pressure of mechanical reproduction is differently expressed in *Crying Doll*

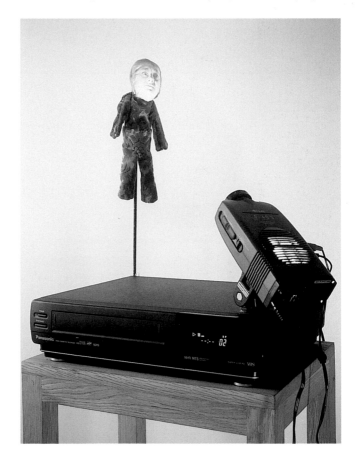

171. **Gary Hill**, *Crux*, 1983–7

172. **Tony Oursler**, *Crying Doll*, 1993

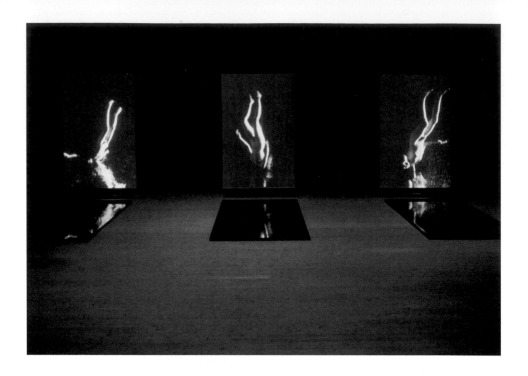

173. **Bill Viola**, *Stations*, 1994
(detail)

(1993) by Tony Oursler (b. 1957), in which a doll-like effigy is
fitted with an animate face composed of video. This uncanny
combination of a 'living' head and a 'dead' body is intensified by
the figure's continuous act of crying as though mourning its
own bifurcation.

 In these works by Hill and Oursler a 'withering away' of the
body is performed as a corollary to its reproduction. In other
types of video installation, such as *Stations* (1994) by Bill Viola (b.
1951), the body in representation experiences ecstatic release.
Each of the five suspended screens in *Stations* carries a lyrical pro-
jection of a nude figure submerged in water as though liberated
from gravity and returned to the womb. In different ways,
Anderson, Hill, Oursler, and Viola offer models of embodiment in
which the boundary between flesh and digital information is
blurred. This combination of the human and the technological
should not, however, be mistaken as a purely private experience.
Functioning as an entity on the Internet, for instance, the artist's
collective ®tmark has developed a cyborgian identity which is
explicitly corporate rather than personal. ®tmark offers a port-
folio of mutual funds whose sponsored activities are 'sold'
through a website to potential shareholders interested in earning

'cultural dividends.' Ironically, one of the group's most notorious actions transposed Anderson's signature technique of vocal displacement to the shelves of toy stores. In 1993 ®tmark channelled $8,000 from a military veterans' group to the Barbie Liberation Organization to fund an action in which the voiceboxes of three hundred talking GI Joe dolls were switched with those of three hundred Barbies, causing a startling scrambling of gender codes for the unsuspecting buyers of these iconic American toys.

From Anderson's pluralization and distortion of her voice to ®tmark's adoption of an anonymous corporate identity on-line, several artists of the 1980s and '90s invented cyborgian strategies to challenge conventional models of the artist's self. During the same period, a complementary set of practices emerged in which the body was imaginatively re-fashioned as though it were a sculptural medium. The shifts and transformations in the

174. ®tmark website page

175. **Cindy Sherman**,
Untitled #155, 1985

176. **Catherine Opie**, *Papa Bear*
from 'Being and Having,' 1991

career of Cindy Sherman (b. 1954) are exemplary in this regard. Although her photographs almost always contain the artist herself, they should not be considered self-portraits: Sherman appears in wildly divergent guises as though her physical presence is little more than a screen onto which various fantasies may be projected. In her series of simulated film stills initiated in 1977, for instance, Sherman impersonates the conventional poses of starlets ranging from traumatized ingenues to alluring coquettes. If, as Craig Owens declared, Laurie Anderson's body functioned as a medium through which various voices emerge, Sherman similarly channels a catalogue of feminine stereotypes. But in the course of the 1980s and '90s, the absorption of commodified femininities in Sherman's art shifted to an accumulation of prosthetic parts. In the mid-1980s, she began to apply masks and joke prostheses like plastic breasts and buttocks to her body until ultimately, in works like *Untitled #155* (1985), human anatomy was almost entirely displaced by cheap novelty items. This work, like Oursler's *Crying Doll*, pivots on the borderline

between the animate and the inanimate. Indeed, in a great deal of art of the 1990s it is precisely the boundary *between* identities or subjective states which is at issue rather than an attempt to specify a particular lifestyle.

In *Being and Having* (1991) by Catherine Opie (b. 1961), 176 which consists of a series of photographic head shots of cross-dressing women, feminine qualities co-exist with ostensibly unambiguous signs of masculinity like facial hair. Rather than allowing masculinity to cancel femininity out, Opie's work demonstrates that gender is not inherently binary — that any individual may possess a contradictory mix of characteristics. Similarly, in her installations composed of cut-out silhouettes of black paper on white walls, such as *Camptown Ladies* (1998), Kara Walker (b. 1969) establishes a discomfiting ambiguity regarding extravagantly painful stereotypes of slave life. In an interview of 1996 Walker referred to the 'inner plantation [which] … this generation of black kids are going to inherit,' and referred to her highly controversial statement, 'All black people in America want to be slaves just a little bit.' Walker's art and her writings have made many uncomfortable, including other African-American artists, on account of their insistence that stereotypes — even the most heinous — cannot be easily expelled from the consciousness of oppressor and oppressed alike. In her works, however, such racist figures drawn as much from fiction as from history are digested and literally 'shit out' in scenes of vulgar scatology where bodies are broken apart and drain away. As the artist

memorably stated in the interview quoted above, 'Really it's about finding one's voice in the wrong end; searching for one's voice and having it come out the wrong way.' Like Opie, for whom gender no longer functions as a binary opposition, Walker refuses to see racism as a clear question of 'us versus them.' Instead, she performs a complex excavation of both the psychological and the sociological dimensions of identification.

In his video and film work of the 1990s, Matthew Barney (b. 1967) initiates such processes of identification but never resolves them so that any permanent differentiation between, for instance, men and women, or animals and humans, is indefinitely suspended. In his epic 'Cremaster' series, consisting of five sequels and prequels produced out of order like the Star Wars films, biological, social, and mythological foundations of selfhood intersect and reflect one another. The term 'cremaster' refers to the muscle which controls the contraction and relaxation of testes in response to different physical or psychological stimuli like increased temperature or fear. Rather than dwelling on cruder modes of genital difference, Barney establishes an elaborate and often hermetic gonadal mythology in which organs are locked in endless cycles of ascent (like ovaries) and descent (like testes).

Cremaster 4 (1994), the first of the cycle which takes place – punningly – on the Isle of Man in the Irish Sea, includes several interlocking stories: a race between two motorcycle teams circling a track in opposite directions (the yellow team ascending and the blue team descending); the ascent of testicular organs from the pockets of the yellow driver's jumpsuit, and a corresponding descent occurring to the blue driver; the mythic journey into and through the island of a satyr-like figure called the Loughton Candidate (played by Barney himself) who, like the famous Loughton ram indigenous to the Isle of Man, has the capacity to grow both descending and ascending horns; and finally the various hijinks of three androgynous fairies played by female body builders whose genitals have been obscured through make-up and prosthetics, and whose hairdos alternately represent ascent (two high buns), descent (two low chignons), and both at once (two high buns and two low chignons). The gorgeous perversity of *Cremaster 4*, filled with voluptuous costumes and bizarre props, positions it on yet another borderline – in genre – between kitschy vaudeville and high tragedy, or Hollywood film and art-world video.

The rise since 1945 of a particular form of the public sphere, generated by mass media and devoted to consumption, has called

178. **Matthew Barney**, *Cremaster 4: Loughton Manual*, 1994 (detail). Using prosthetics, make-up, and elaborate costumes, Barney develops exotic cosmologies containing characters like the Loughton Candidate who blur the boundary between the animal and the human.

forth a politics of identity in which individuals are represented through intensely commodified lifestyles and stereotypical attributes. By establishing a 'double helix' of the social and the biological in which the rise and fall of human organs, sporting competitions, and animist tales of initiation fold into one another endlessly rather than separating out into distinct objects, Barney – like many other artists of the 1990s – suggests a new, post-human world in which the body itself is understood as a public sphere. Here the relaxation and even suspension of sharp differentiation between genders, sexualities, and ethnicities may offer an alternative to a world that has been hemmed in by the commercialization of virtually every act, thought, and emotion.

Timeline

Select Bibliography

List of Illustrations

Index

Groups, Movements and Styles

Influential Artists

Breton, André
Cornell, Joseph
DeKooning, Willem
Gorky, Arshile
Gottlieb, Adolph
Krasner, Lee
Lawrence, Jacob
Matta, Roberto
Newman, Barnett
O'Keeffe, Georgia
Pollock, Jackson

Important Art Events

1945 **'Art Concret'** exhib., Galerie Drouin, Paris (first major post-war exhibition of abstract art in Europe); 1946 **Lucio Fontana**, *White Manifesto*; 1947 **Jackson Pollock**, first 'drip' paintings; **Clyfford Still**, first 'colour field' abstractions

Important Historical Events

1945 US drops atomic bombs on Hiroshima and Nagasaki; End of World War II; United Nations formed; 1947 Independence of India; India/Pakistan partition; 1948 Assassination of Gandhi; State of Israel proclaimed; 1949 NATO formed; Mao proclaims Chinese People's Republic

Groups, Movements and Styles

- POP ART
- ASSEMBLAGE
- ABSTRACT EXPRESSIONISM
- BODY ART
- ENVIRONMENTS AND HAPPENINGS
- POST-PAINTERLY ABSTRACTION
- FLUXUS
- MINIMAL ART
- CONCEPTUAL ART
- PERFORMANCE
- PROCESS ART
- ACTIVIST ART
- EARTH AND LAND ART

Influential Artists

Duchamp, Marcel
Frankenthaler, Helen
Hartigan, Grace
Johns, Jasper
Kaprow, Allan
Kelly, Ellsworth
Louis, Morris
Rauschenberg, Robert
Reinhardt, Ad
Rothko, Mark
Schneemann, Carolee

Stella, Frank
Still, Clyfford
Twombly, Cy

Andre, Carl
Arbus, Diane
Bearden, Romare
Flavin, Dan
Friedlander, Lee
Hesse, Eva
Judd, Donald
Kawara, On
Kienholz, Edward
LeWitt, Sol
Lichtenstein, Roy

Marisol
Martin, Agnes
Oldenburg, Claes
Ono, Yoko
Paik, Nam June
Ruscha, Ed
Warhol, Andy
Winogrand, Garry

Important Art Events

1951 'Abstract Painting and Sculpture in America' exhib., MoMA, NY; **1952 Action Painting**, term coined by Harold Rosenberg; **John Cage**, *4'33"*, Woodstock, NY; **1953 Willem DeKooning**, 'Paintings on the Theme of the Woman' exhib., Sidney Janis Gallery, NY; **1954 Jasper Johns**, first *Flag* paintings; Death of **Henri Matisse**; **1955** First **Documenta** exhibition, Kassel; '**Man, Machine and Motion**' exhib., ICA, London; **1956** Death of **Jackson Pollock**; **1958 Pop Art**, term coined by Lawrence Alloway; '**New American Painting**' exhib., MoMA, NY; **1959 Allan Kaprow**, '18 Happenings in 6 Parts,' Reuben Gallery, NY; **Robert Frank** publishes *The Americans*

1960 Claes Oldenburg, *The Street*; **Andy Warhol**, *Dick Tracy*, first comic strip painting; **Yves Klein**, *anthropométries*; **Pierre Restany**, *New Realist Manifesto*; **1961** '**The Art of Assemblage**' exhib., MoMA, NY; **Clement Greenberg** publishes *Art and Culture*; **Claes Oldenburg**, *The Store*; **1962 Warhol** paints Marilyn Monroe and Campbell's Soup cans; first major exhib., LA; **Ed Ruscha**, *Twenty-Six Gasoline Stations*; Death of **Yves Klein**; **1963 Marcel Duchamp** retrospective, Pasadena; '**Towards a New Abstraction**' exhib., LA; Death of **Piero Manzoni**; **1964** '**Post-painterly Abstraction**' exhib., LA; **Robert Rauschenberg** awarded first prize at Venice Biennale; **Carolee Schneemann**, *Meat Joy*, NY; **Marshall McLuhan** publishes *Understanding Media*; **1965 National Endowment for the Arts** (NEA) founded, US; **1966** '**Primary Structures**' exhib., Jewish Museum, NY; **1967** '**New Documents**' exhib., MoMA, NY; '**Funk Art**' exhib., Berkeley; Death of **René Magritte**; **1968** Death of **Duchamp**; **1969 Arte Povera**, term coined by Germano Celant; '**Anti-Illusion: Procedures/Materials**' exhib., Whitney Museum of American Art, NY; '**When Attitudes Become Form**' exhib., Berne, Krefeld and London; '**Nine at Castelli**' exhib. org. by Robert Morris, NY; **Christo**, first US building wrap (MCA, Chicago); First issue of ***Art & Language***

Important Historical Events

1950 Start of Korean War; **1952** Color television available in the US; **1953** Execution of Julius and Ethel Rosenberg; End of Korean War; **1954** Rise of McCarthyism in the US; US Supreme Court rules racial segregation unconstitutional in public schools; **1955** Rosa Parks prompts Montgomery bus boycott, Alabama; **1956** Soviet troops end Hungarian uprising; **1957** European Economic Community founded; **1958** Explorer I, first US satellite, successfully orbits earth

1961 John F. Kennedy elected US President; Berlin Wall constructed; **1962** Cuban Missile Crisis; **1963** March on Washington led by Martin Luther King; Assassination of President Kennedy; **1964** Start of Vietnam War; Civil Rights Act passed; **1965** Assassination of Malcolm X; **1966** National Organization of Women founded; **1967** Che Guevara killed in Bolivia; **1968** Assassinations of Martin Luther King and Robert F. Kennedy; *Les événements*, student rioting in Paris; **1969** Neil Armstrong first man on the moon; Stonewall gay riot, NY

1970	1980	1990

Groups, Movements and Styles

◼ POP ART ▶

◀ NEO-EXPRESSIONIST PAINTING ▶

INSTALLATION AND VIDEO ART ▶

◀ FLUXUS ▶

◼ MINIMAL ART ▶ APPROPRIATION ART ▶

◼ CONCEPTUAL ART ▶

PERFORMANCE

◼ PROCESS ART ▶

◼ ACTIVIST ART ▶ CONCEPTUAL ABSTRACTION ◀

◼ EARTH AND LAND ART ▶

Influential Artists

Acconci, Vito
Antin, Eleanor
Benglis, Lynda
Bochner, Mel
Burden, Chris
Chicago, Judy
Graham, Dan
Haacke, Hans
Hammons, David
Jonas, Joan
Kelly, Mary
Kosuth, Joseph

Matta-Clark, Gordon
Morris, Robert
Nauman, Bruce
Piper, Adrian
Ringgold, Faith
Rosler, Martha
Saar, Betye
Serra, Richard
Smithson, Robert
Weiner, Lawrence
Wilke, Hannah

Anderson, Laurie
Basquiat, Jean-Michel
Birnbaum, Dara
Gober, Robert
Goldin, Nan
Group Material
Halley, Peter
Haring, Keith
Holzer, Jenny
Koons, Jeff
Kruger, Barbara

Levine, Sherrie
Prince, Richard
Salle, David
Schnabel, Julian
Sherman, Cindy
Wegman, William

Important Art Events

1970 'Information' exhib., MoMA, NY; **'Software'** exhib., Jewish Museum, NY; **Robert Smithson**, *Spiral Jetty*, Great Salt Lake, Utah; **1971 Linda Nochlin** publishes 'Why Have There Been No Great Women Artists?,' *Art News*; **'Contemporary Black Artists in America'** exhib., Whitney Museum of American Art, NY; Feminist Art Program, 'Womanhouse,' LA; **1972 Documenta V**: 'Individual Myths – Parallel Picture Worlds,' Kassel; **1973** Death of **Pablo Picasso**; **Joseph Beuys**, *Coyote*, NY; **Gordon Matta-Clark**, *Splitting*, Englewood, NJ; **1974 Asco**, *Decoy Gang War Victim*, LA; **1976 'Women Artists: 1550–1950'** exhib., Los Angeles County Museum of Art; **1977 Walter de Maria**, *Lightning Field*, New Mexico; **Documenta VI**: 'Art and Media,' Kassel; Opening of the **Centre Georges Pompidou**, Paris; First **'Skulptur Projekt'** exhib., Münster; **Cindy Sherman**, first *Untitled Film Stills*; **1978 'Bad Painting'** exhib., New Museum of Contemporary Art, NY; **1979 Beuys** retrospective exhib., Solomon R. Guggenheim Museum, NY; **Judy Chicago**, *The Dinner Party*

1981 'A New Spirit in Painting' exhib., Royal Academy of Arts, London; **1982 'Transavanguardia'** exhib., Galleria Civica, Modena; **'Zeitgeist'** exhib., Martin-Gropius-Bau, Berlin; **Documenta VII**, Kassel (shows return to painting); **First Carnegie International** exhib., Pittsburgh; **Maya Ying Lin**, *Vietnam Veterans Memorial*; **1983 Laurie Anderson**, *United States*, NY; **Mary Kelly** publishes *Post-Partum Document*; **1984 '"Primitivism" in Twentieth-Century Art: Affinity of the Tribal and the Cultural'** exhib., MoMA, NY; **1985 Group Material**, 'Americana' installation, Whitney Museum of American Art Biennial Exhibition; **Guerrilla Girls** women's collective founded; Saatchi Gallery opens, London; **1986** *Silence=Death*, AIDS activist project; **'Chambres d'Amis'** exhib., Ghent; Death of **Joseph Beuys**; **1987 'Berlinart 1961–1987'** exhib., MoMA, NY; **Documenta VIII**, Kassel; Second **'Skulptur Projekt'** exhib., Münster; Death of **Andy Warhol**; **1988 'Refigured Painting: The German Image 1960–88'** exhib., Solomon R. Guggenheim Museum, NY; **Venice Biennale**, *Aperto 88*; **'Freeze'** exhib., London; **1989** Death of **Salvador Dalí**; **'Magiciens de la Terre'** exhib., Paris; **'Forest of Signs'** exhib., Los Angeles Museum of Contemporary Art; **'Robert Mapplethorpe: The Perfect Moment'** exhib., Washington DC.

Important Historical Events

1973 Salvador Allende overthrown in Chile; **1974** President Nixon resigns after Watergate scandal; **1975** End of Vietnam War

1981 AIDS virus identified; **1985** Gorbachev comes to power in the USSR – beginning of *perestroika*; **1986** Iran-Contra scandal; **1987** ACT UP, AIDS Coalition to Unleash Power, founded; **1989** Berlin Wall comes down

◀ ■ ART POST-MEDIUM ■ ▶

◀ ■ INTERNET ART ■ ▶

■ IDENTITY POLITICS ■ ▶

Barney, Matthew	**Oursler**, Tony
Beecroft, Vanessa	**Pardo**, Jorge
Dion, Mark	**Pettibon**, Raymond
Gonzalez-Torres, Felix	**Pierson**, Jack
Green, Renée	**Sekula**, Allan
Hill, Gary	**Simpson**, Lorna
Kelley, Mike	**Smith**, Kiki
Kilimnik, Karen	**Viola**, Bill
McCarthy, Paul	**Walker**, Kara
Opie, Catherine	**Wilson**, Fred
Orozco, Gabriel	

1990 'Die Endlichkeit der Freiheit' exhib., Berlin; Lucy R. Lippard publishes *Mixed Blessings: New Art in a Multi-Cultural America*; **1991** '*Dis*locations' exhib., MoMA, NY; **1992** 'Post Human' exhib. by Jeffrey Deitch, Lausanne, Turin, Athens and Hamburg; 'Helter Skelter: LA Art in the 1990s' exhib., LA; **1993** Biennial Exhib., Whitney Museum of American Art, NY; **1994** 'Japanese Art after 1945: Scream Against the Sky' exhib., Solomon R. Guggenheim Museum, NY; **1995** 'Rites of Passage: Art for the End of the Century' exhib., Tate Gallery, London; 'Reconsidering the Object of Art, 1965–1975' exhib., Museum of Contemporary Art, LA; **1996** Yve-Alain Bois and Rosalind Krauss, 'L'informe – mode d'emploi' exhib., Centre Georges Pompidou, Paris; 'NowHere' exhib., Louisiana Arts Centre, Denmark; **1997** Bilbao Guggenheim opens in Spain; 'Sensation' exhib., Royal Academy of Arts, London, and Brooklyn Museum of Art, NY (1999); **1998** 'Out of Actions: Between Performance and the Object, 1949–1979,' Geffen Contemporary, LA; **1999** 'The American Century: Art & Culture, 1900–2000' exhib., Whitney Museum of American Art, NY; **2000** Tate Modern opens in London; **2001** Hermitage/Guggenheim Museum opens in Las Vegas; **2002** 'Gerhard Richter: Forty Years of Painting' exhib., MoMA, NY

1990 Germany reunited; Collapse of the USSR; Start of Gulf War; **1991** End of Gulf War; **1995** World Trade Organization established; **1999** US turns Panama Canal over to Panama; Anti-globalization protests, Seattle; **2001** G8 Summit, Genoa; 9/11 terrorist attack on the US; **2002** Earth Summit, Johannesburg

Select Bibliography

I have relied on more sources for *American Art Since 1945* than can be listed here. I have therefore chosen to compile two kinds of bibliography – a series of articles and books which are cited or referred to directly in the text, and a very brief list of general works on the topics of each chapter. Because of the number of artists discussed in this book, it would be impractical to list the many important monographs I consulted.

Chapter 1
Sources Cited
Anderson, Benedict, *Imagined Communities: Reflections on the Origin and Spread of Nationalism*, London: Verso, 1983
Barr, Alfred, *The New American Painting, As Shown in Eight European Countries, 1958-1959*, New York: Museum of Modern Art, 1959
Bois, Yve-Alain, *Painting as Model*, Cambridge, MA: MIT Press, 1993
Chipp, Herschel B., with contributions by Peter Selz and Joshua C. Taylor, *Theories of Modern Art: A Source Book by Artists and Critics*, Berkeley: University of California Press, 1968
Geist, Sidney, 'Work in Progress,' *Art Digest* v 1 n 13 (April 1, 1953): 1
Gibson, Ann Eden, *Abstract Expressionism: Other Politics*, New Haven: Yale University Press, 1997
Greenberg, Clement, *Art and Culture: Critical Essays*, Boston: Beacon Press, 1965, c. 1961
Guilbaut, Serge, *How New York Stole the Idea of Modern Art: Abstract Expressionism, Freedom, and the Cold War*, trans. Arthur Goldhammer, Chicago: University of Chicago Press, 1983
Newman, Barnett, *Barnett Newman: Selected Writings and Interviews*, ed. John P. O'Neill; text notes and commentary by Mollie McNickle; introduction by Richard Shiff, Berkeley: University of California Press, 1992
Rosenberg, Harold, 'American Action Painters,' *Art News* v 51 (December 1952): 22-3+
Shapiro, David and Shapiro, Cécile, eds., *Abstract Expressionism: A Critical Record*, Cambridge: Cambridge University Press, 1990 [for statements by Rothko and Pollock, and article by Barr]

Wagner, Anne Middleton, *Three Artists (Three Women): Modernism and the Art of Hesse, Krasner, and O'Keeffe*, Berkeley: University of California Press, 1996

General References
Anfam, David, *Abstract Expressionism*, New York: Thames & Hudson, 1990
Ashton, Dore, *The New York School: A Cultural Reckoning*, Harmondsworth: Penguin, 1979
Craven, David, *Abstract Expressionism as Cultural Critique: Dissent During the McCarthy Period*, Cambridge and New York: Cambridge University Press, 1999
Frascina, Francis, *Pollock and After: The Critical Debate*, New York: Harper & Row, 1985
Leja, Michael, *Reframing Abstract Expressionism: Subjectivity and Painting in the 1940s*, New Haven: Yale University Press, 1993
Polcari, Stephen, *Abstract Expressionism and the Modern Experience*, Cambridge: Cambridge University Press, 1991
Spigel, Lynn, *Make Room for TV: Television and the Family Ideal in Postwar America*, Chicago: University of Chicago Press, 1992

Chapter 2
Sources Cited
Bois, Yve-Alain, 'Ellsworth Kelly in France: Anti-Composition in Its Many Guises,' in Bois, Jack Cowart, and Alfred Pacquement, *Ellsworth Kelly; the Years in France, 1948-1954*, Washington: National Gallery of Art, 1992
—, 'The Limit of Almost,' in *Ad Reinhardt*, Los Angeles: Museum of Contemporary Art; New York: Museum of Modern Art; New York: Rizzoli, 1991
Cage, John, 'On Robert Rauschenberg, Artist and His Work' [1961], reprinted in Cage, *Silence: Lectures and Writings by John Cage*, Middletown: Wesleyan University Press, 1961
Kaprow, Allan, *Essays on the Blurring of Art and Life*, ed. Jeff Kelley, Berkeley: University of California Press, 1993
Kirby, Michael, 'Happenings: An Introduction,' in *Happenings and Other Acts* [1965], ed. Mariellen R. Sandford, London: Routledge, 1995
Krauss, Rosalind, 'Rauschenberg and the Materialized Image,' *Artforum* v 13, n. 4 (December 1974): 36-43
Rauschenberg, Robert, 'Untitled Statement,' in Dorothy C. Miller, ed.,

Sixteen Americans, New York: Museum of Modern Art, 1959, reprinted in Kristine Stiles and Peter Selz, eds., *Theories and Documents of Contemporary Art: A Sourcebook of Artists' Writings*, Berkeley: University of California Press, 1996
Riesman, David, in collaboration with Reuel Denney and Nathan Glazer, *The Lonely Crowd: A Study of the Changing American Character*, New Haven: Yale University Press, 1950
Rosenberg, Harold, 'Art and Words,' in Rosenberg, *The De-definition of Art: Action Art to Pop to Earthworks*, New York: Horizon Press, 1972 [commenting on Helen Frankenthaler]
Steinberg, Leo, *Other Criteria: Confrontations with Twentieth-Century Art*, New York: Oxford University Press, 1972

General References
Jones, Caroline A., *Machine in the Studio: Constructing the Postwar American Artist*, Chicago: University of Chicago Press, 1996
Orton, Fred, *Figuring Jasper Johns*, Cambridge, MA: Harvard University Press, 1994
Richardson, Brenda, *Frank Stella: The Black Paintings*, with assistance from Mary Martha Ward, Baltimore: Baltimore Museum of Art, 1976
Stich, Sidra, *Made in U.S.A.: An Americanization in Modern Art: the '50s and '60s*, Berkeley: University of California Press, 1987
Tomkins, Calvin, *The Bride & the Bachelors; The Heretical Courtship in Modern Art*, New York: Viking Press, 1965

Chapter 3
Sources Cited
Boorstin, Daniel J., *The Image: A Guide to Pseudo-Events in America*, New York: Harper & Row, 1961
Coplans, John, ed., *Roy Lichtenstein*, New York: Praeger, 1972
Crow, Thomas, 'Saturday Disasters: Trace and Reference in Early Warhol,' in Serge Guilbaut, ed., *Reconstructing Modernism: Art in New York, Paris, and Montreal 1945-1964*, Cambridge, MA: MIT Press, 1990
Debord, Guy, *The Society of the Spectacle* [1967], trans. Donald Nicholson-Smith, New York: Zone Books, 1994
DeCarava, Roy, *The Sweet Flypaper of Life*, photographs by Roy DeCarava; story by Langston Hughes, New York: Simon and Schuster, 1955

Diane Arbus, New York: The Estate of Diane Arbus; Aperture Foundation, Inc., 1972

Foster, Hal, *The Return of the Real: The Avant-Garde at the End of the Century*, Cambridge, MA: MIT Press, 1996

Frank, Robert, *The Americans*, intro by Jack Kerouac, New York: Grove Press, 1959

Oldenburg, Claes, *Store Days; Documents from The Store, 1961, and Ray Gun Theater, 1962*, selected by Claes Oldenburg and Emmett Williams, photos by Robert R. McElroy, New York: Something Else Press, 1967

Rosler, Martha, 'in, around, and afterthoughts (on documentary photography)' [1981], reprinted in Richard Bolton, ed., *The Contest of Meaning: Critical Histories of Photography*, Cambridge, MA: MIT Press, 303-341 [Rosler quotes Szarkowski's unpublished label text for 'New Documents' at the Museum of Modern Art (1967)]

Swenson, G. R., 'What is Pop Art? Part II' [1964], reprinted in Steven Henry Madoff, ed., *Pop Art: A Critical History*, Berkeley: University of California Press, 1997 [includes Wesselmann statement]

Warhol, Andy, *The Philosophy of Andy Warhol (From A to B and Back Again)*, London: Cassell, 1975

General References

Lippard, Lucy R., *Pop Art*, with contributions by Lawrence Alloway, Nancy Marmer [and] Nicolas Calas, New York: Praeger, 1966

Lobel, Michael, *Image Duplicator: Roy Lichtenstein and the Emergence of Pop Art*, New Haven: Yale University Press, 2002

Open City: Street Photographs Since 1950, with essays by Kerry Brougher and Russell Ferguson, Oxford: Museum of Modern Art Oxford; Ostfildern-Ruit: Hatje Cantz Verlag; New York: DAP/ Distributed Art Publishers, 2001

Szarkowski, John, *Photography Until Now*, New York: Museum of Modern Art, distributed by Bulfinch Press, Boston, 1989

Whiting, Cécile, *A Taste for Pop: Pop Art, Gender, and Consumer Culture*, Cambridge: Cambridge University Press, 1997

Chapter 4
Sources Cited

Bourdon, David, 'The Razed Sites of Carl Andre' [1966], reprinted in Gregory Battcock, ed., *Minimal Art: A Critical Anthology*, New York: Dutton, 1968

Brecht, George et. al., *An Anthology of Chance Operations*, ed. La Monte Young, Bronx: L. Young & J. MacLow, 1963

Buchloh, Benjamin H. D., 'Robert Watts: Animate Objects—Inanimate Subjects,' in Benjamin H. D. and Judith F. Rodenbeck, *Experiments in the Everyday: Allan Kaprow and Robert Watts—Events, Objects, Documents*, New York: Miriam and Ira D. Wallach Art Gallery, Columbia University, 1999

Chave, Anna, 'Minimalism and the Rhetoric of Power,' *Arts Magazine*, v 64, n 5 (January 1990): 44-63

Flam, Jack, ed., *Robert Smithson: The Collected Writings*, Berkeley: University of California Press, 1996

Flavin, Dan, '...in daylight or cool white' [1964], reprinted in James Meyer, ed., *Minimalism*, London: Phaidon, 2000

Fried, Michael, *Art and Objecthood: Essays and Reviews*, Chicago: University of Chicago Press, 1998

Higgins, Dick, 'A Child's History of Fluxus,' from *Horizons: The Poetics and Theory of the Intermedia*, Carbondale: Southern Illinois University Press, 1984

Johns, Jasper, *Jasper Johns: Writings, Sketchbook Notes, Interviews*, ed. Kirk Varnedoe; compiled by Christel Hollevoet, New York: Museum of Modern Art, distributed by Harry N. Abrams, 1996

Judd, Donald, *Complete Writings 1959-1975: Gallery Reviews, Book Reviews, Articles, Letters to the Editor, Reports, Statements, Complaints*, Halifax: Press of the Nova Scotia College of Art and Design; New York: New York University Press, 1975

Maciunas, George, letter to Robert Watts [March 11 or 12, 1963] in Jon Hendricks, *Fluxus Codex*, Detroit: The Gilbert and Lila Silverman Fluxus Collection; New York: Harry N. Abrams, 1988, p. 435

Martin, Henry, *An Introduction to George Brecht's Book of the Tumbler on Fire*, Milan: Multhipla, 1978

Morris, Robert, *Continuous Project Altered Daily: The Writings of Robert Morris*, Cambridge, MA: MIT Press; New York: Solomon R. Guggenheim Museum, 1993

Munroe, Alexandra with Jon Hendricks, eds., *Yes Yoko Ono*, New York: Japan Society; Harry N. Abrams, 2000

Plagens, Peter, *Sunshine Muse: Contemporary Art on the West Coast*, New York: Praeger, 1974

Secunda, Arthur, 'John Bernhardt, Charles Frazier, Edward Kienholz'

[interview], *Artforum* v 1, n 5 (October 1962): 30-34

Seitz, William Chapin, *The Art of Assemblage*, New York: Museum of Modern Art, distributed by Doubleday, Garden City, NY, 1961

Solnit, Rebecca, *Secret Exhibition: Six California Artists of the Cold War Era*, San Francisco: City Lights Books, 1990 [quote from Conner]

Sontag, Susan, *Against Interpretation and Other Essays*, New York: Farrar, Straus & Giroux, 1966

General References

Crow, Thomas, *The Rise of the Sixties: American and European Art in the Era of Dissent*, New York: Harry N. Abrams, 1996

Forty Years of California Assemblage, Los Angeles: Wight Art Gallery, University of California, 1989

Goldstein, Ann and Anne Rorimer, *Reconsidering the Object of Art: 1965-1975*, Los Angeles: Museum of Contemporary Art; Cambridge, MA: MIT Press, 1995

Jenkins, Janet, ed., *In the Spirit of Fluxus*, Minneapolis: Walker Art Center, 1993

Marter, Joan, ed., *Off Limits: Rutgers University and the Avant-Garde, 1957-1963*, Newark: Newark Museum; New Brunswick: Rutgers University Press, 1999

Meyer, James, *Minimalism: Art and Polemics in the Sixties*, New Haven: Yale University Press, 2001

—, ed., *Minimalism*, London: Phaidon, 2000

Chapter 5
Sources Cited

Bear, Liza, 'Gordon Matta-Clark' [interview], *Avalanche* (December 1974): 34-37

Flam, Jack, op. cit.

Gillette, Frank and Ira Schneider, 'Wipe Cycle,' in *TV as a Creative Medium*, New York: Howard Wise Gallery, 1969

Hobbs, Robert, *Robert Smithson: Sculpture*, Ithaca: Cornell University Press, 1981

Joan Jonas; Works 1968-1994, Amsterdam: Stedelijk Museum, 1994

Krauss, Rosalind, 'Richard Serra: Sculpture,' in Laura Rosenstock, ed., *Richard Serra: Sculpture*, New York: Museum of Modern Art, 1986

—, 'Video: The Aesthetics of Narcissism,' *October* 1 (Spring 1976): 50-64

McShine, Kynaston L., *Information*, New York: Museum of Modern Art, 1970

Meyer, Ursula, *Conceptual Art*, New York: Dutton, 1972 [includes cited texts by Bochner and Barry]

Morris, Robert, op. cit.

'Richard Serra,' *Avalanche* n 2 (Winter 1971) [this essay includes Serra's list of verbs and Dan Graham's text describing it]

Siegel, Jeanne, 'An Interview with Hans Haacke,' *Arts Magazine*, v 45, n 7 (May 1971): 18-21

Software; Information Technology: Its New Meaning for Art, New York: Jewish Museum, 1970

Tucker, Marcia, 'PheNAUMANology,' *Artforum* v 9, n 4 (December 1970): 38-43

General References

Davis, Douglas, *Art and the Future: A History/Prophecy of the Collaboration Between Science, Technology, and Art*, London: Thames & Hudson, 1973

Hanhardt, John G., ed., *Video Culture: A Critical Investigation*, Layton: G. M. Smith, Peregrine Smith Books, in association with Visual Studies Workshop Press, 1986

Kastner, Jeffrey, ed., *Land and Environmental Art*, with a survey by Brian Wallis, London: Phaidon, 1998

Krauss, Rosalind E, *The Originality of the Avant-Garde and Other Modernist Myths*, Cambridge, MA: MIT Press, 1985

Lee, Pamela M., *Object to be Destroyed: The Work of Gordon Matta-Clark*, Cambridge, MA: MIT Press, 2000

Pincus-Witten, Robert, *Postminimalism into Maximalism, American Art, 1966–1986*, Ann Arbor: UMI Research Press, 1986

Chapter 6

Sources Cited

Buchloh, Benjamin H. D., 'Conceptual Art 1962-1969; From the Aesthetic of Administration to the Critique of Institutions,' *October* n 55 (Winter 1990): 105-143

Chavoya, C. Ondine, 'Orphans of Modernism: The Performance Art of Asco,' in Coco Fusco, ed., *Corpus Delecti; Performance Art of the Americas*, London: Routledge, 2000

Dechter, Joshua, '(Re)Reading On Kawara; The Difference of Repetition,' in On Kawara, *Whole and Parts, 1964-1995*, ed. Xavier Douroux and Franck Gautherot, Dijon: Les presses du réel, 1996

Guerrilla Art Action Group, *GAAG, The Guerrilla Art Action Group, 1969-1976*, New York: Printed Matter, 1978

Gumpert, Lynn and Ned Rifkin, *Persona*, New York: New Museum of Contemporary Art, 1981 [contains Hershman quote]

Jones, Amelia, *Body Art: Performing the Subject*, Minneapolis: University of Minnesota Press, 1998

Jones, Kellie, 'David Hammons' [interview, 1986], reprinted in Russell Ferguson, William Olander, Marcia Tucker, and Karen Fiss, eds., *Discourses: Conversations in Postmodern Art and Culture*, New York: New Museum of Contemporary Art; Cambridge, MA: MIT Press, 1990

Kosuth, Joseph, *Art After Philosophy and After; Collected Writings 1966-1990*, ed. Gabriele Guercio, with a foreword by Jean-François Lyotard, Cambridge, MA: MIT Press, 1991

LeWitt, Sol, 'Sentences on Conceptual Art' [1969], reprinted in Alicia Legg, ed., *Sol LeWitt*, New York: Museum of Modern Art, 1978

Nemser, Cindy, 'An Interview with Vito Acconci,' *Arts Magazine* v 45 n 5 (March 1971): 20-23

Nochlin, Linda, 'Why Have There Been No Great Women Artists?,' *Art News*, v 69 (January 1971): 22-39+

O'Dell, Kathy, *Contract With the Skin: Masochism, Performance Art, and the 1970s*, Minneapolis: University of Minnesota Press, 1998

Piper, Adrian, 'Notes on the Mythic Being I-II,' [1974] in Adrian Piper, *Out of Order, Out of Sight; Volume I: Selected Writings in Meta-Art 1968-1992*, Cambridge, MA: MIT Press, 1996

Rorimer, Anne, *New Art in the 60s and 70s: Redefining Reality*, London: Thames & Hudson, 2001 [Barry's description of the *Telepathic Piece* is quoted here]

Wilke, Hannah, 'Intercourse With...' [1976], reprinted in Thomas H. Kochheiser, ed., *Hannah Wilke: A Retrospective*, Columbia: University of Missouri Press, 1989

General References

Alberro, Alexander and Blake Stimson, eds., *Conceptual Art: A Critical Anthology*, Cambridge, MA: MIT Press, 1999

Broude, Norma and Mary D. Garrard, eds., *The Power of Feminist Art: The American Movement of the 1970s, History and Impact*, New York: Harry N. Abrams, 1994

Buchloh, Benjamin H. D., *Neo-Avantgarde and Culture Industry: Essays on European and American Art from 1955 to 1975*, Cambridge, MA: MIT Press, 2000

Golden, Thelma, ed., *Black Male: Representations of Masculinity in Contemporary American Art*, New York: Harry N. Abrams and Whitney Museum of American Art, 1994

Griswold del Castillo, Richard and Teresa McKenna and Yvonne Yarbro-Bejarano, eds., *Chicano Art: Resistance and Affirmation, 1965–1985*, Los Angeles: Wight Art Gallery, University of California, 1991

Jones, Amelia, ed., *Sexual Politics: Judy Chicago's 'Dinner Party' in Feminist Art History*, Los Angeles: UCLA at the Armand Hammer Museum of Art and Cultural Center in association with the University of California Press, Berkeley, 1996

Patton, Sharon F., *African-American Art*, Oxford: Oxford University Press, 1998

Powell, Richard J., *Black Art and Culture in the 20th Century*, New York and London: Thames & Hudson, 1997

Chapter 7

Sources Cited

Appadurai, Arjun, 'Introduction: commodities and the politics of value,' in Appadurai, ed., *The Social Life of Things; Commodities in Cultural Perspective*, Cambridge: Cambridge University Press, 1986

Birnbaum Daniel et al, *Doug Aitken*, London: Phaidon, 2001

Cotter, Holland, 'Haim Steinbach: Shelf Life,' *Art in America*, v 76, n 5 (May 1988): 156-163; 201 [includes 1987 quote from Steinbach]

Foucault, Michel, *The Archaeology of Knowledge*, trans. A. M. Sheridan Smith, New York: Pantheon Books, 1972

Group Material, 'On Democracy,' in Brian Wallis, ed., *Democracy: A Project by Group Material*, New York: Dia Art Foundation; Seattle: Bay Press, 1990

Kelley, Mike, 'In the Image of Man' [1991], reprinted in John C. Welchman et al, *Mike Kelley*, London: Phaidon, 1999

Owens, Craig, 'Amplifications: Laurie Anderson,' *Art in America*, v 69, n 3 (March 1981): 120-123

Rian, Jeffrey, 'Social Science Fiction: An Interview with Richard Prince,' *Art in America* v 75, n 3 (March 1987): 86-94

Rothschild, Deborah, *Introjection: Tony Oursler; Mid-Career Survey, 1976-1999*, Williamstown: Williams College Museum of Art, 1999

Saltz, Jerry, 'Kara Walker: Ill-Will and Desire' [interview], *Flash Art*, v 29, n 191 (November 1996): 82-6

Sekula, Allan, *Fish Story*, Rotterdam: Witte de With Center for Contemporary Art, 1995

Siegel, Jeanne, 'After Sherrie Levine,' [interview], *Arts Magazine* v 59, n 10 (Summer 1985): 141-144

—, 'Jeff Koons: Unachievable States of Being,' [interview], *Arts Magazine* v 61, n 2 (October 1986): 66-71

Spector, Nancy, *Felix Gonzalez-Torres*, New York: Solomon R. Guggenheim Museum, 1995 [includes quote from Gonzalez-Torres]

Sussman, Elisabeth, *1993 Biennial Exhibition*, New York: Whitney Museum of American Art, in association with Harry N. Abrams, 1993

General References

Crimp, Douglas, *On the Museum's Ruins*, Cambridge, MA: MIT Press, 1993

Deitch, Jeffrey, *Posthuman*, Pully/ Lausanne: FAE Musée d'art contemporain; Rivoli, Torino: Castello di Rivoli, Museo d'arte contemporanea; Athens: Deste Foundation for Contemporary Art; Hamburg: Deichtorhallen Hamburg; New York [distributor]: DAP/Distributed Art Publishers, 1992

Foster, Hal, *Recodings; Art, Spectacle, Cultural Politics*, Port Townsend: Bay Press, 1985

—, ed., *The Anti-Aesthetic: Essays on Postmodern Culture*, Port Townsend: Bay Press, 1983

Hayles, N. Katherine, *How we Became Posthuman: Virtual Bodies in Cybernetics, Literature, and Informatics*, Chicago: University of Chicago Press, 1999

Kwon, Miwon, *One Place After Another: Site-Specific Art and Locational Identity*, Cambridge, MA: MIT Press, 2001

Meyer, Richard, *Outlaw Representation: Censorship and Homosexuality in Twentieth-Century American Art*, Oxford: Oxford University Press, 2002

Owens, Craig, *Beyond Recognition: Representation, Power, and Culture*, ed. Scott Bryson et al., Berkeley: University of California Press, 1992

Rush, Michael, *New Media in Late 20th-Century Art*, New York and London: Thames & Hudson, 1999

Wallis, Brian, ed., *Art After Modernism: Rethinking Representation*, New York: New Museum of Contemporary Art, 1984

—, Marianne Weems, and Philip Yenawine, eds., *Art Matters: How the Culture Wars Changed America*, New York: New York University Press, 1999

Weibel, Peter and Timothy Druckrey, eds., *net_condition: art and global media*, Graz, Austria: Steirischer Herbst; Karlsruhe, Germany: ZKM/Center for Art and Media; Cambridge, MA: MIT Press, 2001

List of Illustrations

10 Jackson Pollock, *Totem Lesson 2*, 1945. Oil on canvas, 182.9 x 152.4 (72 x 60). Australian National Gallery, Canberra. © ARS, NY and DACS, London 2003

11 Mark Rothko, *Primeval Landscape*, 1944. Oil on canvas, 138.1 x 88.9 (54⅜ x 35). Private collection, New York. © Kate Rothko Prizel and Christopher Rothko/DACS 1998

12 Arshile Gorky, *The Liver is the Cock's Comb*, 1944. Oil on canvas, 182.9 x 248.9 (72 x 98). Albright-Knox Art Gallery, Buffalo, New York. Gift of Seymour H. Knox. © ADAGP, Paris and DACS, London 2003

13 Adolph Gottlieb, *The Prisoners*, 1946. Oil, gouache and tempera on canvas, 63.2 x 81.1 (24⅞ x 31¹¹⁄₁₆). The Adolph and Esther Gottlieb Foundation, New York. © Adolph and Esther Gottlieb Foundation/ VAGA, New York/DACS, London 2003

14 Mark Rothko, *No. 61 (Rust and Blue)*, 1953. Oil on canvas, 294 x 232.4 (115¾ x 91½). The Museum of Contemporary Art, Los Angeles, The Panza Collection. © Kate Rothko Prizel and Christopher Rothko/DACS 1998

15 Barnett Newman, *Onement III*, 1949. Oil on canvas, 182.5 x 84.9 (71⅞ x 33½). The Museum of Modern Art, New York. Gift of Mr. and Mrs. Joseph Slifka. © ARS, NY and DACS, London 2003

16 Barnett Newman, *Pagan Void*, 1946. Oil on canvas, 83.8 x 96.5 (33 x 38). Photo Bruce White, courtesy of the Barnett Newman Foundation. © ARS, NY and DACS, London 2003

17 Norman Rockwell, *Framed*, 1946, on the cover of *The Saturday Evening Post*, March 2, 1946. Printed by permission of the Norman Rockwell Family Agency. © 1946 the Norman Rockwell Family Entities

18 Barnett Newman, *Covenant*, 1949. Oil on canvas, 121 x 151 (48 x 60). Hirshhorn Museum and Sculpture Garden, Smithsonian Institution, Washington, gift of Joseph H. Hirshhorn, 1972. Photo Lee Stalworth. © ARS, NY and DACS, London 2003

19 Morris Louis, *Beta Kappa*, 1961. Acrylic on canvas, 262.3 x 439.4 (103¼ x 173). National Gallery of Art, Washington, D.C., Gift of Marcella Louis Brenner. © 1961 Morris Louis

20 Morris Louis, *Beth Heh*, 1958. Acrylic on canvas, 228.6 x 355.6 (90 x 140). Collection of Mr. and Mrs. Graham Gund. © 1958 Morris Louis

21 Helen Frankenthaler, *Mountains and Sea*, 1952. Oil on canvas, 220.6 x 297.8 (86⅞ x 117¼). Collection of the Artist, on loan to the National Gallery of Art, Washington D.C. © Helen Frankenthaler

22 Helen Frankenthaler, *Shatter*, 1953. Oil on canvas, 123.2 x 137.2 (48½ x 54). Collection of the Artist, © Helen Frankenthaler

23 Cy Twombly, *Criticism*, 1955. Oil-based house paint, wax crayon, colored pencil, lead pencil, pastel on canvas, 127 x 147 (50 x 57⅞). Private collection, Rome. By permission of the artist

24 Cy Twombly, *Arcadia*, 1958. Oil-based house paint, wax crayon, colored pencil, lead pencil on canvas, 182.9 x 200 (72 x 78¾). Private collection. By permission of the artist

25 Ad Reinhardt, *Abstract Painting, Red*, 1952. Oil on canvas, 273 x 101.6 (107½ x 40). Museum of Modern Art, New York. Promised Gift of Mr. and Mrs. Gifford Phillips. © ARS, NY and DACS, London 2003

26 Ellsworth Kelly, *Cité*, 1951. Oil on wood, twenty joined panels, 142.9 x 179.1 (56¼ x 70½). Collection San Francisco Museum of Modern Art, EK 40. © Ellsworth Kelly

27 Ellsworth Kelly, *Colors for a Large Wall*, 1951. Oil on canvas, mounted on sixty-four joined wood panels, 243.8 x 243.8 (96 x 96). Collection Museum of Modern Art, New York, EK 46. © Ellsworth Kelly

28 Robert Ryman, *Untitled*, 1961. Oil on canvas, 30.5 x 30.5 (12 x 12). © 2002 Robert Ryman

29 Agnes Martin, *Night Sea*, 1963. Oil on canvas with gold leaf, 182.9 x 182.9 (72 x 72). © 2002 Agnes Martin

30 Frank Stella, *Arbeit Macht Frei*, 1958. Enamel on canvas, 215.9 x 308.6 (85 x 121½). Private collection. © ARS, NY and DACS, London 2003

31 Allan Kaprow, *18 Happenings in 6 Parts*, 1959. Happening (View of Room 2 from Room 1). Courtesy of the Getty Research Institute, Research Library. Photo Scott Hyde

32 Jim Dine, *The Smiling Workman*, 1960. Performance at the Judson Gallery, Judson Memorial Church, New York. Photo Martha Holmes, photo © Martha Holmes/TimePix. © ARS, NY and DACS, London 2003

33 Carolee Schneemann, *Meat Joy*, 1964. Kinetic theatre. © ARS, NY and DACS, London 2003. Photo Robert McElroy. © Robert R. McElroy/VAGA, New York/DACS, London 2003

34 Robert Rauschenberg, *Collection*, 1954. Combine painting: oil, paper, fabric, newspaper, printed reproductions, wood, metal, and mirror on three wood panels, 203.2 x 243.8 x 8.9 (80 x 96 x 3½). San Francisco Museum of Modern Art. Gift of Mr. and Mrs. Harry W. Anderson. © Robert Rauschenberg/ VAGA, New York/DACS, London 2003

35 Robert Rauschenberg, *Rebus*, 1955. Combine painting: oil, paper, fabric, pencil, crayon, newspaper, and printed reproductions on three canvases, 238.8 x 358.1 (94 x 141). Private collection. © Robert Rauschenberg/VAGA, New York/DACS, London 2003

36 Robert Rauschenberg, *Erased DeKooning Drawing*, 1953. Traces of ink and crayon on paper with matt and hand-lettered (ink) label in gold leaf frame, 64.1 x 55.2 (25¼ x 21¾). Collection of the Artist, New York. © Robert Rauschenberg/VAGA, New York/DACS, London 2003

37 Robert Rauschenberg, *Canto XXXIV (XXXIV Drawings for Dante's 'Inferno')*, 1959–60. Solvent transfer, pencil, watercolour, and gouache on paper, 37.1 x 29.2 (14⅝ x 11½). Museum of Modern Art, New York. Anonymous Gift. © Robert Rauschenberg/VAGA, New York/DACS, London 2003

38 Jasper Johns, *Flag*, 1954–5. Encaustic, oil, and collage on fabric mounted on plywood, 107.3 x 153.8 (42¼ x 60⅝). The Museum of Modern Art, New York. Gift of Philip Johnson in honor of Alfred H. Barr, Jr. © Jasper Johns/VAGA, New York/DACS, London 2003

39 Jasper Johns, *Flag*, 1954–5 (detail): see above

40 Jasper Johns, *Gray Alphabets*, 1956. Encaustic and collage on canvas, 167.6 x 124.5 (66 x 49). The Menil Collection, Houston. © Jasper Johns/VAGA, New York/DACS, London 2003

41 Claes Oldenburg, *The Street*, Judson Gallery, Judson Memorial Church, New York, February-March 1960. Courtesy the artist

42 Claes Oldenburg, 'Snapshots from the City,' performance at Judson Gallery, Judson Memorial Church, New York, February 29, March 1-2 1960. Photo Martha Holmes, photo © Martha Holmes/TimePix. Courtesy the artist

43 Claes Oldenburg, *The Store*, 107 East 2nd Street, New York, 1961. Photo Robert McElroy. © Robert R.

McElroy/VAGA, New York/DACS, London 2003. Courtesy the artist

44 Claes Oldenburg, *Bedroom Ensemble 2/3*, 1963–9. Wood, vinyl, metal, fake fur, muslin, Dacron, polyurethane foam, lacquer. Overall dimensions 303 x 512 x 648 (119⅛ x 201⅝ x 255⅛). Museum für Moderne Kunst, Frankfurt. Photo Rudolph Nagel, Frankfurt am Main. Courtesy the artist

45 Andy Warhol, *White Car Crash, Nineteen Times*, 1963. Silkscreen ink on synthetic polymer paint on canvas, 368.3 x 211.5 (145 x 83¼). © The Andy Warhol Foundation for the Visual Arts, Inc./ARS, NY and DACS, London 2003

46 Andy Warhol, *Red Race Riot*, 1963. Silkscreen ink on synthetic polymer paint on canvas, 350 x 210 (137¾ x 82⅝). Museum Ludwig, Cologne. © The Andy Warhol Foundation for the Visual Arts, Inc./ARS, NY and DACS, London 2003

47 Marisol, *John Wayne*, 1963. Mixed media, 264.2 (104). Colorado Springs Fine Arts Center, Julianne Kemper Purchase Fund and Debutante Ball Purchase Fund. © Escobar Marisol/VAGA, New York/DACS, London 2003

48 George Segal, *Cinema*, 1963. Plaster, metal, plexiglass and fluorescent light, 299.7 x 243.8 x 99.1 (118 x 96 x 39). Albright-Knox Gallery, Buffalo, New York. © The George and Helen Segal Foundation/DACS, London/VAGA, New York 2003

49 Andy Warhol, *210 Coca-Cola Bottles*, 1962. Silkscreen ink on synthetic polymer paint on canvas, 208.3 x 266.7 (82 x 105). Collection Martin and Janet Blinder. © The Andy Warhol Foundation for the Visual Arts, Inc./ARS, NY and DACS, London 2003

50 Andy Warhol, *Gold Marilyn Monroe*, 1962. Silkscreen ink on synthetic polymer paint and oil on canvas, 211.4 x 144.7 (83¼ x 57). The Museum of Modern Art, New York. Gift of Philip Johnson. © The Andy Warhol Foundation for the Visual Arts, Inc./ARS, NY and DACS, London 2003

51 Roy Lichtenstein, *Golf Ball*, 1962. Oil on canvas, 81.3 x 86.4 (32 x 34). Private collection. © The Estate of Roy Lichtenstein/DACS 2003

52 Claes Oldenburg, *Proposed Colossal Monument to Replace the Washington Obelisk, Washington, D.C.: Scissors in Motion*, 1967. Crayon and watercolour, 76.2 x 50.2 (30 x 19⅝). Collection of David Whitney, photo

by D. James Dee, New York. Courtesy the artist

53 Roy Lichtenstein, *Seascape II*, 1964. Oil and magna on canvas, 121.9 x 142.2 (48 x 56). Ileana Sonnabend Gallery, Paris. © The Estate of Roy Lichtenstein/DACS 2003

54 Tom Wesselmann, *Still Life #28*, 1964. Acrylic, collage and working TV on board, 121.9 x 152.4 (48 x 60). Harry N. Abrams Family Collection, New York. © Tom Wesselmann/VAGA, New York/DACS, London 2003

55 James Rosenquist, *F-111*, 1965. Oil on canvas, 304.8 x 2621.3 (120 x 1032). The Museum of Modern Art, New York, purchase. © James Rosenquist/VAGA, New York/DACS, London 2003

56 James Rosenquist, *F-111*, 1965 (detail): see above

57 Roy Lichtenstein, *Whaam!*, 1963. Magna on canvas, 172 x 269 (68 x 106). Photo © Tate, London 2003. © The Estate of Roy Lichtenstein/DACS 2003

58 Robert Frank, *Trolley – New Orleans*, 1955–6. Gelatin Silver print, 22.9 x 34.3 (9 x 13½). © 'The Americans,' Robert Frank, courtesy Pace/MacGill Gallery, New York

59 Robert Frank, *Canal Street – New Orleans*, 1955–6. Gelatin Silver print, 18.4 x 27.6 (7¼ x 10⅞). © 'The Americans,' Robert Frank, courtesy Pace/MacGill Gallery, New York

60 Lee Friedlander, *New York City*, 1966. Silver print, 18.7 x 28.3 (7⅜ x 11⅛). Courtesy Fraenkel Gallery, San Francisco

61 Garry Winogrand, *New York*, 1963. Silver print, 21.6 x 32.4 (8½ x 12¾). © The Estate of Garry Winogrand, courtesy Fraenkel Gallery, San Francisco

62 Romare Bearden, *The Dove*, 1964. Cut-and-pasted paper, gouache, pencil, and colored pencil on cardboard, 34 x 47.6 (13⅜ x 18¾). The Museum of Modern Art, New York. Blanchetter Rockefeller Fund. © Romare Bearden Foundation/VAGA, New York/DACS, London 2003

63 Ed Ruscha, *Every Building on the Sunset Strip*, 1966. Black offset printing on white paper; folded and glued, closed dimensions: 17.8 x 14.3 x 1 (7 x 5⅝ x ⅜); extended dimensions: 760.1 (299¼). Courtesy of Ed Ruscha

64 Marcel Duchamp, *In Advance of the Broken Arm*, 1915, original lost; 1945 version. Readymade: wood and galvanized iron snow shovel; height

121.3 (47¾). Yale University Art Gallery, Gift of Katherine Dreier. © Succession Marcel Duchamp/ADAGP, Paris and DACS, London 2003

65 Jasper Johns, *Device*, 1961–2. Oil on canvas with wood, 182.9 x 122.5 (72 x 48¼). Dallas Museum of Fine Arts. © Jasper Johns/VAGA, New York/DACS, London 2003

66 Edward Kienholz, *The Illegal Operation*, 1962. Tableau: stainless steel shopping cart, painted wood stool, electric brass floor lamp with shade, woven rug, enamel-glazed bedpan, bucket and saucepan, assorted metal implements, cigarette butts, and resin on bag of cement, fabric, gauze, and paper, 149.9 x 121.9 x 137.2 (59 x 48 x 54). Monte and Betty Factor Family Collection. © Nancy Reddin Kienholz

67 Bruce Conner, *LOOKING GLASS*, 1964. Mannequin arms, paper, cotton cloth, nylon, beads, metal, twine, glass, leather, plastic, fur, dried blowfish, silk, feathers, elastic, wood, nylon stockings, jewelry, etc. on Masonite, 153.7 x 121.9 x 36.8 (60½ x 48 x 14½). Collection San Francisco Museum of Modern Art, Gift of the Modern Art Council. Photo Ben Blackwell

68 Edward Kienholz, *The Cement Store #1 (Under 5,000 Population)*, 1967. Plaque of engraved brass on walnut, and typed description in walnut frame with glass, 23.5 x 30.5 and 22.9 x 34.3 (9¼ x 12 and 9 x 13½). Collection Nancy Reddin Kienholz. © Nancy Reddin Kienholz

69 Joseph Cornell, *Untitled (Penny Arcade Portrait of Lauren Bacall)*, 1945–6. Construction, 52.1 x 40.6 x 8.9 (20½ x 16 x 3½). The Lindy and Edwin Bergman Joseph Cornell Collection, Chicago. © The Joseph and Robert Cornell Memorial Foundation/VAGA, New York/DACS, London 2003

70 Robert Rauschenberg, *Monogram*, 1955–9. Combine painting: oil, paper, fabric, printed paper, printed reproductions, metal, wood, rubber shoe heel and tennis ball on canvas, with oil on Angora goat and rubber tire, on wood platform mounted on four casters, 106.7 x 160.7 x 163.8 (42 x 63¼ x 64½). Moderna Museet Stockholm. © Robert Rauschenberg/VAGA, New York/DACS, London 2003

71 Robert Morris, exhibition at the Green Gallery, New York, December 1964–January 1965. Left to right: *Untitled (Table)*, *Untitled (Corner*

Beam), *Untitled (Floor Beam)*, *Untitled (Corner Piece)*, and *Untitled (Cloud)*. © ARS, NY and DACS, London 2003

72 Carl Andre, *Lever*, 1966. 137 firebricks, 11.4 x 22.5 x 883.9 (4½ x 8⅞ x 348). National Gallery of Canada, Ottawa, purchased 1969. Photo © National Gallery of Canada. © Carl Andre/VAGA, New York/ DACS, London 2003

73 Robert Morris, *Untitled*, 1965/71. Mirror plate glass on wood, four cubes, each 91.5 x 91.5 x 91.5 (36 x 36 x 36). Tate Modern, London. © ARS, NY and DACS, London 2003. Photo © 1998 Tate Gallery, London

74 Donald Judd, *Untitled*, 1966. Amber plexiglass and stainless steel, 50.8 x 121.9 x 86.4 (20 x 48 x 34). Froehlich Collection, Stuttgart. Art © Donald Judd Foundation/VAGA, New York/ DACS, London 2003

75 Carl Andre, *Monchengladbach Square*, 1968. 36 unit square of hot rolled steel, 0.6 x 299.7 x 299.7 (¼ x 118 x 118). © Carl Andre/VAGA, New York/DACS, London 2003

76 Dan Flavin, *monument 4 those who have been killed in ambush (to P.K. who reminded me about death)*, 1966. Fluorescent light fixtures with four red tubes, each tube 243.8 (96). Collection Dia Center for the Arts, New York. Photo Cathy Carver. © ARS, NY and DACS, London 2003

77 Sol LeWitt, *Modular Structure (floor)*, 1966/68. Baked enamel on steel, 360 x 360 x 64 (141¾ x 141¾ x 25¼). Collection Paul Maenz, Neues Museum Weimar. Photo Jens Ziehe. © ARS, NY and DACS, London 2003

78 Sol LeWitt, *Serial Project # 1 (ABCD)*, 1966–7. Baked enamel on aluminum, 51 x 39 x 399 (20⅛ x 15⅜ x 157⅛). The Museum of Modern Art, New York, Gift of Agnes Gund and purchase (by exchange). © ARS, NY and DACS, London 2003

79 Eva Hesse, *Repetition Nineteen III*, 1968. Fiberglass, 19 units, each 48.3–50.8 x 27.9-32.4 (19-20 x 11-12¾). Museum of Modern Art, New York. Reproduced with the permission of The Estate of Eva Hesse. Galerie Hauser & Wirth, Zurich

80 Eva Hesse, *Accession II*, 1967–8. Galvanized steel, rubber tubing, 78.1 x 78.1 x 78.1 (30¾ x 30¾ x 30¾). Detroit Institute of Art. Reproduced with the permission of The Estate of Eva Hesse. Galerie Hauser & Wirth, Zurich

81 Yoko Ono, *Smoke Painting* score, 1961. © 1961 Yoko Ono

82 Yoko Ono, *Smoke Painting*, from 'Paintings and Drawings by Yoko Ono,' July 17-30, 1961, AG Gallery, NYC. Photo George Maciunas. Courtesy Lenono Photo Archive. © 1961 Yoko Ono

83 Nam June Paik, *Zen for Head*, 1962. Performance of La Monte Young's *Composition 1960 #10* performed at the Fluxus Internationale Festspiele Neuester Musik, Wiesbaden, Germany, 1962. Photo © Maytick, Cologne, Germany and the artist

84 George Brecht, chair inside gallery for 'Iced Dice,' a realization of *Three Chair Events* at the Martha Jackson Gallery, New York, 1961. Photo Robert McElroy. © Robert R. McElroy/VAGA, New York/ DACS, London 2003

85 Raphael Montañez Ortiz, *Piano Destruction Concert*, 1966. Destroyed piano, variable dimensions. Courtesy of the artist

86 Fluxus, Flux Year Box 2, *c.* 1968. Wood boxes with mixed media, 20.3 x 20.3 x 8.6 (8 x 8 x 3⅜) each. The Gilbert and Lila Silverman Fluxus Collection, Detroit

87 Robert Watts, *Safepost/K.U.K. Feldpost/Jockpost (W. C. Fields)*, 1961 (detail). Sheet of thirty stamps, offset printing on gummed paper, 10.2 x 26.7 (4 x 10½). Photo courtesy of Robert Watts Studio Archive, New York

88 Robert Watts, *Stamp Vendor*, 1961. US Government stamp machine loaded to dispense stamps by the artist, 36.8 x 14.6 x 12.7 (14½ x 5¾ x 5). Courtesy of Robert Watts Studio Archive, New York

89 Nam June Paik, *Magnet TV*, 1965. Television and magnet, dimensions variable. Whitney Museum of American Art, New York, purchase, with funds from Dieter Rosenkranz. Photo Peter Moore © Estate of Peter Moore/VAGA, New York/DACS, London 2003

90 Hans Haacke, *MoMa-Poll*, 1970. Installation for audience participation: two transparent acrylic ballot boxes, each 101.6 x 50.8 x 25.4 (40 x 20 x 10), equipped with a photoelectrically triggered counting device and text posted above the boxes. Installed at the 'Information' show, Museum of Modern Art, New York. Photo Hans Haacke. © DACS 2003

91 Hans Haacke, *Grass Grows*, 1969. Earth and grass. Installation in 'Earth Art' exhibition, Andrew Dickson White Museum of Art, Cornell University, Ithaca, New York, 1969. Photo Hans Haacke. © DACS 2003

92 Robert Morris, *Threadwaste*, 1968. Threadwaste, asphalt, mirrors, copper tubing, felt, overall dimensions variable. The Museum of Modern Art, New York, Gift of Philip Johnson. © ARS, NY and DACS, London 2003

93 Richard Serra, *Shovel Plate Prop*, 1969. Lead, 250 x 200 x 80 (98⅜ x 78¾ x 31½). © ARS, NY and DACS, London 2003

94 Lynda Benglis, *For Carl Andre*, 1970. Pigmented polyurethane foam, 142.9 x 135.9 x 118.1 (56¼ x 53½ x 46½). Collection of the Modern Art Museum of Fort Worth, museum purchase, the Benjamin J. Tillar Memorial Trust. © Lynda Benglis/ VAGA, New York/DACS, London 2003

95 Bruce Nauman, *A Cast of the Space Under My Chair*, 1965–8. Concrete, 44.5 x 39.1 x 37.1 (17½ x 15⅜ x 14⅝).Collection Geertjan Visser. © ARS, NY and DACS, London 2003

96 Bruce Nauman, *Corridor Installation (Nick Wilder installation)* 1970 (detail). Wallboard, three closed-circuit video cameras, scanner and mount, four 50.8 (20) black and white monitors, videotape player, videotape (black and white, silent), 304.8 x 1219.2 x 609.6 (120 x 480 x 240) overall. © ARS, NY and DACS, London 2003

97 Bruce Nauman, *Eat/Death*, 1972. Neon tubing with clear glass tubing suspension frame, 19.1 x 64.1 x 5.4 (7½ x 25¼ x 2⅛), edition of six. Courtesy Sonnabend Gallery. © ARS, NY and DACS, London 2003

98 Robert Smithson, *Nonsite (The Palisades, Edgewater, New Jersey)*, 1968. Painted aluminum, enamel and stone, 142 x 66 x 91 (55⅞ x 26 x 35⅞); typed description (signed), and map, 25 x 19 (9⅞ x 7½). Whitney Museum of American Art, New York, purchase, with funds from the Howard and Jean Lipman Foundation. © Estate of Robert Smithson/VAGA, New York/ DACS, London 2003

99 Robert Smithson, *Nonsite (The Palisades, Edgewater, New Jersey)*, 1968 (detail): see above

100 Robert Smithson, *Spiral Jetty*, 1970. Rock, salt, crystals, earth and water, 457.2 x 4.6 m (1500 x 15 ft). Great Salt Lake, Utah. Now destroyed. © Estate of Robert Smithson/VAGA, New York/DACS, London 2003

101 Walter De Maria, *The Lightning Field*, 1977. Long-term installation at Dia Center for the Arts, Quemado, New Mexico. Photo John Cliett. © Dia Center for the Arts

102 Dennis Oppenheim, *Salt Flat*, 1969. 1000 pounds of baker's salt placed on asphalt surface and spread into a rectangle, 15.24 x 30.48 m (50 x 100 ft), Sixth Avenue, New York. Identical dimensions to be transferred in 30.5 x 61 (1 ft x 1 ft x 2 ft) salt-lick blocks to ocean floor off the Bahama Coast. Identical dimensions to be excavated to a depth of 30.5 (1 ft) in Salt Lake Desert, Utah. Courtesy of the artist

103 Gordon Matta-Clark, *Splitting*, 1974. Cibachrome photograph, 76.2 x 101.6 (30 x 40). Private Collection. © ARS, NY and DACS, London 2003

104 Michael Asher, *Museum of Contemporary Art, Chicago, June 8-August 12, 1979*. Photos courtesy of the Museum of Contemporary Art, Chicago. Photos Tom Van Eynde

105 Mel Bochner, *Measurement Room*, 1969. Tape and Letraset on wall. Courtesy Sonnabend Gallery

106 Robert Barry, *Inert Gas Series: Helium*, March 1969. From a measured volume to indefinite expansion. On March 5, 1969 in the Mojave desert in California 2 cubic feet of helium was returned to the atmosphere. Collection, Paul Maenz, Berlin. Courtesy of the artist

107 Frank Gillette and Ira Schneider, *Wipe Cycle*, 1969–84. One CCTV camera, six videotape recorders (two playback pre-recorded material and four record and playback time-delay loops), nine television monitors of which one is a receiver, one audio tape deck, and one automatic switcher, 289.6 x 243.8 x 61 (114 x 96 x 24). Built for the exhibition, 'TV as a Creative Medium,' Howard Wise Gallery, New York. Courtesy Electronic Arts Intermix, New York

108 Nam June Paik, *TV Garden*, 1974. Single-channel video installation with live plants and monitors, colour, sound, dimensions variable. Collection of the artist. Photo Peter Moore © Estate of Peter Moore/VAGA, New York/DACS London 2003

109 Joan Jonas, *Vertical Roll*, 1972. Single channel videotape, black and white, sound. Courtesy of Electronic Arts Intermix, New York

110 Joan Jonas, *Organic Honey's Vertical Roll*, 1972. Multi-media performance event. Courtesy Electronic Arts Intermix, New York

111 Richard Serra, *Boomerang*, 1974. Single channel videotape, black and white, sound. Courtesy of Video Data Bank. © ARS, NY and DACS, London 2003

112 Lynda Benglis, *Now*, 1973. Single channel videotape, black and white, sound. Courtesy of Video Data Bank. © Lynda Benglis/VAGA, New York/DACS, London 2003

113 Peter Campus, *aen*, 1977. Closed-circuit video installation, black and white; low light surveillance camera; blue light. Whitney Museum of American Art, New York. Promised gift of The Bohen Foundation. Courtesy of the artist

114 Dan Graham, *Time Delay Room 1*, 1974. Concept drawing. Courtesy of the artist

115 Joseph Kosuth, *Titled (Art as Idea as Idea), 'Image,'* 1966. Photographic enlargement, 122 x 122 (48 x 48). Collection of Billy Copley and Patricia Brundage. © ARS, NY and DACS, London 2003

116 Lawrence Weiner, *Statements*, 1968. Cover and sample pages from artist's book, 18 x 10 x 0.5 (7⅛ x 3⅞ x ¼). © ARS, NY and DACS, London 2003

117 Guerrilla Art Action Group, photograph of October 16, 1969: action in front of Metropolitan Museum of Art, NY, ridiculing the exhibition 'New York Painting and Sculpture: 1940–1970.' © Jan van Raay

118 Vito Acconci, *Trademarks*, 1970. Photos by Bill Beckley. Courtesy the artist, *Avalanche* magazine, and Barbara Gladstone Gallery, New York

119 Chris Burden, *Shoot*, F-Space, Santa Ana, California, November 19, 1971. Photo courtesy the artist

120 Douglas Huebler, *Variable Piece no. 20* (detail), Bradford, Mass., January 1971. Photographic documentation and text reproduced from the exhibition catalogue Douglas Huebler, Westfälischer Kunstverein, Münster, 1972. © ARS, NY and DACS, London 2003

121 On Kawara, *I Got Up At 9.58 A.M.*, October 13, 1973. Postcard, 13.9 x 8.9 (5½ x 3½). Courtesy of Konrad Fischer Galerie, Düsseldorf

122 Ana Mendieta, *Rape Scene*, April 1973. Photodocumentation of performance at the artist's apartment, Iowa. Courtesy the Estate of Ana Mendieta and Galerie Lelong, New York

123 Eleanor Antin, *Carving: A Traditional Sculpture*, 1972 (detail). 144 black and white photographs and explanatory text, 17.8 x 12.7 (7 x 5) each. Collection of The Art Institute of Chicago. Courtesy Ronald Feldman Fine Arts, New York

124 Eleanor Antin, *The King of Solana Beach*, 1974–5. Life performance (photodocumentation). Courtesy Ronald Feldman Fine Arts, New York

125 Lynn Hershman, *Roberta Interviewing B.P. in Union Square, November 1, 1975*, 1976. C-Print, 76.2 x 101.6 (30 x 40). © Lynn Hershman. Courtesy Robert Koch Gallery, San Francisco, California

126 Adrian Piper, *The Mythic Being, Cycle 1: 4/12/68*, 1974. Page in the *Village Voice*, 38.1 x 27.9 (15 x 11). Courtesy of the artist and Paula Cooper Gallery, New York

127 Hannah Wilke, *S.O.S.-Starification Object Series*, 1974. 28 black and white photographs, 101.6 x 68.6 (40 x 27). © 2002 Marsie, Emanuelle, Damon and Andrew Scharlatt. Courtesy Ronald Feldman Fine Arts, New York

128 Judy Chicago, *Menstruation Bathroom*, 1972. Mixed media site installation at Womanhouse, 1972. © ARS, NY and DACS, London 2003

129 Camille Grey, *Lipstick Bathroom*, 1972. Mixed media site installation at Womanhouse, 1972. Photo Lloyd Hamrol

130 Judy Chicago, *The Dinner Party*, 1979. Mixed media installation. Brooklyn Museum of Art Collection. Gift of The Elizabeth A. Sackler Foundation. © ARS, NY and DACS, London 2003

131 Mary Kelly, *Post-Partum Document, Documentation II: Analysed Utterances and Related Speech Events*, 1975, detail 1 of 23 units. Wood, rubber, ink, 20.3 x 25.4 (8 x 10). Collection Art Gallery of Ontario. Photo Ray Barrie

132 Dana C. Chandler, Jr., *American Penal System... Pan-African Concentration Camps and Death Houses*, 1971, from the Genocide Series. Acrylic on canvas, 27.9 x 43.2 (11 x 17). Courtesy of the artist

133 Betye Saar, *The Liberation of Aunt Jemima*, 1972. Mixed media, 29.8 x 20.3 x 7 (11¾ x 8 x 2¾). Purchased with the aid of funds from the National Endowment for the Arts (selected by The Committee for the Acquisition of Afro-American Art), University of California, Berkeley Art Museum. Photo Benjamin Blackwell

134 David Hammons, *Spade*, 1974. Body print, 36.8 x 29.2 (14½ x 11½). Courtesy Jack Tilton/Anna Kustera Gallery

135 David Hammons, *Spade with Chains*, 1973. Spade, chains, 61 x 25.4 x 12.7 (24 x 10 x 5). Photo Dawoud

Bey. Courtesy Jack Tilton/Anna Kustera Gallery

136 Faith Ringgold, *Flag for the Moon: Die Nigger Black Light #10*, 1969. Oil on canvas, 91.4 x 127 (36 x 50). Private collection. Faith Ringgold © 1969

137 Faith Ringgold, *The Wake and Resurrection of the Bicentennial Negro*, 1976. Lifesize soft sculpture. Private collection. Faith Ringgold © 1976

138 Sherrie Levine, *After Walker Evans # 4*, 1981. Black and white photograph, 25.4 x 20.3 (10 x 8). Courtesy of the artist

139 Martha Rosler, *The Bowery in Two Inadequate Descriptive Systems*, 1974–5 (detail). 45 black and white photographs and 3 black panels each measuring 20.3 x 25.4 (8 x 10). © Martha Rosler, 1974–5. Courtesy of Gorney Bravin + Lee, New York

140 John Baldessari, *Blasted Allegories (Colorful Sentence) – Stern Stoic Streak (Y.O.R.V.B.G.)*, 1978. Black and white and color photographs on board, 77.5 x 101.6 (30¼ x 40). Collection Lowe Art Museum. Museum purchase through a grant from NEA, accession no. 81.0556. Courtesy the artist

141 Richard Prince, *Untitled (Cowboy)*, 1991–2. Ektacolour photograph, 121.9 x 182.9 (48 x 72). Courtesy Barbara Gladstone

142 Sherrie Levine, *Broad Stripe 2*, 1985. Casein and wax on mahogany, 61 x 50.8 (24 x 20). Courtesy of the artist

143 Richard Prince, *Competition Orange*, 1988–9. Fiberglass, wood, oil, and enamel, 154.9 x 131.4 x 17.5 (61 x 51¾ x 6⅞). Courtesy Barbara Gladstone

144 Dara Birnbaum, *PM Magazine*, 1982/93. Mixed media installation. San Francisco Museum of Modern Art, San Francisco

145 James Welling, *August 16A*, 1980. Gelatin silver print, 11.7 x 9.5 (4⅝ x 3¾). Courtesy of Gorney Bravin + Lee, New York

146 David Salle, *The Tulip Mania of Holland*, 1985. Oil on canvas, 335.3 x 519.4 (132 x 204½). The Carnegie Museum of Art, Pittsburg, A. W. Mellon Acquisition Endowment Fund, 1986. © David Salle/VAGA, New York/DACS, London 2003

147 Peter Halley, *Prison and Cell with Smokestack and Conduit*, 1985. Day-Glo acrylic, acrylic, and Roll-a-Tex on canvas, 160 x 274.3 (63 x 108). Courtesy of the artist

148 Jenny Holzer, *Selections from Truisms*, 1982. Spectacolor Board, 609.6 x 1219.2 (240 x 480). Installation, Times Square, New York. Sponsored by the Public Art Fund, Inc. NY. Photo courtesy of Jenny Holzer Studio. © ARS, NY and DACS, London 2003

149 Raymond Pettibon, installation view at Regen Projects, Los Angeles, September 8 - October 14, 2000. Photo Joshua White. Courtesy Regen Projects, Los Angeles

150 Doug Aitken, *electric earth*, 1999. Eight laserdisc installation, dimensions variable. Installation view at Venice Biennale. Courtesy 303 Gallery, New York

151 Maciej Wisniewski, *netomat*, 1999. Internet browser software. Courtesy of Postmasters Gallery, New York

152 Mark Napier, *Riot*, 1999. Alternative web browser (potatoland.org/riot). © Mark Napier

153 Haim Steinbach, *ultra red #2*, 1986. Plastic laminated wood shelf, enameled cast iron pots, plastic and metal digital clocks, glass, metal and coloured oil 'Lava Lites', 165 x 193 x 48.3 (65 x 76 x 19). Photo David Lubarsky. Collection of the Guggenheim Museum. Courtesy of Sonnabend Gallery, New York

154 Mike Kelley, *More Love Hours Than Can Ever Be Repaid* and *The Wages of Sin*, 1987. Found handmade stuffed animals and afghans on canvas with dried corn; wax candles on wood and metal base, two parts. *More Love Hours Than Can Ever Be Repaid*, 228.6 x 302.3 x 12.7 (90 x 119 x 5); *The Wages of Sin*, 132.1 x 60.3 x 60.3 (52 x 23¾ x 23¾). Courtesy of the artist and Metro Pictures

155 Jeff Koons, *New Shelton Wet/Dry Tripledecker*, 1981. Vacuum cleaners, Plexiglas, and fluorescent lights, 316.2 x 71.1 x 71.1 (124½ x 28 x 28). © Jeff Koons

156 Felix Gonzalez-Torres, *'Untitled' (Lover Boys)*, 1991. Blue and white candies, individually wrapped in cellophane, endless supply. Ideal weight: 161 kg (355 lbs). Courtesy Andrea Rosen Gallery, New York, in representation of The Estate of Felix Gonzalez-Torres. Photo Dirk Gysels. © The Estate of Felix Gonzalez-Torres

157 Robert Gober, *Visible: Untitled*, 1991. Wood, beeswax, leather, fabric and human hair, 38.7 x 41.9 x 114.3 (15¼ x 16½ x 45); Background: *Forest*, 1991. Silkscreen on paper, set of 10 panels, 457.2 x 315 (180 x 124). Installation, Galerie Nationale du Jeu de Paume, Paris, 1991. Photo K. Ignatiadis. Courtesy of the artist

158 Group Material, 'Americana,' 1985. Installation at the 1985 Whitney Biennial. Photo Geoffrey Clements. Courtesy of Group Material

159 Louise Lawler, *Pollock & Tureen, Arranged by Mr. & Mrs. Burton Tremaine, Connecticut*, 1984. Cibachrome, 71.1 x 99.1 (28 x 39). Courtesy the artist and Metro Pictures

160 Fred Wilson, 'Mining the Museum,' exhibition at the Maryland Historical Society, 1992–3 (details showing silver vessels and slave shackles exhibited together). Courtesy the artist and Metro Pictures

161 Mark Dion, *History Trash Dig*, 1995. Mixed media installation, including archaeological artifacts from the Fribourg city centre, dimensions variable. FRI-Art, Centre d'Art Contemporain Kunsthalle, Fribourg, Switzerland. Photo Elianne Laubscher. Courtesy of the artist

162 Renée Green, *Import/Export Funk Office*, 1992. Installation at 'Public Offerings', April 1 - July 29, 2001, MOCA at the Geffen Contemporary, Los Angeles. Courtesy of the artist

163 Allan Sekula, *Panorama, Mid-Atlantic*, 1993, from *Fish Story*, 1989–1995. Courtesy Galerie Michel Rein, Paris; Christopher Grimes Gallery, Santa Monica

164 Simon Leung, *Surf Vietnam*, 1998. Installation view (in collaboration with Huntington Beach High School surfing team). Mixed media, variable dimensions. Courtesy of the artist

165 Barbara Kruger, *Untitled (I shop therefore I am)*, 1987. Photograph silkscreen/vinyl, 281.9 x 287 (111 x 113). Courtesy Mary Boone Gallery.

166 Barbara Kruger, *Untitled (You thrive on mistaken identity)*, 1981. Photograph, 152.4 x 101.6 (60 x 40). Courtesy Mary Boone Gallery, New York

167 Lorna Simpson, *ID*, 1990. Two gelatin silver prints, two plastic plaques, 121.9 x 208.3 (48 x 82), edition of 4. Courtesy Sean Kelly Gallery, New York

168 Silence=Death Project, Silence=Death, 1986. Poster, offset lithography (also used as placard, T-shirt, button, and sticker), 73.7 x 61 (29 x 24). © ACT UP, New York

169 Guerrilla Girls, *Do women have to be naked to get into the Met. Museum?* Poster and bus placard. © 1989 by the Guerrilla Girls

170 Laurie Anderson, *United States*, 1983 (detail). Photo Bob Bielecki. Courtesy of the artist

Index

Page numbers in *italic* refer to illustrations